SOMETHING IN MY MIND BESIDES THE EVERYDAY

Women and Literacy

BY

Jennifer Horsman

*To all the literacy students
who have taught me so much*

CANADIAN CATALOGUING IN PUBLICATION DATA
Horsman, Jennifer, 1954—
Something in my mind besides the everyday: women and literacy

ISBN 0-88961-145-9

1. Literacy — Nova Scotia. 2. Rural women — Education — Nova Scotia. 3. Occupational training for women — Nova Scotia. 4. Rural women — Nova Scotia — Social conditions. I. Title.

LC154.2.N6H67 1990 374'.012'082 C90-094725-X

Copyright © 1990 Jennifer Horsman

Cover art: Marcia McMurdy
Cover design: Denise Maxwell
Editing: Ann Decter
Copy editing and proofreading: Kate Forster

All rights reserved. No part of this book may be used or reproduced in any manner whatsoever without written permission except in the case of brief quotations embodied in critical articles and reviews.
For information address Women's Press.

Published by Women's Press, 517 College Street, Suite 233, Toronto, Ontario, Canada M6G 4A2.

This book was produced by the collective effort of Women's Press and is a project of the Social Issues Group.

Women's Press gratefully acknowledges financial support from the National Literacy Secretariat, Department of the Secretary of State of Canada, The Canada Council and the Ontario Arts Council.

Printed and bound in Canada.
1 2 3 4 1994 1993 1992 1991 1990

Contents

Introduction ... 9

CHAPTER ONE
Living "Illiteracy": The Social Disorganization of
Women's Lives .. 25
*"Being Married, You Are There
to Cook and Clean"* 36
"He Could Walk Away" 45
"It Must Be the System" 55
Trouble with "Nerves" 65
"I Want to Depend on Myself" 80

CHAPTER TWO
Living an "Everyday" Life: Dreams of Literacy 87
*"As Long as I Can Live
without Worrying"* 87
"Going Somewhere" 98
"A Better Life for My Children" 105
"It All Comes Back to the Job" 115

CHAPTER THREE
Asking for the Moon and Stars: The Social Context of
Women's Desires for Literacy 123
Defining Literacy 124
Images of the "Other" 135
The Labour Market 150

CHAPTER FOUR
Training Programs: Caught in the Social Services Net ... 165
Fitting Workers to Technology 165
The Social Service Net 173
Redefining "Need" 182

CHAPTER FIVE
Conclusion .. 207

References .. 229

Acknowledgments

The research and writing of this study has not been an individual enterprise — many others have played an important role in its creation.

First, I must draw attention to the many women who were prepared to sit in their kitchens and tell me about their lives in intimate detail. I felt I had a trust not only to keep their information confidential but also to make good use of it, to expose and clarify the inequalities of the social system and the problem of illiteracy as it is socially constructed. Without the women working in literacy programs and upgrading and training programs who gave generously of their time, I would not have been able to meet so many participants. The program workers spent long hours talking to me openly about their programs and helped me to make further contacts. I respect the strength with which they work to serve the participants by pushing the limits of their programs, and hope that this study will enable them to broaden their individual picture.

As I floundered and struggled with the initial study, my friends and colleagues at the Ontario Institute for Studies in Education (OISE), in the Participatory Research Group and in the literacy community supported and helped me through an often agonizing process. In particular, Kathleen Rockhill and Philip Corrigan offered incredible help and support, which stopped me from giving up in the early stages of the research. Many friends provided me with stimulating discussion, encouraged me, and had faith that I could do the work when I lost that faith myself. Andrew, Lois, Mary and Linzi, each in their own way, provided continued support over many years. Without it, this work would never have been finished. Andrew's perceptive readings of drafts and his ongoing encouragement were especially valuable.

Most of all, though, I have to thank Susan Heald and Elaine Gaber-Katz. Susan worked with me extensively. Her support

was crucial in helping me to clarify the focus and to grapple with the concepts of poststructuralism. As friend and literacy practitioner, Elaine worked with me over many years, discussed the issues and read proposals, papers and chapters. She also helped me to realize that I was writing the initial thesis for my mother, so that my mother might understand and even come to share my political perspectives. Elaine critiqued it with her mother in mind, to ensure that my account would not be patronizing or belittling to those who live in poverty. She encouraged me to believe that the work could be of value to others in the literacy community. If this proves to be the case, it will be largely due to her assistance.

Maureen FitzGerald encouraged me to hand the initial manuscript in to Women's Press so that this study could get a wider audience than the thesis, which now sits on the shelves of a university library! Ann Decter helped me to take on the task of rewriting and reorganizing the material to make it more accessible. Her insightful reading was outstanding. Together we created this book, which would never have come into being without her supportive editing.

Finally, I must take responsibility for the ideas presented here, but only to acknowledge responsibility for any mistakes or errors. The process that has brought the ideas together to create this study and book has been a shared one. I want to thank all the women who have helped me feel less isolated in this endeavour despite the individuality of the writing process.

Introduction

As International Literacy Year, 1990 has brought attention to the issue of illiteracy. The media is full of accounts of people who cannot read and write, the horrors of their lives without literacy and the promise of change when they become literate.

> All illiterate adults liken the inability to read and write to being disabled or chained in a prison.... The sense of being caged and blinded is not morbid fantasy. People who can't read may be able to walk freely but they can't go far. (Callwood 1990, 39)

> The Saturday sun streams onto the scrubbed kitchen table in the public housing project where Bev Colley and Ken Burrows are playing Scrabble.... The words slowly emerging from the scrambled letters are Colley's key to a new life — already their wonders have taken her from public assistance to employment as building caretaker. (Crawford 1990)

The danger in this type of presentation is that it separates the literate from the illiterate as if there is a clear-cut division and, by creating myths about illiteracy, increases the problems experienced by those labelled illiterate. It suggests that simply to improve literacy skills will change a person's life.

Susan Hannaford, a woman with a disability, wrote angrily about the effect of the Year of the Disabled:

> Assigning a "special" year to the "disabled," with all its trappings — collecting boxes, tea-parties, and a pat on the head — serves a clear ideological function: the separation of the "abnormal" from the rest of society. To the "bad" (the criminal) and the "mad" (the mental patient) is added the "sad" (the disabled). Once labelled and categorized in this way, people stop being people, and stereotyped

attitudes and explanations of "them" take over. (quoted in TVOntario 1989)

Similarly, we must listen to those who are labelled illiterate and seek to understand their lives, rather than simply trying to "help those poor souls who can't read and write." A rigid dichotomy is depicted between the literate and the illiterate. The "illiterate" are frequently spoken of as though they were a uniform group. Language differences, whether between languages or of dialect within the same language, and the varied circumstances and backgrounds of those labelled illiterate are not made apparent.

Those of us who are literate easily believe that to be illiterate is a terrible state, and often we do not question further what illiteracy means. We do not ask why some people are illiterate or why our society is organized around the assumption that everyone is literate, even though we hear frequently that many are not. Graff cautions us about claims for the importance of literacy:

> [S]uch an overwhelming concern with literacy can only increase one's suspicions that the significance of a universal high degree of literacy is grossly misrepresented. It is overvalued partly because literate people, such as educators, knowing the value of their own work, fail to recognize the value of anyone else's. (quoted in Graff 1981, 2)

Much of the devaluing of the illiterate is based on the assumption that to be illiterate is to be less than human, "other" understood from the perspective of the literate "us." Literacy is seen as necessary to allow an individual to reflect on and comprehend her or his past and future. Many scholars have argued that literacy is essential for reflection and rational thought. Olson (1977) states:

> The faculty of language stands at the centre of our conception of mankind [sic]: speech makes us human and literacy makes us civilized. (257)

A study of the Vai people in Liberia, which questioned such claims for the intellectual and civilizing effects of literacy, concluded that

> research does not support designing adult literacy programs on the assumption that nonliterates do not think abstractly, do not reason logically, or lack other basic mental processes. (Scribner and Cole 1978, 459)

But such assumptions are often implicit in literacy programming. The illiterate are frequently spoken of as naive or childlike.

The work which studies literacy as if it were autonomous from social context displays cultural bias and ethnocentrism. Those of us who are literate may be tempted to assume that the value of literacy is self-evident, because we believe in the importance of our own literacy. But:

> The skills and concepts that accompany literacy acquisition, in whatever form, do not stem in some automatic way from the inherent qualities of literacy, as some authors would have us believe, but are aspects of a specific ideology. Faith in the power and qualities of literacy is itself socially learnt and is not an adequate tool with which to embark on a description of its practice. (Street 1984, 1)

There is strong evidence that literacy is based in social conditions. Clanchy's account of the growth of a "literate mentality" suggests that the importance of literacy is as a form of power for ruling (1979), and that although literacy did make a major change in society, this should not necessarily be seen as an advance in civilization. In a study of nineteenth-century Canada, Graff (1981) identifies the key factors which made a major difference to occupation and wealth: not literacy but ethnic and class origin. He challenges the idea that it is literacy itself that leads to social improvement and "civilization," arguing that attempts to teach literacy as neutral are part of the attempts by ruling classes to exercise social control. Historical studies suggest that the introduction of standardized schooling,

instead of expanding literacy as commonly assumed, was a way of controlling the multiple literacies then in existence and creating *one* schooled literacy. Many historians have argued that schooling was primarily intended to control mass literacy rather than to promote widespread literacy (Cook-Gumperz 1986, 28).

Our common-sense assumption is that literacy is simply literacy and clearly a good thing. This assumption breaks down when we explore how views on literacy and illiteracy have reversed over the last century (Donald 1983; Cook-Gumperz 1986). Previously, the literacy of the working classes was seen as a problem; now, the continuation of illiteracy is seen as a major crisis. Conservatives once saw unbridled literacy as a threat, but they also saw the potential of literacy for regulation and discipline:

> What the reformers were after, beside economy, was a system of social police which would open up the labour market and render that labour factor of production mobile and docile, that is, disciplined and as nearly rational and predictable as may be. (in Corrigan and Gillespie 1977, 13)

This historical awareness should make us cautious of current horrific descriptions of mass illiteracy as causing Canada's failure to compete in world markets, and make us question why illiteracy is now on the agenda. It should also make us wonder whether literacy programs are simply reinforcing the "social police" or offering literacy as a tool to be used by learners as they wish.

The imposition of "standard" language has been part of the process of creating a "social police." Thus, the teaching of reading and writing has been the inculcation of a particular form of language claimed to be "standard." Through the use of this language "the exploited classes, child and adult, have been induced to consent to the conditions of their own cultural subordination" (Batsleer et al. 1985, 36). Which language, or which form of a language, becomes the "standard" is a matter of power. It is simply the language "with the army and

gunboats" (Craven and Jackson 1985). The process of imposing "standard" English labels all other English "below standard" and makes "standard English" appear, not as a particular historical and class-based form of language, "but as *the* language itself, the neutral and unchanging norm by which all other practices are judged" (Batsleer et al. 1985, 38). Studies which concluded that working-class English is a restricted code unsuitable for abstract thought have been influential, even though further studies refuted these conclusions and revealed Black and working-class English as extremely complex.

Because "standard" English is the language of schooling, literacy, for most children, has meant learning a language that is a form of "'second language' whose orthodoxies have little to do with the language of home or street" (Batsleer et al. 1985, 14). In this process, the student's own language comes to seem incorrect, which can easily lead to students seeing themselves as inferior. This domination of the means of expression and communication denies different groups their own voice and ways of thought (Maguire et al. 1982, 108) and goes a long way toward explaining how school has been a place of silencing and becoming "stupid" for working-class children from many communities.

The enforcement of a single literacy in schools is a political process which not only privileges the speakers of "standard" English but also develops certain forms of thinking and communicating. It shapes students "into particular kinds of social beings" (Sola and Bennet 1985, 88). The type of reading and writing taught in schools serves to preserve current forms of power, but this particular form of literacy appears as "Literacy." This process silences and delegitimizes alternative forms of literacy, such as those derived from oral narrative styles, and makes it impossible to imagine the powers of understanding and consciousness which would be associated with such literacies.

There is a particularly charged power dynamic around the issue of literacy for women. One of the few media accounts which speaks of women's illiteracy illustrates this:

> Male egos take another battering in the war of the sexes. The Southam Literacy Survey shows women are more skilled readers.

The article is addressed to "all men" and ends: "say while your wife is reading that book why not just hide this [article]" (Calamai 1987b). Although the male author writes jokingly, the assumption that it is a problem for men that women are more "skilled readers" shows women's literacy to be a threat to male power.

Rockhill (1987a; 1987b) develops these themes much further in a study of immigrant women in the United States:

> Women engage in literacy practices as part of the work of the family. When it becomes associated with education, literacy poses the potential of change and is experienced as both a threat and a desire. Thus the anomaly that literacy is women's work but not women's right. (1987b, 330)

She argues that the assumption that literacy is "neutral" causes us to miss this dynamic in women's lives, and points to the need to look at the "personal" to understand the gendered practices which reinforce the subordination of women. But literacy programs are rarely set up with women's needs in mind.

Much women's writing on the subject of illiteracy critiques material which makes women invisible or portrays women as helpless and incompetent. When women are included and considered as participants or potential participants in literacy programs, they are frequently deemed to "need" literacy in relation to their roles as mothers and wives. This is especially striking in Canada, where "family literacy" has become the new catchphrase. This is interpreted in many different ways and is leading to a wide variety of programming. It is usually argued for on the basis that women need to be literate to break the "cycle of illiteracy" in which the children of parents with limited literacy in turn leave school with limited skills. This

emphasis can easily lead to blaming women for their children's school failure.

By failing to study the relationship between women and literacy, scholars have given only a partial account of adult literacy (Kazemak 1988). The absence of such study suggests

> at the best a naivete or ignorance on our part as literacy scholars and, at the worst, a conscious or unconscious disdain for the *specific* literacy needs of women within a patriarchal society. This omission of information on the functions, uses, and needs of literacy among women makes any theoretical or practical discussion of adult literacy incomplete, if not suspect. (23)

This book grew out of a belief that the omission of studies about women and literacy is crucial. If we are to challenge the myths of illiteracy, we need studies which start from the standpoint of the women who are labelled "illiterate" or "silent." We need to listen to women's own accounts of their lives. Only in this way can we hope to create programs for women that will meet their needs and enable them to challenge the status quo.

My experience in the literacy field as a paid worker and a volunteer provided the impetus for the research that spawned this book. I was strongly drawn to explore the words of those "illiterates" with whom I had worked, whose lives had remained an enigma to me. The stories they had shared with me were snippets told in a language shaped by the relation of student and teacher within a literacy program. In that context they were constructed as "illiterates" and the sense that they made of their own lives was invisible. I undertook this research to move beyond the label of "illiteracy."

I carried out the research in one county in Nova Scotia, Canada. During the spring and early summer of 1986 I conducted interviews with twenty-three women who had participated or were participating in literacy, upgrading and training programs, and with ten workers in these programs. I also interviewed other workers in such areas as public health,

Canada Employment and Immigration, services for battered women, and Social Services.

Although it is commonly assumed that most Maritimers live in rural areas and farm or fish, this is far from true in the 1980s. In 1981 the county had a population of approximately 44,000 (Department of Development 1987)[1]; 46.6 percent of these people were urban[2] dwellers. Only 4.4 percent were farm dwellers. The remaining 49 percent lived in rural areas but were not farmers. In this county, the county town, with a population of approximately 12,000, is the centre for all the county services. It is surrounded by many small towns with populations between a few hundred and a thousand residents. As there is no local bus service, the only public transportation in the county is provided by a bus line that links the county town to other main towns in the Maritimes.

Employment in the area is varied. Well-known maritime employment areas — agriculture, forestry, fishing, trapping, and mining — are generally on the decline. Lumbering is still important in the rural areas. Operating a power saw or heavy machinery in the woods is a primary source of employment for men with little education, but the overall numbers employed have declined greatly as specialized machinery has taken the place of workers. These traditional areas of work now employ relatively small numbers of workers in the county. In their place, manufacturing, construction, transportation, communication, trade, business, personal services, public administration and defence currently employ substantial portions of the male population.

For women, the job opportunities are much narrower. Significant numbers of women are employed in manufacturing, in trade, and in business and personal services. Although there are small manufacturers in the larger towns, only three

[1] Although there are limitations to what is actually being measured by census data (see Shamai and Corrigan 1987), I am using the census as my main source. I do not offer this data as "fact"; it is provided merely to give some background.

[2] Urban is defined as settlements of more than 1,000.

manufacturers in the county employ more than two hundred workers. Each of these factories employs a substantial number of women. There is a gendered division of labour in the factories: Women frequently operate machinery while men repair it and supervise the women's work. Women with limited literacy look to restaurant and motel work and shop sales work as the only alternatives to factory work.

Projects have been set up in the area to encourage women to enter male-dominated trades. But women with limited literacy, as well as those with higher skills, are still largely employed in traditional areas of women's work. One literacy program worker said that the women in her program would not train in non-traditional fields because

> I think that they believe "Why should I attempt to be a welder? The bottom line is nobody's going to hire me." And they're probably right, particularly in an area like this.

Another literacy worker pointed out that women with male partners were discouraged from entering non-traditional fields. Men object to their wives and girlfriends being in a classroom or workplace with other men. Women with higher levels of education tend to look for jobs in the traditional female areas — clerical work and the "helping" professions.

The school system in the county consists of elementary schools (to grade six), junior high school (grades seven to nine) and senior high (grades ten to twelve). There are thirty-three schools in the county (Department of Development 1987). In most parts of the county, children travel to school by bus, journeying increasingly longer distances as they go higher in the system. Several literacy workers mentioned that many of the women in literacy and upgrading programs were from parts of the county where they had had a long journey to senior high school. They had dropped out when they changed from junior to senior high schools. Although there are three senior high schools, one in each of three larger towns in different regions of the county, there is only one vocational school in the

county town, to which students are bussed from all over the county.

One program coordinator said that for women in the county "to get a grade twelve is non-traditional." But the 1981 census data does not suggest that women leave school earlier than men: 2,130 women and 3,440 men are recorded as having less than grade nine education in the county. More women than men are recorded as having grade nine to thirteen. But men are more often certified in a trade. A greater number of women than men have spent some time at university, but the majority of university graduates are men. Shamai and Corrigan have observed (1987) that, contrary to the "popular myth" that the "education system is helping females to close the socioeconomic gap between the sexes," census data suggests that the probability of females going on to the next level of schooling decreases as the level rises.

Incomes in the area are generally below the Canadian average. Many jobs, for both men and women, pay minimum wage — four dollars an hour. For women, much of the available work is part-time shift work. Some of the factory work and much of the "woods work" that men do is paid on a piece-rate basis, which encourages workers to cut corners on safety in order to earn more money. Statistics Canada reports that the average annual family income in the county was approximately $20,000 in 1980, which is 95 percent of the provincial average. But 47.6 percent of income tax returns in 1983 reported incomes of less than $10,000. The Statistics Canada poverty line was an annual income of $11,850 for a two-person family in 1985, so it can be assumed that many in this county live in poverty.

The average income of single parents in the county was approximately $11,000 in 1981. According to the census data, there were 1,215 single parents in the county. There are very few daycare places in the county, and even fewer subsidized places. For 1,215 single parents, with at least that many children, there are twenty-four subsidized places. Many single parents are forced to seek help from social assistance, first locally (municipal assistance for residents of the county town,

county assistance for those in the rest of the county) and then from provincial family benefits — "mothers' allowance." A single mother receives $8,100 per year on provincial family benefits. On Municipal Allowance, a single mother would receive only about $5,220 per year (quoted in Williams 1988).

A woman is not eligible for provincial assistance until she has taken the father of her child to court for child-support payments, because financial support of the mother and child is assumed to be the father's responsibility. The process of getting benefits can be prolonged interminably if the father cannot be located, if he refuses to appear in court, or if he denies paternity. If he does appear and a rate of maintenance payments is established, the woman becomes eligible for provincial benefits. But if the father fails to pay, the woman is faced with an inadequate income during the slow process while she takes him to court again.

Social activities for both men and women include sports clubs and church organizations. There is a volunteer fire brigade and a variety of service clubs for men. Women are frequently involved in Home and School Associations, Women's Institute groups, and the ladies' auxiliaries of hospitals and of men's service organizations. Women get together informally, sometimes to sew quilts, and men gather in the taverns. But many of the women interviewed participated in few of these activities. One woman said:

> It was a major, major problem in my marriage that I wanted to be involved in Home and School. It was another major problem that I wanted to learn to sew and devote one evening a week to sewing classes ... and then the big crunch — I think — was my wanting to write my GEDs.

According to many women I spoke to, men in the area are very traditional. One woman told me, "you're in redneck territory now." In spite of this, there is some feminist women's organizing in the county: A newly established women's centre offers educational activities in the county town, and a feminist network organized around health issues is active throughout

the province. Feminists have also been active organizing services for battered women. A project was initiated to research the need for a transition house in the county and set up a centre which would provide a service to women in violent situations. The centre is now maintained mainly on a volunteer basis, offering support and taking women in need to local "safe" houses.

According to government data, the population of the county is largely of British origin, and 98 percent of the residents in the county speak English as their mother tongue (Department of Development 1986, 37). Early settlers of the area, the Acadians, were driven out in 1755. The land they occupied was later taken over by settlers of Scottish and Irish descent from New England. Other groups of immigrants included many direct from Northern Ireland as well as United Empire Loyalists (Department of Development 1974, 7-11). There are three small communities of Black Nova Scotians in the county town. There is a small Micmac Indian community on the outskirts of the town. In 1986, there were 462 residents on this reserve (Department of Development 1986).

Twenty-two of the women with limited literacy I interviewed were white. One woman interviewed was mixed-race, Native and Black. I have not identified this woman's race in my description of her, as that would deny her the promised confidentiality. The failure to explore the experience of Native and Black women in this study was a joint result of the limits of my efforts and the process used to locate interviewees — referrals from program workers of women in educational programs. The separation of the Black and Micmac communities from the white community meant that few Black or Native students were involved in the education programs I located, so I was only able to identify the one mixed-race participant whom I interviewed. Although it was not my intention, it is clear that I have carried out a study of white women in the county with limited literacy skills.

The literacy and upgrading field employs mostly women, usually in part-time or short-term capacities. All of my inter-

views with direct service workers were with white women. The coordinators of several of the programs and the senior personnel in the agencies that identified the "need" for the programs were a network of strong older women, several close to retirement. Many of them were divorced and had built careers themselves when they were single parents.

When I spoke to workers in education programs, I identified the sort of women I was seeking to make contact with as "women who had limited literacy skills." The women referred to me included women who had been tested and judged to be reading below grade five level, who were learning to read using Laubach literacy materials; women who had been tested as above grade five level with less than grade twelve schooling, who were preparing for the a high school equivalency examination, GED; and women who were considered by their trainers to have a limited education, who were participating in training programs.

Trying to identify "illiterates" to interview, while at the same time questioning the definition of illiteracy and what literacy and illiteracy mean in women's lives, is inherently contradictory:

> It is impossible, of course, to mark off a group as an entity without sharing complicity with its ideological definition. (Spivak 1987, 118)

To choose "illiterates" based on any one definition, such as school grade level completed, a basic education test, functionality, or even women's own reports, would mean privileging that definition. The literacy skills of some of the women interviewed were clearly limited, but the skills of others were more confusing, and the various ways of measuring illiteracy all suggest a different account of their abilities. All of the women were judged by others to have problems in their lives, and limited literacy skills were usually seen as the cause of these problems. This population of twenty-three women became the main focus of my study, which compares and

contrasts their accounts of themselves with accounts of them given by education workers.

I had begun my research seeking to question the concept of illiteracy but still had a sense of literacy as something unitary, universal, almost something that could be tested. As I analyzed the interviews, the women's accounts of their lives pushed me farther and farther away from an analysis based in the organizing concept of illiteracy. Gradually the inadequacy of this concept to encompass the complexities of these women's lives became clear.

In this study I have drawn on the concept of discourse[3] to speak about language in a particular way. When we speak of "illiterates," or "mothers," or any other category, we have a whole complex set of terms and assumptions implied by the category that allows us to understand what it means to be "illiterate" or "mother." All of these — language, assumptions, and meanings — constitute discourse. This oral and written language is found in and helps to shape bureaucratic processes and social relations. In this way it helps to form our subjectivity, our sense of self. For example, because of a network of language and expectations about mothering, I know what I should do to be a "good mother." But not only do *I* know this, so do other mothers, and social workers, who are all informed by the discourse of mothering. As a result of this discourse, social workers are empowered to initiate processes through which my child may be taken away from me if they judge that I am not a "good mother"; this in turn reinforces the discourse. Because there is some shared understanding of this concept, I may consent to be governed in this way. My subjectivity and those of the social workers are shaped by the taken-for-granted concepts embedded in discourses about mothering. I do not, however, have to accept entirely the mainstream expectations of my

[3] My use of the term "discourse" is drawn from Foucault (e.g., 1980; 1982) and feminist poststructuralist scholars (e.g., De Lauretis 1986; Henriques, Hollway, Urwin, Venn and Walkerdine 1984; Martin, 1982; Steedman, Urwin and Walkerdine 1985; Weedon 1987).

role as mother. Through my language and actions I may be able to adapt my role and contest the assumptions embedded in these discourses. But discourses which are endorsed by bureaucratic processes and authorities have weight which in themselves will shape my life.

The concept of discourse allows us to speak of the importance of language as a way of framing reality and shaping how we see ourselves and the world. It provides a tool to help us understand what the women said in interviews. Recognizing that the women's accounts of themselves are embedded in discourse allows us to look critically at the concept of "illiteracy." Discourse theories offer a way of seeing how we give meaning to experience through language. Discourse theories give us the concept of the "subject" in the discourse.

> There are two meanings of the word "subject": subject to someone else by control and dependence; and tied to his [sic] own identity by a conscience or self-knowledge. Both meanings suggest a form of power which subjugates and makes subject to. (Foucault 1982, 781)

As Weedon explains,

> To speak is to assume a subject position within discourse and to become subjected to the power and regulation of the discourse. (1987, 119)

It is this dual sense of being a subject that is crucial to discourse. People are seen neither as helpless puppets subjected to control through discourses, nor as the traditional rational individual who makes free choices. Discourses are not monolithic. Although discourses which are made powerful through institutional frameworks are an important form of control, we can also contest and challenge them. As we participate in resistant discourses, we are part of a process of changing perceptions of experience and forming new subjectivities.

In this book I shall explore discourses of illiteracy through the accounts of literacy workers and the women labelled

illiterate, and consider the ways in which these women enter into and resist dominant discourses.

Since coming to question the meaning of "illiteracy" and the discourse surrounding it, I find it problematic as a term. Where it has felt too clumsy to avoid the use of the term "illiteracy," I have marked it with quotation marks. To avoid using it, I frequently speak of women with "limited literacy," although this is not entirely appropriate either; it still suggests that there is "literacy," which is normal, and "limited literacy," which is abnormal and inadequate. I have not qualified the use of the term "illiterate" by adding the descriptor "functionally," as this term carries with it connotations of incompetence which were not evident in these women's lives.

These women have endured many oppressions and yet continue to be strong, functioning competently in the midst of problems that would perhaps defeat many of those who judge them incompetent and unable to function. They face the world with a self-deprecating humour and an enduring hope that they can improve their lives or their children's lives. Listening to their words forces us to question many of the persistent myths about the "illiterate" and the education programs they "need."

CHAPTER ONE

Living "Illiteracy": The Social Disorganization of Women's Lives

Behind the label of illiteracy lie the stories of some women's lives. This book explores the stories of women who live in the 1980s in a county in Nova Scotia, Canada. The lives of these women are organized or *dis*organized in relation to the needs of others and by definitions of their needs shaped by bureaucratic forms. The disorganization of their lives creates dependencies, the context in which the label of illiteracy and their desires for change through increased education co-exist.

"Look at the Dummy"

This group of rural women in Nova Scotia, who did not finish school, usually blamed themselves for leaving it, for having made a bad "choice" about what to do. This explanation concealed the complicated circumstances in their lives that had influenced their school-leaving. It also made invisible the social organization of their home and school life. Most women wished they had not left school when they did. The refrain was stated concisely by Alice, who was in her early thirties. Alice had left school before completing grade eleven and married a few months later. Her father was violent and an alcoholic. She said:

If I could do it over again, there's a lot I could do.

Literacy workers interviewed assumed that most women who leave school early do so because of pregnancy. Several women *did* first mention this as the reason they had left school, but once they began to talk in more detail it became clear that

seeing this as *the* reason obscured other factors. Maxine said she needed to escape an oppressive home, and her pregnancy allowed her to do this. Maxine, thirty-nine, had a mother whom she could never please and who terrified her:

> When I was a kid I never had no friends and I stayed home and I helped with housework, and my sisters roamed the streets and I stayed home. I didn't do nothing right. Boy, there was a yardstick right behind me: "You do that or wham." I mean I was scared of her; she'd push you down a flight of stairs by the hair of your head. I could tell you stories — your hair would stand on end.

She was sixteen and in grade seven when she got pregnant and left school, not surprisingly, for, as she put it:

> I didn't know nothing, absolutely nothing about the facts of life; I didn't know why I ended up pregnant.

When her mother insisted that she have the baby adopted, she stood up to her mother and left home in order to keep it.

In contrast, Josie had her family's support, so, for her, pregnancy did not mean she had to drop out of school. She spoke of her family as a source of strength and security, of her mother and grandmother living to a great old age and giving her a legacy of strength:

> I keep telling myself you don't give up. My mother always says "You weren't born a quitter; you were born a go-getter." So far anything I wanted I've gone for it.

After the birth of her first child she was able to return to school for a while, leaving her daughter in her mother's care. But when, after leaving in grade nine, she was tested and placed in grade four, Josie felt unable to endure school.

Seeing pregnancy as the sole reason for dropping out hides the organization of the family and school, structures which do not often provide supports that would permit girls to continue

in school after the birth of a child. It is this failure that gives pregnancy its significance as a cause of school-leaving.[1]

Two of the women said they had to escape from violent and abusive homes. Their escapes from home and from school became intertwined, as once they were on their own they needed to support themselves. Pat left her abusive home and said she was unable to continue at school because the psychiatric drugs she was being given prevented her thinking. She was abused and rejected as a child; her mother had wanted a boy and so refused to acknowledge her. Her childhood was one of neglect and violence.

> This doctor that delivered me told me the whole story: He said, "Right from birth ... she just wouldn't hold you; the staff had to take over." She just said, "I don't want nothing to do with her." And when I was taken home ... she would just leave me in a room with the door closed and ignore me.

When she accused her brother of sexually abusing her, her mother refused to believe her. She suffered from a serious illness which was mis-diagnosed as psychological and left untreated. After she left school she spent some time in hospital, where she was treated for a "nervous breakdown." When she came out, she left home and her doctor helped her to get a job as a homemaker.

Alice described herself as so "shy" that when she was injured in an accident and unable to get to school on foot as she had been doing, she did not negotiate with teachers to arrange

1 Public education for teenagers even today recommends abstinence from sexual activity rather than contraception, and so contributes to the feeling that "nice" girls should not be prepared with contraceptives. Since abortions are not readily available in the province, a girl's "choices" in relation to pregnancy are limited. For example, a publication of the Nova Scotia Advisory Council on the Status of Women (1984) tells teenagers to "say no and mean it" and provides no information on contraceptives or abortion.

transportation to attend school or to keep up with the work at home.

> Looking back on it now, I could kick my rear that I didn't make an attempt to find help or ask for help.... But if I had've been a little more outgoing — I was very shy — I probably could have asked a teacher or someone who lived up in that area. I was so inside myself, so shy it was almost like a sickness.

She said she hated school because her fear of her alcoholic father also made her fearful of other men and authority. She even feared her authoritarian female teacher.

Alice married to escape her home.

> That was one of the reasons why I got married when I was seventeen, probably — it was a way to get out. Dad was still drinking.... It's hard to remember what I thought when I was fifteen or sixteen. I don't think I even considered what I was going to be doing when I finished school. I think I thought in terms of "School's finished: marriage, kids, family."

The man she married was very like her father. The cycle of violence and the need to escape began again in her new home:

> As to characteristics between Dad and my ex-husband, they are a lot the same. They are very possessive. They want to be dominant, rule the roost, which I didn't see because my ex-husband didn't drink when we married, you know, the first few years ...

Several other women described themselves as so shy they were unable to function. Judy couldn't face going to a new school when her mother moved, so she left at fifteen.

> A bit shy is an understatement. Even in school they suggested I didn't have male teachers. I was so shy, it was unreal.

Her shyness silenced her in school, and Judy left early.

> Oh, I liked school, but I was just too shy. If I thought about anything I'd never tell anybody.

She reflected that she was so shy because her mother, bringing up fifteen children, was extremely strict with her and Judy was very alone.

> I guess my mum was so strict — there were so many kids and they were a lot older than I was. There was eight years between me and the next kid and he left home at sixteen, so I was on my own. And she was very strict, she already had four girls and they didn't do so well.... She thought if she was a bit more strict it would help.

Frieda's shyness and embarrassment in school was more a result of the teacher than her home life. She left school in grade eight.

> I couldn't take the criticism of the teacher, he just stood me up in class, I just couldn't do math at all. He used to call me retarded in front of the whole class of children and then they used to chase me around the school grounds when I went out for recess: "Hey, look at the dummy. Look at the dummy." And he put a dunce's cap on me every time he got a chance.

This teacher's construction of Frieda as stupid and a dummy was a silencing process, until she found her voice.

> One day he called me names and put me up at the front of the class on a chair with the cone cap that he made, and I felt stupid. So he said, "Get up and go to the front of the class and sit on the chair, please." And I said, "You go to hell, please." And I walked out the door.

But when relating her rejection of his authority to silence and label, Frieda called herself "stupid" for leaving school. She could not avoid the label of stupidity: If she stayed she was called stupid; if she left, that, too, was stupid.

> When I quit school — well, left school for reasons I just don't want to talk about — because it was *stupid*, I guess, to do that.

When these women describe themselves as "shy" during adolescence, they describe a kind of silence. They are silenced at school and at home through threats or physical violence. Oppressive interactions with those who have authority over them define and negate them. But the label "shy" focuses attention on the girls as lacking assertiveness, rather than on the situations and authority structures which silenced them. The social organization of the school and home has constructed these girls as stupid and made them silent.

The social organization of the family was a key element in preventing some of the women from continuing in school. The gendered division of labour in the household meant that when help was needed within the home — especially when adult women were at work — girls were expected by their family to be available to help out. Their schoolwork was seen as less vital than their labour in the household. Women described helping out during a pregnancy or caring for infants or children in the extended family. Barb explained the work she did:

> I was housekeeping, babysitting for Mum because she was working. The rest of them were in school. And then [my younger brother] came along. At the time Dad took me out of school and Mum had [my younger brother].

> I wasn't ... [in school] for very long because Dad yanked me out.... He said: "She'd learn more at home than she'd learn there."

The comment suggests that her father saw caring for children as more important than what Barb would learn at school. Barb's experience of school, like Frieda's, was of being labelled stupid. She, too, ran away when she was made to feel like a dunce.

> I had one teacher, she picked on us constantly. Her nails, oh God, I think they were about that long. One night — she'd dig them into your head — she had my poor finger red as that package there, pushing it up against the blackboard. Oh, she picked on all of us. So I took off on her, she sent someone after me, but they never caught up to me. I went down where Dad worked ... and I never went back. I left my purse there and my coat, but he had to go and get it for me, I never went in. What started it for me, we had new math with dollars and cents signs. And I didn't know at the time, my answers were right but I didn't have my dollar and cent signs. She didn't tell me, she didn't tell anybody, but she only picked on me. Two weeks I came home with my knuckles red as a beet.... they got her fired, everything was OK after that.
>
> Then we went to a concert ... and someone had called Dad up at work and said I was on the stage with a bunch of retarded kids, and that kind of made him decide, "She's not going there no more." And ever since that I haven't been to school no more. I never went back.

Jane was taken out of school in grade seven, first to care for her father and then for a younger brother and generally to help out with the housework.

> Well, I didn't quit, I was taken out, then my Mum used to get fed up, she'd say, "Get the heck back to school, can't take no more of you." Well, my Dad was sick quite often, his heart or whatever, they didn't know what it was. He was sick quite often. He was forty-one when he passed away. But she would take me out so that I could be home with my younger brother, so she had someone there to look after him, tend to the dinner and things like that.

Jane, in her early thirties, was one of eleven children. She was brought up mostly by her mother, alone, while her father was away fishing or mining. Jane's mother was unable to cope alone

with so many children. Life was extreme poverty and hard work:

> Getting up five o'clock every morning, taking out ashes, putting the stoves on, getting your brothers and sisters up. Get them off to school, then try to get yourself off to school.... Then come home and get into your "play" clothes and start your work at home.

Instead of being free to play, they spent long hours locked in their rooms.

> We weren't allowed to [get up when we wanted to]. We had to wait till we were called, and sometimes she wouldn't call us for a couple of days at a time, except to go to school. Then when school was over we'd have to go back to our rooms ... except to steal coal. We used to have to go and find the trains and fill up these bags of coal and fill up this big bin and stuff like that. I remember one time it was so cold and it was storming out, and our feet were freezing and I was crying. I couldn't feel my feet; they were getting number all the time and she wouldn't let us in and I screamed and hollered and she said "Fine." She said, "If you want to come in you're staying in bed the rest of the night."

Jane's mother was "unable to cope" and received drug treatment for depression. Jane lived her childhood in the face of an arbitrary and often violent authority.

> Mum was the one that let us go hungry and stay in our rooms, but Dad didn't know that Mum was letting us go hungry or keeping us in our rooms all the time, so when he was home we'd go outside for a while.... The thing was, first Mum would beat you, then she'd get the older ones to beat you, and then when Dad came he would — like it wasn't just one, it was the group.

Mary, in her early thirties, was an only child, whose parents divorced when she was an infant. Except for the first few months of her life, she lived with her grandparents. Her mother was judged an "unfit mother" when her father gave an account to the judge of her having "men in there" when her husband was at work. Mary's grandparents protected her from both her parents. Her father beat her, and threatened that if she ever got pregnant he "wouldn't stand for it" but would put her "in a home." Her grandparents also raised another girl. As a teenager, this girl became pregnant and brought first one son and then a second to be cared for by Mary's grandparents. Mary was pulled out of school at the age of twelve by her elderly grandparents to take care of the children.

> They had three other little kids here, my grandparents did. They was getting too old, so that's why they had to take me out of school. So I had to stay and look after them and bring them up.

She also went, when needed, to help a relative keep house and look after her children. She spoke of working extremely hard, but said that, at the time, she was "pleased to be away from school."

> I used to have some nice teachers and some other teachers they used to be cranky, that's why I didn't really care if I did go to school or if I didn't go. I just figured they just didn't use me nice so why should I be nice to them.... When I started in grade primary the teacher wouldn't let me use this — use my left hand, she tied my left hand behind my back and made me use my right hand. And I come home and told Mum and Dad about it and they was pretty mad and Mum wrote a note the next day and I give it to her. It still didn't bother her. She up and done it again, tied my hands behind my back again. And that's what kind of set me off from school altogether, the way I was treated when I first started school.

Although some of the other women were not pulled out of school, their families did not encourage them to continue. As Jean described it,

> I wasn't interested in it. I always had fun, but as each one of us got older our education wasn't that important.

This combined with Jean's own dislike of school. Even though she had "fun," she was subjected to a violent and often unreasonable authority. She learnt from the experiences of beatings both at home and at school to hide her tears in laughter and so deny her mother and her teachers the satisfaction of control.

> I didn't like [school]. It was one of those Catholic schools. We had to wear a uniform. I didn't like it. It was strict, very, very strict. The sisters used to crack me on the knuckles. And I remember one time, there was a snowstorm. I had to come up a big hill, and I had to walk up that to school. And it was a cold day and my sister and her husband made me put on a pair of those stretchy pants — she put a pair of those on me and told me to go right to the bathroom and take them off.... I got caught by one of the sisters and she took me down to the principal's office ... we were never allowed [to wear pants]. I got a strapping.... I was a typical bad girl. I clowned around a lot and I always hung around with the kids that weren't there to study, were there to have fun. They didn't like that. I was always laughing and I got into trouble.

She left school during grade nine and was glad to get out and earn her own living. At first, Jean liked her waitressing work.

> I liked it when I first got out of school, but I never liked it when I come to [the county town].... I was younger [then] and it was my first paying job and it was better than studying.

Many of the women sought independence by getting out into the work force, like Jean, or by marriage, like Marion:

> I don't know, I just didn't want to go back, I knew I'd regret it.... [I said] well, I'll only get married and have kids — but I never expected to be separated.

Her parents did not oppose her leaving school, because they didn't expect to have any influence.

> They didn't say too much, they knew — like there's seven of us, I'm third oldest — so they figured the more she nagged the other ones the more they didn't go back. They said it was up to me.

She left school in grade eight to babysit, not worried about qualifications since she expected only to marry. She was soon married, but a few years later her husband left and she had to raise their two small children alone.

Sharon's mother, Dorothy, described her own attitude to school:

> I didn't [like it] much when I was going to school.
>
> I just didn't have any interest in school. I just wanted to get out and go to work, I just wanted to ... earn my own money ... have my own things. This is mostly why I quit school.

Dorothy left after grade six. But for her, too, the attempt at "escape" was not successful. She was soon married and doing minimum-waged factory work. She had a heart attack brought on by the heavy work and had to change jobs. When she was at home sick with a minor problem, family finances made the possibility of being unable to work for a week into a crisis. After all her years of work, she was still working for family survival and not "for her own things."

> I wanted to get out and work and make my own money. I only did it for a couple of years and then I got married and here I am.

Few of the women felt school was a place to think of careers.

> School never pushed anything like that. They never pushed a career. They never pushed study hard, be a scientist or stuff like that.... They just didn't seem to care, just as long as you got out of there. That's all they cared about.

For working-class girls, school was not a place that offered alternatives and options for the future. It was a time to get through, a place to leave. They experienced a gendered, "classed" organization of schooling which channelled them, like other working-class girls in Nova Scotia, into dead-end jobs and/or housework.

The arbitrary, controlling and often violent authority that the girls experienced at home or at school and which helped to form their sense of shyness, their self-perceived stupidity and lack of confidence, is not visible in language about drop-outs. School did not have to be a place of extraordinary cruelty to make girls leave; some were simply unable to find anything of interest to them. As girls, many of these women experienced sexual and/or physical abuse and all worked hard in the household. The social organization of women primarily as wives and mothers leads to expectations on the part of the school, the family and the girls themselves that they will simply become wives and mothers, working outside the household only to "help out" with family finances. The young women's attempts to "escape" from arbitrary authority at school and/or at home led them into minimum-wage jobs and marriage and motherhood, which simply replaced one set of authorities with another. Many then sought to escape these new circumstances.

"Being Married, You Are There to Cook and Clean"

One escape route was marriage. Eleven of the twenty-three women were still living with husbands, and six were separated

or divorced. Many felt controlled, or at least strongly influenced, by their husbands or boyfriends. Jill had been married to a man whom she described as discouraging her from doing anything or going anywhere. She had been stranded in a house far from any community, unable to go anywhere except an occasional trip to bingo. Even the bingo was only possible if she earned the money to go by taking on babysitting. In contrast, her husband went off regularly to sports events, leaving her at home without a vehicle. She seemed to have expected to be a very traditional wife, but to have no life at all was more than she could bear.

> Being married, you are there to cook and clean, look after the kids if you have them, look after the housework, but I always thought you'd get out too, you'd do things together. Like I don't believe a wife should go out, like a lot of them will go out to bars. I would never do something like that. But we didn't have any life at all.

Jill spoke of her husband's sabotage of her efforts to continue her education:

> I never got through with it — just the studying — nobody would leave me alone long enough to study, between [my daughter] and [my husband]. He didn't think that was such a hot idea either. I think he was afraid I would get a higher income than him.

By refusing to drive her into town, he also made it impossible for her to continue a job as a waitress.

> Once I went out and worked and it lasted a week. I had no transportation and he just wouldn't let me do it.... I had to go in with him in the morning and after a week he didn't like it, so I quit.

But, earlier, he had not been able to dissuade her from taking a course in baking.

> I wouldn't let him then. I wasn't married to him then.

Although she suggests that she saw no difference in her role when she was living with her partner and when they were married, marriage seemed to be crucial in Jill's submission to this man's authority over her. Having left him, she is now very clear that she won't let another man have the power to dictate to her, even though her new friend is supportive:

> I have goals now, I'm not letting any man stand in the way. I already experienced one and I won't let anybody else — but he's all for it — in fact he's pushing me even more.

For some women, going to upgrading was one of many battles in living within a violent relationship. Alice fought her ex-husband to be able to complete a business training course.

> Whether he admitted it or not, I think he realized I was getting something where I could get a job and could possibly support myself, so I think he saw it as a threat. Although if you asked him now he would tell you how he supported me, how he kept the kids quiet so that I could do homework, and how he never said boo. Whereas in fact [this was far from true].

She also had to fight to get a driver's licence. She described it as her "mini war." She said he wanted her to be isolated and dependent on him, with no friends and no way of getting out.

> That was what he wanted.... I think it's probably pretty strange to anyone that doesn't realize the kind of a life that a battered woman lives. Because like I said before, I made it my little mini war trying to win battle after battle to get my own little place, my own little piece of myself.

Some men offered the women support to take on their own challenges, but even for these men it was not always easy to accept the independence that changes could bring. Pat was perhaps a special case: She had spent ten years in and out of psychiatric hospitals, and discovering that she was not manic depressive brought major changes to her relationship with her husband. She had met her future husband when she was in a

psychiatric hospital. Eventually they married, but she was still periodically hospitalized and continued to be treated with drugs. At the end of a difficult pregnancy she was finally diagnosed with a serious disease which she had suffered from all her life. The neglect of this disease, and perhaps the drugs she had been on for so many years, caused her to suffer from further complications. After the diagnosis of her medical problems, with the support of one doctor, she threw out the psychiatric drugs and began to live without them. She told me about her husband's support:

> He always had the strength to believe that someday [I would] ... not be taking these drugs. He firmly believed that. I can remember when I was so depressed and I really thought and took a long hard look at being married. There were so many setbacks, and the experiences I'd had, and that guy loved me and believed in me. And see, I was very lucky and blessed to have that man come in my life, and he's the one that encouraged me to go to that school — "You can do it" — and am I ever glad he pushed me, because I found that I *can* do it.

Although she spoke here about his faith that she could get off psychiatric drugs she also talked a lot about the problems her husband had when she decided to stop taking the drugs. He could not easily accept the change in their relationship.

> I was dependent on him terribly the first four years, because I was drugged. But since I came off the drugs, I'm maybe more independent than *he* is.... It was [a hard adjustment for him to make]. It affected the marriage, because he couldn't accept the switch. He was *convinced* I was manic. And it was an awful shock to him to find that I wasn't. *Now* he's starting to understand; *now* he's starting to accept.

Several women described husbands who offered support for their education which was in some way conditional. For Maxine, this support came only after she had faced her

husband's opposition. Maxine's husband had been unemployed for some time and she dreamt that her training would prepare her to be self-employed so that she could support the family. Early on she said that he was very strongly opposed. Later she said:

> Not very much now. He's told my daughter that he's really proud of me — didn't tell me — but he told her, but that's OK, I don't mind that, at least I know he does appreciate what I'm doing.

Previously he had tried to discourage her from taking part in the course, telling her it wasn't any good.

> Well, he was pretty upset and [said] it was foolish and it wasn't a very good course and all this nonsense. But since I've been doing it I've been real good.

Maxine felt this was because he was upset that she got paid a training allowance, while he was unable to get a job and bring in any money.

> He's not working, he's fifty and it's difficult for him to find a job. He's so upset because I got a job and he didn't. I think he blames himself because he's not working.... He was on a training last winter and then he got laid off about Christmas time. And then he never got another one. Then I got on this one and he was mad. I don't think he was mad at me. He more thinks a woman should be at home, in the house. Yes, he's real old-fashioned, but I told him I wanted to help out because we needed it and we don't have much. I know how to do without: I don't have hot water; I don't have a pump and no fancy house — no carpets, no oilcloth. You learn to do without a lot, 'specially when you're raising children. You just don't have that extra money to fancy your house up.

The expectation that it is a man's role to be the provider meant that Maxine's husband struggled with the situation in which she could get "work" when he couldn't. She was only able to

justify participating in a training course to him in terms of what she could bring into the household to "help out." Maxine said her husband had stood by her during her first pregnancy.

> My husband that I married took me in and looked after me and I've been with him ever since.

He also supported her through the infant deaths of three later children and during a major depression following her father's death. She felt she owed a lot to her husband, and she was very determined in her statements that "he's good to me."

> Yes, I even had a nervous breakdown and he stood by me. I went for help but nobody'd help me. But he helped me through it all.... I still love him, I'll always love him. He's always been so good to me.... He wishes he could give me more, but I know he can't and I accept it.

The social organization that delineates women's role as "housewife" and men's as "breadwinner" for the family leads to men discouraging women from improving their education. But it is seen as women's role to help their children with homework. For that reason, some men encouraged their wives to improve their education. Frieda and Sandra, two sisters-in-law who were neighbours, talked about their husbands' attitude to their taking part in the upgrading program. Sandra said:

> He doesn't mind one way or the other. He doesn't put me off.

And Frieda said:

> He doesn't put me off either.

He did not want her to participate for her own sake, but because she would be better able to help the children with their homework, which is seen as her work.

> He thinks that it's good that I'm doing ... [upgrading] because the kids are getting older, getting in higher

grades, and they're going to come to me more often. See, I do the school end of [things].

When women are seen as responsible for all work in the household, men, by their lack of active help with household work, can make it very hard for their wives to participate in an educational program. Darlene, Marion's sister, said her husband tells her off when she puts herself down. But supporting her to go to work or to go on a course was a different matter.

Well, he doesn't want me to go to work. He'd rather me be at home, but he said "That's up to you." He said, "I really didn't want you to go on this course ... but I didn't want to say no because then that would be pushing my ideas on you, so I thought I'd let you try it and find out how hard it is." But I told him that I wanted a career after the kids were in school. "I don't care, when the kids are in school you can go to work," he said. If it came to it that I *had* to work, then he wouldn't mind, but I don't really have to work, he's got a good job.

Working outside the home is only "necessary" if the man is unable to provide adequately for his family. The impact of the attitude Darlene describes is that he probably will not go out of his way to help with the childcare or household tasks. So the course *will* be hard for his wife.

The unequal balance of power between women and their husbands is such that it can be assumed that women will be supportive of their partners. It is seen as part of women's role to nurture and make space for the achievements of others. Men do not seek women's permission for their activities. In contrast, for men to support their womenfolk is seen as generous. And that support may simply mean not refusing permission for an activity. If women improving their education threatens the power balance of the family, men's hostility may come in many forms — from failing to "help" with women's work of childcare, housework or preparing meals,

to outright violence. Some women receive support from their male partners that encourages them to take on challenges and build their own confidence. Others simply receive the "support" of non-opposition.

Whether women have a paid job outside the home or work as homemakers, the social organization of the work in the household often leaves women who live with men responsible for the majority of the daily work required in the household. Many of the Nova Scotian women accepted the traditional perception of their job as "wife." They saw this work as extensive, including not only a wide variety of household tasks, but also waiting on men, fetching and carrying for them. Mary carried out this work for her grandfather and the young man she had brought up. Her work included a range of heavy and time-consuming tasks: She carried water from a nearby tap as there was no running water in the house, walked a lengthy distance to shop, cooked on a wood stove, cleaned the house, and washed dishes and laundry by hand. She even walked to the store to get the young man's paycheque cashed for him. Mary was certain that she would not like marriage.

> I just like to be by myself and be my own boss and do what I want.

However, she had taken on a role very similar to that of wife for her grandfather and the young man she had raised.

Most of the women saw the paperwork as part of their housework, including filling in their husband's unemployment forms, writing his letters, paying the bills, keeping accounts and banking. The women seemed to carry out these tasks even if their own literacy was shaky and their husband's more proficient. Only when they were completely unable to do the work did they pass it on to their husbands, usually with some guilt and much appreciation that he was

doing *their* work for them.[2] Marina saw herself as failing to do her duty:

> [It] makes me feel I'm an awfully poor wife, if I can't even look after the finances. I should be doing it, not relying on family to do it for us.

Marina had been labelled mentally handicapped as a child. As a child she was taken care of by her grandmother and then passed on to another couple who agreed to take care of her. She was married to a man who was also in the literacy program. He was abusive, but it was hard for her to imagine any alternatives to living with him. Even though both she and her husband cannot do the book work, Marina is convinced that she is an inadequate wife because she is unable to do it.

Several of the women described their husbands as demanding children. Alice commented ironically about men's expectations. She captured well the sleight of hand in the discourse that women should not work outside the household and that, if they do, it should be made as invisible as possible and housework carried out exactly as if they were home all day. Alice could not imagine ever marrying again, unless she could find a man who was different.

> Women, if they work — which they shouldn't, they should be home with their kids — should rush right home after work and prepare supper for him, he's going to be home any minute!
>
> [He isn't capable of] ... ironing his own shirt, or picking up his own socks, so why could he make his supper?

[2] Of course, at all levels of literacy it is a common expectation that writing all the letters for the family, even to the man's relatives, is part of women's work. Women even sign cards and letters as if they were also from their husbands.

> ... I guess I'll always be single if I can't find ... [a man] that isn't [traditional]. I don't want another baby to look after. I'd like to have someone to have a relationship with that can talk intelligently. That's one thing that I missed when I was married, an intelligent conversation with an adult.

It was hard for Alice to leave her marriage — she had been fearful of how difficult it might be to be on her own.

> I think one of the fears of getting out on my own was that I would be totally responsible for everything. But then I was totally responsible for everything anyway.

Though women often take on major responsibilities in the household, the perception that men are "responsible" for the family can lead to the appearance that women are more dependent on men than is actually the case. When discourse tells us that women are not responsible for themselves and their families, it is not easy to articulate the degree of responsibility that women frequently carry because their work becomes invisible. Much of the work women do is only noticed when it is not done, and so women may not easily see how all-encompassing their responsibilities often are.

"He Could Walk Away"

Children were very clearly seen as women's work. Whether the women were single parents or living with a man, the responsibility for all aspects of the children's care usually rested on them. Children figured in the lives of most of the women. Sixteen were raising children, and three had raised or were about to raise children. Maria had given up her child for adoption. Mary had brought up three children that were not her own. Barb was pregnant with her first child. Seven of the women (including Barb) were bringing up their children alone: four as a result of separations and divorces, three as "unmarried mothers."

Women assumed immediate responsibility for the implications of pregnancy, something they said the men did not do. Susan explained:

> He could walk away scot free, but I'm not. He looks like the shabby one at the end. He ... can't keep up with his responsibilities.

Even having an abortion or giving up a child for adoption was seen as "taking on" the responsibility of a child. The women felt a responsibility to weigh the sort of life the child would have if they decided to raise it.

Having taken on the "responsibility" of bringing up a child, the next problem is to determine what you have a responsibility to do: to be at home with your child, or work to support her; to stay near family, or go to the city in search of a job. Several of the women felt admonished by others to act differently, to be more "responsible." The women wanted to take their responsibilities seriously, and were prepared to put their children first, but they also wanted to have *some* life for themselves. Susan's mother continually accused Susan of not mothering correctly and threatened to have the child taken away from her daughter, into her own custody. The child became a pawn in the battle between Susan and her mother.

Linda spoke of her wish to get out occasionally and her mother's disapproval of it, stemming from the fact that her mother didn't have such opportunities when she was young and had children:

> And you do want to go ... and leave your child for a couple of hours, or something like that. I don't think I should feel bad about that. People say you have a baby — you have a responsibility. They say you have a responsibility now, you can't do that, you can't do [anything].

Being "responsible" seems to mean being with the child *all* the time. Linda seemed to spend most of her time caring for her little girl. She felt torn between her parents, who wanted her to stay home and care for her child, and the welfare workers, who

pressured her to get a job. She was thinking about working if she could get her daughter into a good daycare. But the pressure to mother adequately, by being with the child all the time, means that even if she is careful in her choice of daycare, she knows she will feel guilty if anything goes wrong. She feels that no daycare can really be adequate.

Many of the women had mothers whom they considered abusive or who had been labelled "unfit mothers" by the Children's Aid. They were desperate not to repeat the pattern with their own children. Several of the women saw the Children's Aid as a form of regulation of their mothering. Some feared that their children would be taken away from them, and others had actually experienced having their children put into care.

Jane had left an abusive family life and been in psychiatric care. Later she moved to another town. Soon after she got there she became pregnant; not long after that, she became pregnant a second time. After her own experience of childhood, she found it difficult to know how to treat her children and went to a parenting course to try to learn how. She continued on psychiatric drugs and went as an outpatient to a psychiatric clinic at the hospital. Her second child was taken away from her on the recommendation of her psychiatrist, who told her that two children were too much for her to cope with. After many years of intensive medical treatment, she flushed the psychiatric drugs down the toilet, much to the horror of her doctor. Having questioned the judgment of psychiatrists about what drugs she needed, she was left wondering about their judgment that she couldn't cope with two children.

Alice's fear of being judged an unfit mother isolated her more completely in the house, as she did not dare go out without her children unless she could leave them with her parents.

> I didn't want to be seen as an unfit mother, or anything along those lines. The Child Protection could take my children away from me, or they would take my social

assistance away from me because of something I might have done.

The expression "something I might have done" suggests that anything might be judged as "wrong" and cause her children to be removed. In a rural area in particular, women know that everything they do can be observed and reported on. The behaviour of single mothers is particularly subject to scrutiny. In some counties in Nova Scotia, "unwed mothers" must be "supervised and 'approved' by child welfare workers" before they can be seen as eligible for social assistance (Council of the Nova Scotia Association of Social Workers 1987, 6). This supervision makes single mothers particularly vulnerable. Their children can become pawns in women's power battles with their ex-husbands. Alice said that when she asked the Children's Aid to "monitor the situation" when her eldest daughter was living with her ex-husband, he and her mother-in-law went to the Children's Aid and told them to check on her because "she's got three kids and she's at the tavern all the time."

As Leonard and Speakman (1986) observe, the state's "right" to intervene in families that are "going wrong" is often imposed on working-class families.

> Working-class families were seen as "going wrong" more often than middle-class ones (not surprisingly, given their material circumstances and the fact that the standards of "going well" were middle-class ones), so this intervention mainly involved control of the working-class family. (9-10)

Alice describes herself as having "imagined fears." But the fear that the women without partners will be unable to support their families, or unable to cope with their children alone on an inadequate income, and so be judged "unfit mothers," is very real. As well as Jane's second child, one child Mary took care of had been taken into "care" by Children's Aid.

Many of the women felt stifled by being with their children most of the time, cut off from the company of any adult. But

when the children were gone they were often at a loss for what to do. The assumption that women will take sole responsibility for children and will always put their children first leaves women desperate for an opportunity to escape this responsibility, yet frequently unable to enjoy their time alone when they gain it, because they have subsumed themselves in their children. Marion said:

> I can't wait 'til bedtime, and then I'm bored — I usually just sit there and watch TV, wishing there was something to do.

Susan also spoke of having time on her hands when her parents take her daughter for a holiday.

Women without a partner felt trapped while they were at home caring for children. Others, who went out to work, still felt a lack of meaning. As Jane said,

> You're shut off from the world if you're just bringing up a child and working and nothing else.

Women's full-time responsibility for childcare makes it hard for women to attend activities outside the home, including educational programs. Several literacy program workers described instances where the man had, often at the last minute before classes or exams, refused to "babysit," leaving the woman feeling the responsibility to stay at home. Even the use of the term "babysit" contains within it the meaning of men's performance of childcare: Women are not described as babysitting their own children. It is just what they do, usually while doing many other household tasks. In contrast, men are, like the hired babysitter, seen simply as minding the child for payment or as a favour temporarily. The man always has the power to take back this favour and refuse to babysit.

Judy and her husband were both trying to find work, although Judy had some work babysitting a relative's children. She described her husband as supportive because he "babysat" her children.

> Even like at nights, if I can't be bothered with my own kids — which happens — he puts them into bed and says: "Let your mother alone, let her study," which I find is good, and for tutoring and stuff, he'll babysit.

In her account, she is clear that it is her duty that he helps out with.

One woman's sister had decided that although she would like to improve her education, it would have to wait until her children were in school. Then she would have the time and energy to make it possible to try to upgrade her education.

> She was thinking about it, but it's just hard with two children. And like she said, she'd kind of like to wait until they got in school and then take her upgrading.

Several women did take on literacy classes and spoke of the way the children disturbed their lessons or their "homework," making it hard to learn anything. Jill described her daughter as particularly devilish and distracting:

> She tries to get things, she jiggles the table.

Judy found her children made it hard to study, so she went to the program office for her class while her husband took care of her two children at home. She felt that it would be "a lot harder to try and learn with them around." The organization of children as women's work means that it is rare for men to keep children quiet so that women can study. Jill found that her children *and* her husband were all so demanding that she wasn't able to get her work done. She dropped out of the course.

Older children can be supportive of the fact that their mother, too, is learning. Alice said her kids were "pretty good":

> They sort of took it as, "We have to do homework too, Mum has to do homework," that type of thing. We all have to do homework together.

Judy spoke about the problems of arranging childcare but then explained that her children were the reason to seek education, not barriers to her plans.

> Now I have something to do all these [studies] for. I have them to do it for.

Many of the women did a lot of "work" helping children with schoolwork. They gave children tests to help them learn and prepare for school tests, they explained problems the children were stuck on, and they helped children do research for special projects which required encyclopedias, visits to libraries and collecting pictures. They also generally showed interest in their children's performance at school and encouraged them to do their homework. This activity is "work," although in the language of mothering it would more typically be described as "helping the children with their homework."

Women themselves rarely acknowledge the practical constraints which they are very much aware of. Instead they blame themselves for *their* failure. There is a similarity between the work of teachers and the work of parents which the normal language serves to disguise. Teachers are described as "teaching" whereas parents are simply "helping." The complex and skilled nature of the work expected of parents is rendered invisible. Frieda's description of helping her children with their schoolwork makes it clear that she sees it as an important job. It is a project that takes most of her evenings, and covers a range of work with each of her children.

The women always saw helping with the schoolwork as *their* work, not their husbands'. Frieda's husband shared the view that it was Frieda's responsibility and encouraged her to take an upgrading course to be better prepared to help the children. She wanted to know the "answers" as well as the "questions." She believed a woman should have grade twelve, because without it, there will come a point when she can no longer help her children.

> If [you] ... have small children and [they're] ... going through school, you have to stop a certain time and say "Well, I can't go any further, because I haven't got that education." But if you've got your grade twelve, that's as far as you're going to go in elementary high and secondary — so you're there.

Helping with the homework was also described by several women as a learning process for themselves. Frieda felt her children's work provided her with a broader education than the limited subjects she studied in her upgrading program. She described the work she had done very proudly:

> Now that I've gone through from primary to ten with [my daughter] the only thing I really couldn't do with her — after long division, I couldn't do nothing with math, so she went along on her own. But everything else — I know all about the mechanics of the body and all this stuff, biology — the taking and dissecting of frogs and stuff like that.

The women's role included interacting with the school. It was their job to respond to notes sent home, to read reports, to prepare their children for special events — send them with the required money, clothing or equipment. Many of these requirements are communicated in the form of notes sent home with the children. Most of the women, even those who described their literacy skills as being quite limited, felt that they had adequate literacy to carry out such tasks.

It is not only the women themselves who think that "good" mothers should be literate. Teachers, "experts" and the media regularly attribute working-class children's poor achievements in school to their parents' failure to read to their children, their lack of interest in education, the poor example they set, and even their failure to raise their children correctly.

A counsellor in one upgrading and work-preparation program attributed Maxine's children's school problems to Maxine's inadequate reading skills. She said that Maxine ob-

viously did have a reading problem, even though Maxine herself didn't think she had any need for better skills. The counsellor felt that the fact that Maxine's children were in special schools "showed" that Maxine's reading skills were inadequate. She felt that if Maxine's reading level had been better, she might have been able to do more for her children. She had no doubt that if the children were doing poorly in school, the mother was responsible. It was Maxine's duty to improve her skills, in order to be an adequate mother. This implied that Maxine was bringing up her children carelessly and irresponsibly. It differs from Maxine's account of her love for her children, her care for them even when she was having a "nervous breakdown," and her interest in providing them with good meals in spite of her inadequate income. It renders invisible all the work Maxine actually does, hiding it under a general label of incompetence.

Josie illustrated how teachers make it clear to women that they have a role to play in their children's schoolwork that cannot be accomplished with limited literacy skills. Josie was criticized because her daughter's homework was inadequate.

> There was one teacher she got there, she said to me, she said my daughter wrote a project and some of the words she misspelled and some of the words she forgot to dot her *i* so they looked like *e*. And she must have had a hard day: When I come in she said, "Well, couldn't you help your daughter with her project? Didn't you read it to make sure all the words were correct?" I just looked at her, and in another way she's saying "Are you a dummy or what?"

Although Josie understood that the teacher thought her stupid, she resisted this judgment and distanced herself from it. She even showed sympathy with the teacher's unreasonable judgment, suggesting that "she must have had a hard day." But would she tell this tale to other parents, or would any complaints she might have about the school be silenced by this process of laying the blame for her daughter's lack of school success on her? As Smith has stated

(1986, 34), the allocation of blame to the mother means she always has something to hide:

> You could always have done more, better, differently. You've always got something to conceal. It makes it very hard to talk about problems your child is having in school to other parents, even if you think it's the school that's creating the problem.

Similarly, when Barb's tutor found out that Barb was pregnant, she introduced pamphlets on childbirth and childrearing to the curriculum. Barb saw this as a statement that the tutor saw her as stupid, as incapable of bringing up a child without literacy skills.

> If she hadn't found out that I was [pregnant] I don't think she'd have brought [information on pregnancy] in. But I had a younger brother and I looked after him since the day he was born and I told her that.

No explanation seemed to have any effect. Barb realized that the tutor was convinced that she must "need" to learn about pregnancy and childcare.

> She figured because I didn't have that much of a grade in school I wouldn't know anything about how to look after an infant, a baby, or anything else like that. I *told* her I'd looked after [my brother] the day he came home from hospital.

Barb contested the need to read in order to raise her child and argued for the value of experience.

> I admit I can't read very good. I *can* read, but there are some words that I can't understand and I can't figure out what they are.... [She thinks] I *should* read these [pamphlets on childcare], I should *have* to read these, but I *don't* have to read anything to look after [a child].

Literacy comes to symbolize being a "good" mother.

The role expected of women in relation to their children is such that they feel they must demonstrate the importance of reading. They must read to their children, must help their children with their homework, and, if they are single parents, must get a well-paying job which will provide for them. Good reading and writing skills are needed for these tasks. However, the presence of children and the full-time, round-the-clock role many mothers must play in the care, feeding, play and schooling of their children can leave women with so little time, energy and sense of self that participation in a literacy program is difficult. Women with male partners may, like single parents, be solely responsible for childcare, because it appears that many men assume — and society is structured to reinforce this assumption — that all aspects of childcare are a woman's sole responsibility.

"It Must Be the System"

The responsibility women assume for their children, the fact they don't "walk away scot free," as Susan said earlier, often forces them onto welfare. Many of the women who were on welfare were single parents. As one coordinator explained:

> Every woman's one man away from welfare. When that man dies or runs off or something then they have to ... do something, and we do get women who come in with all the tales of woe — "He left and I don't have any money and I have these kids and I need an apartment and I need to upgrade myself."

As a single parent herself, she was sympathetic, but concerned that women are not trained or prepared to be able to support themselves, and without a man's support are likely to be poor. Women grow up to believe the myth of marriage and living happily ever after. Marion had left school thinking:

> "Well, I'll only get married and have kids," but I never expected to be separated.

Another program coordinator, who is a single parent, said in reply: "No one ever does." Alone with the responsibility of children, women are particularly in danger of living in poverty. Scott (1984) pointed out:

> This distinct character of women's poverty has two sources: women bear the major responsibility for childrearing; and women's income and economic mobility are limited further by occupational segregation, sex discrimination and sexual harassment. The two are, of course, closely related.
>
> The expectations placed on women from the time they are born direct their educational and job choices, and prepare them to accommodate all other interests to their family responsibilities, which are duly placed upon their waiting shoulders. Yet when they duly carry out those duties to the letter they are penalized. (23)

Five of the women were in training programs which paid a training allowance. The remaining six single parents were all on municipal, county or provincial assistance. Several of the women with partners were also on assistance. Women who had to depend on welfare after leaving violent relationships spoke of the irony of simply replacing one repressive form of control with another. When the women spoke about their lives on welfare they spoke of their poverty and their shame about being on welfare. Their dislike of being controlled, and of being made to feel guilty and responsible for their failure, echoed through all their descriptions.

A single mother takes on the primary responsibility for her child. But to take on the full financial responsibility of bringing up a child alone, she needs access to a variety of services and to jobs that pay more than minimum wage. Access to childcare is especially important. One program worker pointed out that at the same time as an allowance for childcare had been introduced, many of the training programs had been removed.

> The government has finally realized that one of the main reasons women can't take the training is because they don't have the extra money to pay for daycare service. So in the new Canadian Job Strategy they allow for that with the new training allowance. So that has taken away one of the roadblocks. But by the same token you have cutbacks in the upgrading.

As there are very few subsidized daycare places available in the province, single mothers are in the impossible position of not being able to afford to work because childcare costs would eat up most of their income. The lack of services (such as subsidized childcare) and the gendered labour market (few jobs pay adequate wages to women) make it extremely difficult for single mothers to get off welfare. They are left feeling as if there is something they should do, even though their options are limited.

Welfare does not provide enough to financially support a family without the constant fear of having insufficient money to deal with a crisis, or simply to buy the basic necessities for the whole month. The single mothers on welfare described their depression and demoralization as they continually struggled to pay for the essentials. They were frequently unable to manage and had to seek help from their families. Several of the women described how their mothers helped out when they had no money left, even to buy milk. Alice had to rely on welfare when, after fighting to preserve some sense of herself within a violent marriage, she finally left with her four children. She described the help she needed:

> If it hadn't been for my parents, my kids would have starved. Oh, I don't know how many [times] ... when I didn't have anything in the house I'd put the kids in the car and go to Mum's and Mum would give them supper. And if it hadn't been for them, they'd have starved to death, child protection would have come and took them, I know.

Alice was aware that without her parents' help, her inability to feed her children would have led to the removal of her children, not to an increase in support. She would be judged an "unfit mother." Alice knew that welfare mothers are often seen as feckless, wasting government money. She also knew, however, that her cheque wasn't sufficient to buy all the essentials for herself and her four children, let alone to cope with illnesses and crises. The Nova Scotia Department of Agriculture (1986) estimated that in November 1986 it cost a family of four in Halifax $406 a month for food alone, but a typical municipal assistance total monthly rate for a family of four is $489 (Council of the Nova Scotia Association of Social Workers 1987), out of which they must buy food, as well as all other necessities. Alice resisted the judgment that it is she who is at fault.

> I would like to see anybody, anybody involved with social services budget and buy groceries and all the things they have to buy for a month with $164 a month — I'd love to see it, because I couldn't do it.

All the single parents on assistance spoke at length of the problems of managing on little money. For several, the most depressing feature seemed to be that they were unable to be orderly, to be clear of debts and in control of their budget in the way they liked, in spite of careful budgeting to spread costs. The welfare system disorganizes their attempts to organize their finances.

Susan had grown up in a family with a violent, alcoholic father, and when she became pregnant, her mother rejected her. Her boyfriend took no responsibility for the child, even seeking to deny paternity. So she and her daughter lived in an apartment, dependent on welfare. She often felt desperately lonely as she coped with her young daughter, cut off from any family support, and trying to take control of her life. When a tax rebate allowed her to clear up her debts, it lifted much of her depression, as she felt finally able to get her finances straight — for a little while, at least.

I paid everybody off. I owe nothing now: paid my light bill, paid my cable right up to October, got everything right up to date. And I feel better, nobody saying, "Well, you owe me this much and when am I getting this." I got my bank statement straight.... I paid off my Sears account — I owed a lot to Sears — I paid off Sears and I paid off Zellers — which was not a lot.

Marion, on assistance because she had been caring alone for two small children since her husband left her, found that family benefits just paid her rent and provided enough food for survival. But her little girl suffered from several serious ailments. The medical care and the travel costs to visit her in hospital had to be battled for constantly. She did fight for money to cover these expenses, even though being on welfare made her "feel like a bum." She was trying hard to save the two hundred dollars she needed for a damage deposit on a new apartment, a difficult task out of her "mothers' allowance."

It was not only single parents who complained about the problem of managing on little money. Betty, with two children, lived with her husband in a small house belonging to his mother, which was described by program workers as a "tar-paper shack." The house was a long way from town on the edge of a straggling community. They had no telephone. Betty's husband, having worked part-time, was on unemployment benefit of $76 every two weeks, and Betty had been unable to get any job. They received "partial assistance" from the county social service office to supplement the unemployment benefit. Betty, too, described hard times:

I mean we can't own our own home. The work just isn't steady enough and sometimes we go without food. It's unbelievable, people sit there listening to you and sometimes they don't believe what you're saying, but it's true. Oh, we've gone two, three weeks on end without food — like water, maybe a slice of bread here and there, well [my daughter], she was the only one that was with us at the

time, she always had something to eat. But it all comes back to the job.

One of the program workers told of women who had had financial problems while they were on assistance. One was put on probation for writing bad cheques for groceries. The program worker said:

> Now, I saw the stores that the cheques were written for and the items that she bought — they were not — it wasn't jewellery and it wasn't clothing, it was groceries. And I know the reason that she did [it] was that she wouldn't go back to the municipal assistance worker.

Another account was of a woman who had managed to get herself an apartment, but when she got onto a provincial employment program she was not paid for a month. She had told her social worker that she was employed, and so her assistance had been cut off. The interval without pay meant she was unable to pay her rent and so was evicted from her apartment. As the program worker said, "The municipal assistance worker refused to give her the money to pay the rent until she got her cheque. She had to give up her apartment, take her child and move back in with her parents." Although the program worker relating these accounts said they were the most dramatic she had experienced, she did feel they were indicative of the problems within the welfare system. She felt they illustrated the extreme poverty of many women on welfare, the arbitrary control which can be exerted by social workers, and the difficulty many women have with asking for "help" from social services. In these cases, the social service system disorganizes the women's attempts to take control and deal with their responsibilities.

To obtain provincial benefits, which allow single mothers a little more to live on than municipal or county benefits, women must provide the provincial authority with the name and address of the father of their child. This attempt to assert the responsibility of the father for the child is used to withhold

benefits from women. They are made to feel "bad" even though they *have* taken on the responsibility of bringing up their child. One program worker explained the process:

> The government doesn't want to take on that man's financial responsibility. It doesn't matter what happens to her and the child. It only matters that the provincial government does not want to be carrying the financial responsibilities.

In order to provide the address of the father of their child to the provincial authorities, single mothers are forced into desperate straits. Linda had a terrible time trying to get Provincial Assistance when she did not know where the father of her child was. She was unable to take him to court and was accused of lying because she could not provide his address. Another woman defrauded the telephone company because she could not afford the long-distance calls needed to try to track down the father. Women are often faced with the problems created when men don't appear in court, or when they deny paternity. The process is a long, drawn-out one. In the interim, women have to try to live on municipal or county benefits; they suffer the financial problems of living on minimal benefits, and they suffer from the humiliation of the whole process which stigmatizes them and leaves them feeling unable to do "the right thing."

The welfare system organizes the women's lives and leaves them feeling controlled by the bureaucratic force of the social service system. When women queried anything, they were simply told "That's the way it is." Betty felt that the manner of many of the officials was "I'm just it. You do what I say." This organizational process extends beyond whether women will be allowed benefits and into how they can live their lives. Betty was unhappy when she was on assistance, because she had been told by a social assistance worker, who found Betty's brother-in-law visiting, that she should not have company for too long. Alice saw clearly that the control was never-ending if you were on welfare. The children could not

invite their friends for sleepover, because I'm on social assistance. I can't let them stay at my place. If I can support kids staying overnight then I don't need that much social assistance.... Well, I've ... felt that my life has been controlled. You know one of the reasons I left my marriage was that I was too controlled. How can you be independent if you have to rely on government for the finances to feed your kids?

The women on welfare felt scrutinized and pushed to be "good" — to be appreciative of the benefits they were given. One of the program workers explained the implication of the way recipients are treated by social services:

You've put yourself in this position and you're not a very "nice" person, a very "good" person, because you've *allowed* this to happen to you, you've *let* this happen to you, you've *made* this happen to you.

The women with children felt that they did not know what to do to be "good." They are confronted with conflicting values: They should stay home and take care of their children, but they should also go out to work and support their children instead of being dependent on welfare. They want to do what's best for their children. They take welfare because they need it for their children. Most of them need it because there is no paternal support. Marion explained:

If it wasn't for the kids I wouldn't [take welfare]. I wouldn't [get a chance] anyway, because they wouldn't give it to me.

Marion had accepted a Christmas gift for people on welfare. She hated to, but felt that she had to do it for the sake of her children. Several of the women on welfare believe it is important for their children that they stay home and take care of them until they are of school age. Yet the shame of being on welfare made them think they should try to get a job, even though it is

not a viable option because of the lack of childcare and the lack of jobs. Linda explained:

> You just want to go and wring someone's neck sometimes. But you grin and bear it, and think "Maybe I *should* take a full-time job, if she can get into a daycare."

Betty's response to welfare is that you have to fight it. Her response to being made to feel "bad" by welfare is to say that she will only take what she absolutely has to in order to survive. Then she is clear that she must fight for what she regards as essential. She will not even let welfare pay for her GED exam, which they forced her into, unless there is no alternative when the time comes. When she has no other option, she justifies fighting as the only way to get what she and her family need.

> No, I won't fight for something unless I really have to, then there's nothing stopping me, I'm just that type of person.... I get right upset first, oh, I shiver, and when I get mad I just start shaking and shaking and then I start bawling and then I go and get what I want to get.... It seems like force is the only way a person is going to get through the world. Like the way things are going, if you don't push for it you don't get — plain and simple.

In contrast, although Mary is also managing on very little, she will not take on the system. Her resistance to being made to feel obligated to the social service system is to let them give her whatever they "take a notion" to give her. Her pride demands that she take what "assistance" she is given. She feels that to demand more is to beg.

> She figures if she wants to give me a raise she'll give it and if she don't, you just don't get it.... I won't call her and I won't ask her. I won't beg, that's one thing I won't do, no. Like I say, no, it's up to her. If she decides to give me a raise, well, that's fine and dandy, and if not, well, that's all right with me.

The assistance policy, which removes "one-for-one" any money women earn from their assistance cheques, provides little incentive to try to earn money. Mix-ups, where women were paid too much or too little at a pay period, made it very hard for the women on welfare to budget when they started and stopped short-term jobs or training projects. Susan told a saga of how she had been receiving unemployment benefits as well as mothers' allowance, but her unemployment benefits were cut off because she was unable to go and look for work while her young daughter was severely ill. When her social worker was late sending in information to mothers' assistance, she ended up with no unemployment cheque and a much reduced welfare cheque. For one month she and her young daughter had to live on $180. The social worker commented that she was due more money but said "don't count on it" and "we'll see," when Susan asked about backdated money. It forcefully brought home to her her lack of power.

> I was just going through the roof with him. He thinks that it's coming out of his pocket. I wish it was. Sometimes I want to take it out of his pocket. Some of them are really hard down there.

Alice described problems through bureaucratic delays that caused various overpayments. She thought she would be paying them back for the rest of her life.

> I'm going to be in awful trouble when I finish this. I'm going to be in real deep water financially.... It's almost like you're penalized for going to work.

Women who try to return to receiving assistance after finishing a temporary job, or even women who obtain a permanent job, frequently find themselves trapped in debt from bureaucratic errors.

The women spoke often about the complex practicalities of the welfare system and what you could and could not get support for. But most often they talked about how awful they felt being on any form of assistance. They did not experience

receiving welfare as something they had a right to, something which led to greater equality in society; they experienced it as begging. As Alice said,

> I don't know, it must be the system, the ways it makes you feel. It's not a nice feeling, it's almost like the money is coming out of the worker that is sitting in front of you asking you all these questions, it's almost like it is coming out of his pocket or whatever.

Betty also experienced the feeling that she was begging from an individual.

> It's just as if she's pulling out her wallet from her purse or something: "Well, here, you've got to be awfully good people to deserve this," sort of thing.

Mothers' allowance or other assistance provides women with their basic financial necessities. The "client" relationship with the social worker organizes women's lives and makes them feel that they must be very "good" and appreciative to deserve the "help" they received. Even though there are few jobs, women are defined as incompetent and illiterate and their inability to support themselves and their children leads to a relationship with the welfare system which disorganizes their lives and provides them only with what others judge as "good for them."

Trouble with "Nerves"

Illiteracy is often considered to lead to isolation, especially for rural women. But women's isolation is created by many other aspects of social organization. The power relations between men and women — men's control over access to a vehicle and over what women feel able to participate in — lead to women's isolated situation in the household, and are usually seen as "natural." The gendered organization of society also makes it appear natural for families to live in a location suitable for the man's work and for women to stay at home as "housewives."

When illiteracy is seen as the "cause" of isolation, the illiterate woman is seen as responsible for her own isolation and attention is diverted away from the other sources of isolation which are embedded in the social organization of women's lives.

The social organization of rural life increases the difficulties for some women in getting to work, to classes, or even to social events. The women who lived outside the towns frequently had no access to transportation. Linda contrasted this rural situation with her experience of the city:

> To get around, it was easy because [there were] buses and everything, any city has that.

But in rural areas buses are provided only to take children to and from school.

In this Nova Scotian county, the only public bus service is a service from the county town to the provincial capital. Women who want to get to town need access to a vehicle and money for gas. This is difficult. Frequently the man leaves for the day with the one family vehicle, and the woman has no transportation until he returns. As Frieda said,

> My husband has a vehicle and the vehicle works to take him to work.

Frieda's play on the word "works" draws attention to the sense of necessity for the family vehicle to be seen as belonging to the man and for his needs as the main "breadwinner" to be given priority. Many women live too far away from the nearest store to go out to the shops during the week, so the once-weekly shopping expedition is done by women with their partners on Friday evening. Frieda, Sandra and Maureen all lived in a remote part of the county, down a long dirt road, far from any distinct community. Frieda and Maureen were both in the early stages of building their own houses and living in them as they did so. When their husbands left to work in the woods, they were left without transportation. During the daytime, they had nowhere to go except to each other's homes.

Women living in rural locations often simply cannot get out. Costs put vehicles out of reach for many women.

Sandra: [Gas costs] ... five dollars a day.

Frieda: You have to save for two months getting paid weekly to buy a half-decent vehicle and then you wonder whether you're going to get there or not.

Sandra: ... when [my sister-in-law] gets a different day off, then I can't get in or I stay at my mother's [in town].

Transportation for women during the day is not seen as a priority by local authorities, and buses are not made available to take adults to education programs. Men's jobs usually define where families will live, and men's needs are put first with regard to access to the family vehicle. Owning a second car is not only impossible for many families because of low wages, but it is also often not encouraged by men. Men's power over their wives makes their judgment of women's need for transportation significant. Often they do not see it as a priority, and sometimes they even forbid women access to a vehicle. Many women do not have a driver's licence because they have not been encouraged to try for one or their husbands have actively opposed it. It is not their role, and there is no vehicle available anyway. Male control over transportation works as a means of control over the movements of wives, whether intended by the men or not.

Discourses of mothering which assign to mothers total responsibility for their children also isolate mothers in the home. Women talked of being shut in the house with little or no social contact outside the extended family and little social life. Many of the women had little experience making friends in childhood. The social organization of the women's lives as girls, kept at home to help with the work of the household, may have contributed to the later isolation of these women. The abuse many of the women had experienced in childhood, both in the home and at school, had silenced them and led to them being labelled "shy," so that they became isolated from other

children. Many of these women did not have the experience of making friends. Maxine spoke of her isolation at home:

> Well, when I was a kid I never had no friends. I stayed home and I helped with housework, my sisters roamed the streets and I stayed home.

She, like others, was painfully shy at school, which exacerbated her loneliness. Mistreatment in school, the process whereby they were constructed as stupid, added to their solitariness and silence. Maxine said,

> At school I'd just sit by myself. I never bothered anybody. I always wished I had friends when I was a kid.

Many of the women were distant even from neighbours. They did not describe neighbours as potential friends, but as people who might talk about them behind their backs. Rural life can be isolating for those who live on "back roads," but for those who live in small communities, often next door to their mother-in-law or sister-in-law, it may be impossible to do anything without everybody knowing. Maxine and Jean both spoke of their feelings about neighbours:

> When you get to know neighbours you're all right until — then they more or less stab you in the back.

> I've seen too many of the people fighting with this or that one. They couldn't even go to the mailbox because they'd be talking about them and they'd be mad at them. They'd say, "Did you hear what she said?" It was awful. At least when I go down to the bottom of the hill people will wave to me, they don't say, "That [Jean] said this." That's the way I like it: Stay out of their lives; they stay out of mine.

Only the extended family seemed to be trusted, although some women were also suspicious of the family. And for some of the women, brought up by mothers who hurt them, it was hard to trust other women.

Being uprooted to the location of a husband's job, or moving near a husband's family, contributes to women's isolation. Some of the women had friends, but then moved to outlying places with their husbands and lost touch with these childhood friends. Some men further increase this isolation by limiting their wives' means of contact with other women. Alice was only able to socialize with her neighbours, and only took her driving test after prolonged battles with her husband. When women finally left partners and moved again, they sometimes lost the friends they had managed to find. Alice said,

> Where I used to live there was about twelve families and all us girls pretty well — we'd go back and forth for coffee. We were friends. Well, when you become a divorced person you don't have that anymore because somehow they seem to think you're not attached to any man any more, so you might grab theirs.

The construction of the single woman as a threat, incomplete on her own and looking for a new husband, can cut her off from her old friends.

Not all women were isolated from personal friends. For some of the women, the friend or relative who helped with tasks that required literacy was one person they had a close relationship with. Some women spoke eagerly of their close friends. Sharon, who was single, said confidently "I have a lot of friends" and went on to describe a dance that a whole crowd of her friends and family had gone to. Maria, recently separated, spoke of having one close friend she could talk to.

Several of the women with the most limited literacy skills had one particular friend or family member they trusted to provide assistance with tasks requiring reading and writing. As the women spoke about their relationship with this person, it became clear that it was a reciprocal relationship that thrived on the interdependence between the two. The woman with limited literacy skills offered help in a variety of ways, and received help with tasks requiring reading and writing. Josie described this kind of relationship with her sister-in-law:

> Now with the reading part she helps me, with the children I help her — she's not [used to children].

Josie also helped her sister-in-law crochet.

> I have showed her crocheting. She's made baby blankets she can't finish and I've helped her finish it. We have a good time.

Josie said her relationship with her sister-in-law was "fun."

> My sister-in-law, she can help me with the reading, spelling the words, and mostly I can read the notes, if she takes notes down. Like we're supposed to sit and take notes, she'll just tell me you don't have to, I'll give you my notes afterwards and I'll say OK, which is really fun. I enjoy that part when she helps me. So she said if she had time — and she really doesn't have the time, she's got three little ones and the oldest one is four or five, I'm not really sure. So as she says, she's pressed for time right now, but she would really like to help me and that would be fun. It would be more like friendship.

Their relationship is reciprocal, grounded in their different competencies, and appears to give them both pleasure.

Josie is unusual because as well as her sister-in-law, she described her husband as a support and friend who can help her with reading tasks.

> We're close. If I have any problems he helps me right out. We read the papers, he helps me read the paper. He tells me about the good sales — the prices I understand ... but to read the items ...

She has difficulty reading the notes and information sent home from school, but here again her husband would help.

> I try to read it and the girls will ask, "Well, Mum, can we go?" or "Mum, can we have this?" I'll say "Well, you'll have to wait until your father comes home" — not telling

them that I can't read it. Like I'll read some of the words, but when it comes to the big ones I'll try to figure out what it means, how to pronounce it. Then I just know when he comes home he'll tell me.

She said it made her feel good that he was such a good friend and so supportive.

Maxine also enjoyed a reciprocal relationship which made it possible to receive help without feeling stupid.

I've made good friends with Joan. We work together and she helps me and I help her and we made good friends. I like the rest of the class, but we're not as close.

For Barb it was her sister-in-law, Betty, who provided this interdependent support. Betty was in the upgrading program with substantially better reading skills than Barb, but it was not always reading tasks that Barb needed help on. Barb was pregnant with her first child, whereas Betty had already had two children. So Betty was the expert on pregnancy and able to give Barb advice. She also provided general encouragement to take on difficult tasks and helped with filling in forms and dealing with the requirements of bureaucracy. Barb praised Betty's help in response to the question of whether it felt all right to have to ask for help:

Yes — if it hadn't been for them I wouldn't have gone as far as I did, like my licence, I wouldn't have gone in and got that. The one I find has been most helpful on everything is sitting right here in a blue shirt [i.e., Betty]. What to expect when you get to the hospital, labour and all this, she's been a lot of help.

Betty replied,

You can't really tell what's going to happen by reading a book. You can't tell.

Both agreed that experience was the way to learn. They felt that experience was important for understanding print material.

Barb felt that she would be happy to improve her reading skills with Betty to help her.

> If she explained, she would be able to do it better because she knows what I've been through, what school's been like for me. I think she can understand a lot better than anyone else could.... I don't know what I'd do without her.

The help is not one-sided; Barb is also of great help to Betty. Barb provides the encouragement Betty needs to take on the system and fight for the benefits they must have to live. Barb said:

> Sometimes she almost gives up ... she says: "I give up" and then I don't know what I do, but I convince her and she goes back in and usually she comes out happy as can be.

Betty explained:

> If I shy away from something, [Barb's] right in there.... It almost takes two people, you've got a back-up. If I don't do this they're going to tease me, so I'd better get right in there.

During the interview, Barb and Betty both expressed their appreciation of each other more clearly than they might ever otherwise have done. Barb had worried whether sometimes she was a bother.

> Sometimes I don't know how she'll react. Sometimes she'll say "I don't mind," and I get the feeling she does but she won't say anything.

Betty commented:

> I like helping people.

For some of the women the close friend was also a family member. Sisters and sisters-in-law figured often in the women's personal networks. Most often the friend was a woman — only occasionally a husband or brother. The interdependence of this

special relationship gave the women support for a sense of themselves as skilled, rather than stupid and "skill-less" because of their limited literacy. This close support contrasts with the frequent assumption that illiteracy leads to isolation. These experiences suggest that when a woman has been able to find one friend or relative to provide regular help, it can lead to a close friendship providing both members with valuable support.

Fingeret has identified this interdependence of relationships for illiterate adults. Her work has provided a much-needed contrast to the abundance of work that assumes the illiterate must be in a pitiful state of dependence (e.g., Kozol 1980; Eberle and Robinson 1979). She sums up her study (1983b):

> Most of the illiterate adults in this study create and maintain social networks that are characterized by reciprocity: each adult still maintains final personal authority over and responsibility for personal actions and attitudes. Illiterate adults are considered dependent and incompetent by the literate society because they are unable to perform reading and writing tasks autonomously. However when reading is seen as one of many skills contributed to the exchange relations in a social network, illiteracy no longer defines dependence in the social context of these illiterate adults. (145)

Fingeret's urban "illiterate" adults seek help from a wide variety of people who make up a broad social network and personal community. In contrast, these rural women's social network was often not so broad; it usually consisted primarily of the extended family. Rather than a network of possible helpers with whom different material would be shared depending on their degree of intimacy, most of the women reported one close woman friend, who was often also a family member, with whom a supportive and interdependent relationship had developed. Her phrase "exchange relations" does not seem precisely appropriate here, suggesting, as it

does, the economics of an exchange, rather than the mutuality of help that characterized the friendships the women described.

Many of the women bemoaned the lack of a social place where it was acceptable for them to drop in without a male partner. They wanted somewhere like a tavern, a drop-in, where they could feel comfortable alone and could go to have a chat with other women. Women spoke about being hassled when they went to the tavern, even in a group:

> I don't know, I must have a sign on me: "I'm not attached, try to pick me up." I don't know, you get hit on so much and propositioned.

Women are accused of not caring for their children adequately when they go to the tavern. Alice's ex-husband, Barb and Betty all suggested that for a woman to drink at a bar is to be a "bad" mother. Jill tried going to the tavern once but said it looked bad being there and will not go again.

> There isn't a place where it's just a drop-in for women like the tavern is for men. They can drop in for a cold beer on the way home from work. Can we do that? Talk about discrimination.

Jane explained,

> I don't drink or smoke or anything so there's not many places to go if you don't do those [things].

Several of the women went to bingo or to church groups occasionally. But mostly they spoke of wishing there was somewhere else they could go to meet other women like themselves and chat.

Several had to think hard to remember when they had last been to a social event: a dance, a concert or simply for a drink. Maureen could only remember going out without the children once in the previous eight months.

> Well, we went out, let's see, when we first moved up here last August, before we started building the house, we went

out to a dance. We never went out to a dance again till this year in May. Well, we go visit, but the kids are always with us.

Many of the women complained about not doing anything or going anywhere. Jill explained vividly the experience of having no social life when she was with her husband:

> If I had stayed, even now if I was to come back, I think I'd end up in a nut house because you can't just live with no social life, no communication. You just can't do it.

Even though her social life was still limited after she separated, a move to town, where there were people nearby, made her feel less isolated.

The work that women do in the household has little status or reward and may not be intellectually stimulating, and when the work is completed women are often isolated at home, bored and lonely. Mary described her life with one word: "boring." Asked what she did every day, she said, "Oh, not too much." And when her chores were done she said she did "nothing." Even though she said she had nothing to do, she was proud of not watching television during the day and described her quiet life as her "way" because she would "sooner stay at home" than go out.

Many of the other women also described themselves as bored at home. Betty said:

> I just more or less sit around and watch TV, make my eyes bad.

Later she said she was simply "watching television, eating and getting fat." Maureen talked of physical problems as a result of sitting around in the house too much of the time. She suffered from migraines and got very edgy because she sat there "twenty-four hours a day, every day."

This extreme isolation frequently contributed to depression. Given the experiences of some of the women's lives and childhoods, it was not surprising that they felt there was

something wrong with them and sought medical help. Many described childhoods where they were physically or sexually abused, where they were ignored, locked away, or passed from family to family by their parents or Children's Aid. They described their present life as staying isolated at home seven days a week and only getting out of the house for the weekly shopping trip, or working long hard shifts in a factory in stressful, dangerous conditions, and taking care of and feeding their family. They talked of the difficulties of trying to manage on insufficient money to feed the children and pay the bills, of always hoping that the latest job application would be the successful one.

Women went to doctors with depression, headaches and other symptoms of stress, and described themselves as "unable to cope" and having trouble with their "nerves." This issue was raised by almost half of the women. Skodra (1987) says that the term "nerves" is used by physicians to speak of "psychosomatic illness, that is, bodily pain which is rooted in emotional or affective disturbance" (165). She says that this labelling serves to reinterpret women's problems of "thinking too much" into an illness. Thus it denies women the materiality of their bodies and lives, pressuring them to accept the status quo.

Several of the women had been diagnosed early in their lives as having psychiatric problems. Two, Jane and Pat, had been institutionalized for a number of years. Jane was first treated for her "nerves" at sixteen and left home to be hospitalized. Pat was given psychiatric drugs when she was eleven and hospitalized when she was sixteen. After that she spent many years in institutions. She feels that her past treatment for mental illness continues to affect how she is treated by medical professionals and others. Combined with her lack of education, this history creates a barrier between her and the more educated women she meets through her husband.

Many of the women had been prescribed anti-depressants by their doctors. Jane described asking for some "help" when she was struggling to bring up her daughter alone. She was

given a myriad of drugs even though all she had wanted was a mild drug because she wasn't sleeping. She later realized that maybe she hadn't needed any drug.

> She brought me down three bottles of pills. I said, "Take them back, I don't want them." I said, "You said something mild, not the whole three bottles of pills, so take them back." And then I discovered later on that all I needed to do was eat, so I started eating and I felt so much better and my nerves got better after I quit smoking.

Women frequently talked about being unable to get any help other than a high dosage of drugs. Pat felt that all she and a friend needed was to be able to talk through their anger about their physical and sexual abuse as children, but:

> Doctors and psychiatrists don't understand that. They say, "Increase your pills!" Poor Louise, as soon as they see her getting hyper and upset — all she wants to do is talk about her feelings, but they keep shoving the pills down.

Regardless of the practical problems in their lives, several women felt that if they were unhappy they would be told they needed more drugs. Jane said,

> The thing is, social workers ... say, "Now what's the problem?" and you tell them your problem and they say, "You need an increase in help." That's what they say.... When I said I was feeling good, "Well you're at the right level [of drugs]," and if I went the next week and said I was feeling depressed again they'd put me up again [to higher levels of drugs].

But depression in women is perhaps the only acceptable way for women to indicate that they are not happy with the conditions of their lives. Oakley (1981) suggests that medicine presents women in a particular way and "the effects of these typifications act as a way of controlling women, of obstructing women's recognition that their lot is not an entirely happy one

and could do with some radical change" (100-101). Individual doctors may have little to offer besides drugs, because they cannot change the social organization of women's lives. But their decision to treat through the use of drugs works to assist the women to accommodate to the conditions of their lives and to accept the status quo. The drugs keep women docile and unable to think clearly.

Several women described how hard it was to deal with everyday life, let alone participate in a literacy program while they were on drugs. Jane, after being treated with many drugs herself, began to realize that this was how her mother, who was violent and abusive, had also been treated. She had been on so many drugs that she didn't know what she was doing and was virtually unable to parent. When Pat tried to go to a program, she found she couldn't cope.

> Whether you were a bit slow or whether — they just didn't consider that. I wasn't slow, I was just drugged to death! So the doctor told me never to try to study while I was under them drugs. Because it was just too hard on me — I just couldn't.

While on drugs, Pat could not deal with a course that might have changed her circumstances. The doctor did not alter the drugs so that she could do what she wanted; instead he advised her not to do it.

Several women tried to get off the drugs or reduce the number that they were taking. They felt they received little support from the medical system for this. Jane threw all her drugs down the toilet in spite of strong opposition from her psychiatrist. Pat, after years in and out of mental institutions and a life lived on medication, discovered that she had had a physical problem which had remained untreated. The discovery gave her confidence.

> It's been simply just wrong diagnosis. So it took me two years to even build up my confidence to come off the stuff. Because you see one doctor said, "Don't you dare come

off it, you can't possibly function, you'd have to be in an institution." I didn't know which one to believe, so finally one day I just … took them and dumped them down the toilet. I've been off everything now for almost five years. And see — now I can see what the world is — I was just living in a fog.

Maxine tried to stay off drugs so that she could continue to function in her roles as wife and mother. She felt she had to be able to drive so that she could drive her husband to the hospital if necessary. She had learnt to cope with her depression without injuring the children, by getting away from them when she felt she might hurt them.

I'd go by myself and cry to myself away from them, I never hurt them or anything. It was just the sense I had of going away from them, not to hurt the children. My kids mattered a lot to me because I really loved them — I still do.

The medical system exerted a powerful control over many of these women. Women who have been hospitalized in psychiatric institutions described themselves as having had no rights. They said they had been given hysterectomies, had their "tubes tied" and their children taken away from them, been "imprisoned" in mental hospitals, given shock treatment and forced to take drugs on the justification that they were incompetent to judge for themselves. As Pat realized after freeing herself from the medical system,

You weren't asked, you were told, and I had forgotten — I had to learn I had power, I had rights.

The power of the medical system is one element in the way authority and expertise disempowers women, taking away their sense of their own ability to make judgments. This feeling of being unable to judge can then leave a woman vulnerable to influence from all directions.

The societal judgment that those who are seen as mentally unstable are unfit to make decisions about their own lives has been extended to include those who are on welfare or illiterate. All are judged not to know what is best for them. The practice of welfare and literacy is based on a network of professionals who diagnose their clients' "needs" and solve their problems.

"I Want to Depend on Myself"

All the women were eager to organize their own lives, to have their own source of income and gain independence from welfare, the medical system, husbands and families. Several of those with partners saw a job as a way to achieve some independence from their husbands. As Frieda said,

> I tell you, most women want to find a little bit of independence.

As Betty said, being independent means not having to depend on welfare or a husband.

> I want to be my own person. I don't want to be dependent on him. I've always been an independent person. I want to depend on myself and no one else.

With limited employment prospects, searching for a job is often a full-time occupation. Betty told me that in her search for a job she went to the same factory every morning inquiring for work.

> Yes, every day, except for the days I was sick or didn't have the gas or something....

> And he'd say, "I'm sorry, there's nothing today. Come back some other time." So I'd go in the next morning. "I'm sorry, nothing's changed. Come back some other time." I'd go in the next morning ... that went on for a full year and I just said to heck with it.

She never did get a job there, although vacancies came up. It appeared to her that she had been judged a troublemaker or not a hard worker — a judgment against which there was no appeal.

Judy described the job hunt as a "losing battle."

> I go to the same place and I do it once a week, fill out applications one more time.

Like most of the other women, Judy found the Manpower office little help in her search for a job. Judy described in detail what so many of the women complained about:

> I go out looking. I don't care for Manpower, I don't find that they find enough, have enough there, and you've got to sit around and you wait an hour or so just to talk to somebody.... I can't be bothered. You go in, and you look around just to see nothing. And if you do find something the wait is so long, by the time you get processed and figure out whether the job's already been taken, which often happens. You wait there for the hour you can go and see the people about the job. You get out there and they've already filled the place. I just find it easier to go and do it myself.

Each woman's approach to job hunting seemed to be dependent on her network of personal connections. They checked frequently with a particular factory or motel where friends or relatives were working. This is based on practical circumstances. Their contact can tell them when vacancies occur and can "put in a good word for them," and they are familiar with what is involved in the work, the conditions of work, and the pay and hours. If they get the job, they can share transportation. This concrete knowledge and practical circumstance contributes to structuring a job search.

These women had concrete knowledge of the reality of the jobs they were likely to find. Many had worked in factories, restaurants and stores themselves and had seen the toll that twenty or thirty years of such work had taken on their mothers.

They saw this work as a "job" in contrast with a "career." Dorothy said her work was not interesting, "it was just a job." A job was not the sort of thing, as Dorothy said, that "I would've picked for myself." Only four of the twenty-three women interviewed, who were in upgrading programs or had limited literacy skills, had paid work when the interviews began — Sandra was working in a motel, Jane, a single parent, was working in a home for the aged, and Dorothy and Judy were caring for children in the home. Judy saw her childcare work as temporary, while she looked for a job which would get her out of the house. Sharon, who had extensive experience as a waitress, eventually got a job. Barb, on maternity leave drawing unemployment insurance benefits, had a factory job to return to after the birth of her child. Three of the women's husbands were unemployed and one had part-time work. Three of the men did woods work; the remainder did a variety of other manual jobs. Many of the women were looking for a job, any job, but longing for a career which would allow them to escape the material circumstances of the work they knew too well.

Factory work was the most demanding of the available work. The shift work in particular was a strain for women taking care of children, and even more acute for women with sole responsibility for children. Marion described the work at one factory:

> You work seven days and get one day off, work seven days and get two days off, work seven days and get three days off, or whatever. And you work ... 7:00 to 3:00, 3:00 to 11:00, 11:00 to 7:00. And it just got too much and I was bringing her up by myself at the time and living at Mum's.... My nerves, my nerves were bad.... I don't want to go back there. I find it too hard. I just get so tired.

Dorothy's experience shows the problems of doing shift work when caring for children.

There was a *very* lot of lifting, it really was. With the hours that you put in, it was a long strenuous day and I had kids home to look after. I couldn't go home and go to bed and sleep, I couldn't do that because I had little kids to look after. So it really made it hard for me, you never got your sleep, that was the big thing, you never got your rest.

It's not only the shift work that makes factory work so arduous. The work in many factories is physically demanding, as Dorothy explained:

It's heavy work, it really is. I was there for ten years. You had to weigh the yarn, and the yarn was in big baskets bigger than this table. And you had to lift them down to a weigher and weigh them, and the yarn's heavy itself. And you had to lift big skeins of yarn and put them through a great big dryer and they're heavy when they're soaking wringing wet out of the washer. There's like a great big washer they wash the yarn in, and then when it's ready — it's sopping wet when it comes out.

Many of the women gave the same account of hard, heavy work and tiring shifts. In one factory, the employees were treated well, but women were injured and became ill from the chemicals. In another factory, women felt the work was not so heavy but said,

You've got to work for your money.

Twice as much [as] ... you're getting paid for.

They were paid on a piecework basis, so the skilled could increase their income, but when machines broke down they had to wait, losing money until the men had repaired them.

Many women had seen the effect of work on their mothers. Barb's mother had high blood pressure after working for thirty-five years. Sharon's mother, Dorothy, pulled a muscle in her heart from all the heavy lifting and had a heart attack. Several of the women themselves were suffering from "nerves."

Dorothy felt that if she had had more of an education she would have been able to avoid the heavy work which had been so hard on her health.

> Maybe if I had've had more education I could've maybe got a job in a store and maybe prevented the heart attack. [It was] such heavy work and such odd hours and long hours.

Women who had worked as waitresses knew the stresses of restaurant work.

> A waitress job, nothing to brag about. It's a lot of mind work, always pasting a smile on when you get these people who are very rude. They think if you're waiting on tables you're a lower class and you get a lot of those kinds of people. There's many times I've felt like letting them have it.

Being on their feet all day was tiring, but customers were worse. Most of the women complained about what was expected by the customers as well as by the employers. Jean had worked as a waitress, except for a short stint working in a factory, ever since she left school. She was married with four children, and working as a waitress had allowed her to be home with the children until her husband came home from work. But she was very clear that she didn't want this kind of work for her children. She told them,

> Do you want to end up working in a restaurant, a dive restaurant? ... Work in a dive restaurant, listen to a bunch of drunks come in at one or two o'clock in the morning. I don't want that for them.

Jean talked about how hard it was trying to please everyone. She also spoke of hours of scrubbing and cleaning, particularly at the end of the day, for no pay.

Two women spoke about working in a laundry — heavy lifting in tremendous heat for low pay. Women felt that in all these areas of work there was little recourse for hard and even

unfair conditions. They knew what happened when people tried to bring a union in or complained to the Department of Labour. Sharon said it wasn't worth fighting anything because

> I could fight it, but if I go back and I make one mistake then I'm out the door. So it wouldn't be worth my time.

Women who are sole-support mothers working at a minimum-wage job find it almost impossible to make ends meet. Jane said:

> I make $277 every two weeks and a hundred of it goes on babysitting, so I make $354 a month.

By the time she paid her rent there was very little left. Jane was supporting one child. Others with more children described the complete impossibility of existing on a minimum-wage job. As Frieda explained, babysitting can cost $10 or $15 a day. At minimum wage:

> All right, you've got $32. What have you got left? You've got $17 for working all day — eight hours.

Then she added on the cost of transportation. She and her sister-in-law estimated that to drive to work from where they live would cost $5 minimum per day for gas. When they also considered the cost of payments on a car, the income gained from doing a hard eight hours of work was minimal.

The lives of these women in rural Nova Scotia are largely organized in relation to the needs of others. This organization is essentially *dis*organization, women living their lives around the demands of their male partners and children, and sometimes also extended family members. The organization of space, time and resources are usually located outside women's control and based on the needs of others. For women situated in a rural location, frequent changes of location, or lack of access to a car are factors that are organized primarily in relation to men's work needs, but affect women's lives.

Dependence — on men, on inadequately paid work and on social service assistance — is threaded through the lives of

many of these women. Dependence leads to violence: the violence of women's isolation in the household and sometimes the actual physical violence of men's domination of women; the violence of the drudgery of inadequately paid, hard, monotonous jobs; the violence of living on an inadequate welfare income and enduring the humiliation of receiving assistance. The violence, both psychological and physical, of dependence on a man is often endured in the silence and isolation of the home. The violence of the workplace is more often shared and spoken about; although the violence of receiving welfare may be a shared experience, the stigma attached frequently makes women ashamed to speak of what they have endured. The violence of these women's lives is frequently obscured by the illusion that illiteracy creates women's problems — that it is illiteracy that "disables" women or "chains" them in prison. In that way our attention is focused not on the disorganization of women's lives but on women's failure to become literate. These women's lives are the context in which they experience the "promise" of literacy, and dream of how different their lives will be when they improve their education level.

CHAPTER TWO

Living an "Everyday" Life: Dreams of Literacy

"As Long as I Can Live without Worrying"

Although many of the Nova Scotian women were looking for a job, what they longed for was "a career." The term "a career" described work that would be less backbreaking and more interesting and would pay a wage that would free them from continual worries about survival. "A career" would make available the middle-class lifestyle that the media and advertising characterize as "ordinary." The women were clear about the difference between a job and "a career." They saw "a career" as the sort of work one "chooses," and many saw education as key to being able to make "choices." As Sharon's mother, Dorothy, said:

> You've got more choices to go by if you've got something to work with.

Jean also talked about the greater options available if you have an education:

> The job opportunities would have been better. I wouldn't have been a waitress for seventeen years. I wouldn't have had drunks, and if I didn't like the job or like my boss I wouldn't have stayed because I needed the money. The opportunities would have been a lot better.

Dorothy considered the possibility of doing work at home:

> If you had a good education you could always have work in your own home and do it there. But I haven't got no education to do something like that. You know,

bookkeeping or something like that, you could always bring it into your own home and have time to do your work and get yourself some money.

Many dreamt of escape from boring, meaningless and heavy work into something easier and more interesting. Judy said:

I'm sick of factory work, and I don't want to work in a restaurant any more because my legs hurt. And I'd take a business course or something, but in order to do that you have to have grade twelve.

Literacy or upgrading courses were the first step toward work with meaning, work that women would choose. Linda said:

I was glad though, in a way, to get out of waitressing. My Mum has been a waitress seventeen or eighteen years, and it's been hard on her; there's not much she can do now. If I can get a chance to better myself and do something I really want to do, I'm going to take the chance.

The women knew the concrete details of the jobs they did *not* want to do. They had first-hand experience of many of them, or they had heard the accounts from their mothers and friends and seen the effects of the arduous work. They did not have the same knowledge of the day-to-day realities of the work they dreamt of doing. They did not have friends and relatives doing the jobs they dreamt of. What little they knew about these careers came from glamorized portrayals in the media or from popular mythology.

The dominant discourse tells women that more education leads to jobs with higher wages, so it is not surprising that many of the women believe that education will give them better-paying jobs. Frieda, for example, said:

All you have to learn is the secretarial skills like filing and shorthand and stuff like that. Then you can get into an office where you can make good money, $7 or $8 an hour rather than $4.

And, as Frieda said, "They pay you good if you're good."

The mothers who were on welfare felt education was essential. It held the possibility of a career — a job paying more than minimum wage. It is only with a higher-paying job that women have any hope of supporting themselves and their children and getting off welfare. Marion feared that, if she didn't get an education,

> I'd always be on welfare the rest of my life.

When women spoke about what sort of a job they wanted to get, the main description — especially from the single parents — was in terms of earning enough not to have to worry about basic survival.

> Hopefully we can get into something that will be worth all this hard work ... pays a little bit of money, so I won't have to worry about where the next bit of money is coming from for supper or breakfast or bread or milk.

Susan explained that a major reason for taking on the "hard work" of the upgrading was to gain this freedom from worry. Both Marion and Linda agreed:

> I don't know what I want to do, only something that pays money so that when I've paid my bills, I still have money to go from payday to payday.

> I can start all over again and try and get a good-paying job.... It doesn't bother me that much [what I do] as long as I can live without worrying where the next money's going to come from.

Linda believed that the necessary ingredient for this is education:

> I just wanted to get my grade twelve. I realized that if you want to get a good-paying job you have to have your education. I'd better get to it.

The women were not certain about what job they wanted to do; they simply wanted to be free of worries about survival, and

they were certain that education is the route that will get them there.

Their children are key in making the women consider the importance of a better income. Children are costly *and* their mothers want something different for them. Linda said:

> With the baby it's more expensive than just by yourself. When I was by myself it didn't bother me so much just to get by, but now with her I want [something different].

Because of the children, she feels both an obligation to earn more money and a desire to provide a life "different" from her own.

Even for women with partners, upgrading is crucial to earning more than minimum wage to support the family. Betty said:

> It's just more or less to help me find a job, like a better-paying job than $4 an hour. You know I'd settle for $5 an hour — if I could get it. I know how to cook. I'm a cook and a waitress and they just pay minimum wage if you're lucky. And you know that can't support a family or anything like that. So I'm just more or less looking for the education part of it — I'd like to know all of this stuff and — the job aspect of it.

Though the women need more money for their children, they don't want them to "get spoilt."

> Like I don't want them to get everything. I want them to know the value of money. They'd get an allowance. If they said "I want…" I'd say, "Well, you save your allowance." Let them do it that way so that they know the value of money so they don't get everything handed on a silver platter. If they have to have something for school, like material, I'd be able to get it for them.

Susan gets depressed because she can't buy things for her daughter while she is on mothers' assistance. Yet she feels that her daughter is learning the "value of money" by not having too much.

Women who are on their own know that they have to support their family now and in the future. As Alice said,

> If I need more education then I should get it now. I've got to support myself. I've got to support my kids, and there isn't anybody that's going to support me when I'm sixty-five either.

Alice lost everything she had when she left her violent husband and has had to start again.

> I want to support my kids. We live in an apartment which is a nice apartment. I'm not knocking it or anything, but I would like to have my own home. I left my home. I left everything in my home and my kids don't have a backyard to play in.

Dorothy brought up eight children and dealt with three medical crises. She referred repeatedly to how different she felt her life would have been if she had had an education:

> If I had've had the education I could have gone and got myself a good job that paid good money. And then maybe, you know, we might not have had such a rough time.

She added:

> It might have been a lot easier to look after the bills and stuff like that with a good education and a good job.

But it was more than just the money: An education appeared to offer a more middle-class lifestyle, a lifestyle that was less harsh and where people didn't have such "rough" times. The common assumption is that education is the passport to a middle-class lifestyle — "a career," not simply a job. Women operate within this perception when they speak and dream about what difference education will make in their lives and the lives of their children.

Several of the women were not specific about what work they dreamt of doing; they just knew the sort of job they wanted

to escape, and described the work they wanted to do simply in terms of any work with meaning. Alice said:

> I want to work. I don't want to work at something that I don't like just to earn an income. I want to work at something that I can enjoy getting up in the morning where I think I'm accomplishing something, where I can get paid a reasonable amount to live on.

Though that does not seem like a lot to ask, Alice felt that it was.

> I'm asking for the moon and the stars and everything else. It's too much, it's too much.

Her wish for a job that offered satisfaction echoes many of the other women's yearning for some sort of "career." Susan said:

> Working at something I want to do, something I can wake up every morning and I just can't wait to get there.

They frequently explained that they didn't know what they wanted to do, but were clear about wanting work with meaning, work that contrasted with the jobs they knew and had done, jobs of drudgery and boredom. As Marion said,

> I want something that I know what I'm working for — something that I know I've achieved it.

This dream of a different life contrasts with "not making it." For Susan "not making it" was

> Working at [a doughnut shop]. That's where I worked and I didn't like it. But I had to work there for the money, and you go there and you hate it, so you're not going to be happy ... you're dragging, hating to go there.

The words of these women were echoed by a worker in one of the programs. Although not all of the women who spoke in this way were in her program, the similarity of the images suggests that the program workers do play a role in structuring this dream for the women who participate in their programs.

One of the carrots is, "Look, after three years you can tell them to take their assistance and tell them to put it where the sun doesn't shine and you can be independent and you can live. You can have a job that provides you with a sense of satisfaction, that you like getting up in the morning, that you feel like you're really participating and contributing and you feel that you're helping other people or at least doing a good job." ... Because when you look at all of the things they've got to overcome to get the education or training, there's got to be something good out there to make it worthwhile.

Many of the women had as their career goal clerical work or work in the caring professions, traditional areas for women. But the clerical work some dreamed of was seen by others as lacking meaning. Alice said:

I do not want to sit in an office for eight hours a day and answer the phone and type up things and not get credit for any accomplishments at all. You're a glorified gofer, that's what you are when you're a secretary. I don't think secretaries get enough credit for the work that they do because they are the foundations of every organization.

To have the possibility of entering a profession or even a trade, these women needed to embark on further training after they completed their upgrading. Many said that their immediate goal after finishing their General Education Development (GED) would be to investigate the availability of further training. Some, like Susan, were not sure what training:

When I get my grade twelve I'll have to see what I can do from there.

Others, like Frieda, knew exactly what they wanted:

I've got to have a certificate, a grade twelve certificate.... I'm going to take a course in something I've always

wanted to — nursing, but I'll take nurse's aid or assistant, but I want to be a nurse.

Pat was certain where her talents lay but knew that she required qualifications to be recognized:

> You definitely need qualifications. I've done an awful lot of counselling, in the [psychiatric hospital] and just in life. But it's not recognized. I'd like to be able to get that.

Sharon wanted to get into the armed forces, where there would be training opportunities. Betty wanted to take a hairdressing course, and several women wanted to take business courses. The women hoped to open up the possibility of a different type of work and different lifestyle through training possibilities.

The women's career dreams seem to symbolize yearnings for class mobility. Many stressed that the work they would like to do would involve the need to dress well. This stress on dressing well appears to express a desire to avoid work that is dirty and physically demanding, and to obtain work which carries status, is social and permits access to a middle-class lifestyle. At various times women said:

> I like the idea of getting dressed up to go to work.

> I like to wear dresses.

> I like to be able to dress.... I like to be able to meet people.

"Dressing" contrasted with the jeans they wore about the house and seemed to symbolize the idea of going out into the world and having a presence there. One of the literacy coordinators was surprised by the way the women dressed up to attend the GED exam, but that seemed to fit with the idea of the GED as the source of access to the outside world where you can "dress" and have status. The women wanted to be "somebody" and identified this with dressing well and meeting people, in contrast with the isolation of the home or the dirt and drudgery of heavy manual labour.

Susan described in detail the middle-class life she wanted:

I'd like to have a career that I really want to do, not something you have to do because you need to live. And ... further myself and some day be the president or be the owner of a company, instead of always sitting down there being $4.50, $5.00 an hour. And I feel if you have a good job your life has a little more meaning to it, I really do, instead of this "I don't know what I'm doing." My life has no meaning, other than getting up, going to school, looking after her, but if I had something to get up to in the morning, dress nice for, go out and meet the world, meet the ... everyday kind of life — the things that go on in life, the things that go on in life that you need to handle. This way the least little thing gets you down because you don't go nowhere, you don't do nothing. If I had a good job I could have a nice little home and do things that most parents do, take them to Florida, go to the Toronto zoo. Where can you go if you're here on mother's assistance? You're lucky if you can go to P.E.I., but if I furthered myself and got to do something that I'd like to do and worked hard enough at it — I think it's going to pay off in the long run.

She sees an "everyday kind of life" as having a job with meaning and being able to afford to take her child to Florida. As she struggles with day-to-day survival, she dreams of the sort of life that the media implies is simply ordinary — the result of hard work through which anybody can become "somebody."

When women spoke about a desirable career, they frequently expressed desires to work with those in need: children, the deaf, the mentally handicapped, victims of violence, or the sick. These are, of course, the professional areas usually seen as most suited to women and correspond to much of the work they have already done as wives, mothers and caregivers. They also represent moving from being victims, people with problems themselves, to being able to help others. The women were often certain that they had the main skill that was needed to do such

work: They loved kids, they had the same experience and would be able to help, they cared for people in distress. In spite of this they often described these careers as unattainable goals.

Betty did not want a traditionally caring profession, but one which she felt would have impact in the world. But, like many of the other women, she saw her dream as unattainable.

> I don't think I'd be able to go through with it. I dreamt of getting into law for so long, but it's really out the window.... This is a big dream, I'd die if I ever went through [with] it.

Although women spoke of these career dreams as unrealistic, impossible dreams, many of the women had taken practical steps toward pursuing their goal — two women, for example, had taught themselves sign language in order to work with the deaf.

Marion said:

> I don't know. I'd still like to be a nurse, I think, but to go to school all them years, I'd be so old. I always had that problem, didn't know what I really wanted to do.

Over and over again she repeated "I don't know":

> I don't know where to ... what to do or anything.

> I don't know where to go, what to do, where to start or anything.

And yet she *did* know: She wanted to be a nurse. It seemed instead that she lacked the concrete knowledge, the contact with others in the field which would enable her to see fully what becoming a nurse required. But she also knew that it would be very difficult with two children and little financial support. She was unlikely to be able to make the leap that would enable her to get into this profession. Perhaps she said "I don't know" so frequently when asked to "choose" her career because she believed there is no fit between what she would "choose" and what is probable. With two dependent

children she is unlikely to manage to get the training necessary to make her dream a reality.

Similarly, Betty gave a contradictory message about her heart's desire to be a lawyer. She knew about the work, but also felt that she did not understand what it would involve. She said that most of what she knew about the profession was from the media and realized that her knowledge was distorted. She, too, did not consider her career dream a practical possibility:

> I don't let myself think about it. I dream about it, but I don't usually think about it.

The attraction of law for Betty was not the money, she said:

> It's the excitement, of doing this. I can fill this paper out and everybody's going to go by it. It's more or less that type of thing.

Jean also saw her desire to work with deaf children as simply a dream, even though she had learnt sign language. Although she had a desire to work with the deaf, she described herself as having no ambition. The dominant discourse offers her no explanation for her failure to achieve this career dream, other than her own lack of ambition.

Many of the women used images of movement and "being" when they spoke of their education. "Going somewhere" and "being somebody" were phrases repeated over and over with many variations. Several of the women spoke frequently of having "come a long way." For Susan, "coming a long way" seemed to be tied both to learning to cope better with her daughter and to improving her education. She wanted to "get somewhere" and saw her upgrading as the necessary first step to "doing something":

> I've come a long way and I'm just glad that I've left home, I've learnt a lot, and I've learnt to handle [my daughter] a lot better, and I've learnt there is more to life than just sitting at home listening to my parents growl. I can make it if I really try. And I went and took my GED and I didn't

do very good, but I expected that because of my reading and my writing, and I'm now trying to improve my English.

The satisfaction of having "come a long way" was tempered by Susan's depression and despair as she struggled to live on welfare and raise her daughter alone.

Marion's friends describe her, too, as having come a long way because she took her GED and got a grade eleven pass. Pat also felt she had come a long way, but she was frustrated that when she got discontented, wanting to achieve more, others tried to console her. They told her she had come a long way and that she should be thankful, but she felt there was still a barrier between her and her educated friends because she is not educated: "There's a certain line there." She wanted to take a course and improve her English and math and perhaps train to become a counsellor. For her the changes have not come fast enough.

"Going Somewhere"

Images of coming a long way and "going somewhere" contrast with images of women trapped in the house. Women who live in isolated rural areas, who work in the household caring for young children, are often lonely and seek the company of other women in similar circumstances. There are few legitimate social events for women. Literacy and upgrading tutoring and classes provide a rare opportunity to meet other women. Those who go to the program office for tutoring or classes are able to get out of the house. Many women assert that this is both learning time and social time.

Women often spoke about the literacy or upgrading class as an opportunity for social contact that would help them feel less isolated from the world. Schoolwork was also seen as a way simply of passing the time. Betty saved her homework to fill in the time:

> I could have sat right down and did it all and had nothing to do for the rest of the time until next Thursday. Well, I

leave it, or I'll do it when I get bored, which is very often.

Mary said she would participate in the literacy program just for something to do:

> Well, I said, it might ... occupy some time, I guess.

But schoolwork is not just *any* way of filling time — the social interaction is also an important aspect of the program for many women. Mary realized that she would not have got the same social enjoyment if her tutor had been a man:

> If it was a man that was talking about it with me, I would be more or less uncomfortable and everything. I don't think I would be able to do it.

It was very important

> to have somebody to chat with, to talk to.

Her tutor came twice a week, and they did a lesson from the Laubach text and then had tea and "chit-chat." The tutoring session did not, however, fulfil her need for social contact. Asked if she would have preferred to do something that got her out of the house and meeting people, she simply said she would have liked to do something like that, too. Several other women spoke about doing some work during literacy sessions and then having a chat with their tutor. Sandra spoke for her sister-in-law Frieda:

> But you must get bored. You don't go nowhere, do nothing. Her outing of the week is getting groceries. No wonder she's enjoying the school.

Women who were in groups, rather than tutoring, were full of praise for the way a group allowed them to meet other women in the same position as them. Maxine said:

> I've made friends here and I'm pleased and I'm happy, I'm happier than I ever was.

Jane had been afraid that in a group at the literacy program she would look stupid, but instead, as she said, "We turned out like one big family." Pat described the same program as Jane, where she also developed friendships and enjoyed the personal way that the teachers related:

> One teacher ... who was at that school, God love us, she was sweet she would say "[Pat], if you need help give us a call," and they met you on a personal level. Even through the study of the English we got talking and she had health problems and she was getting fed up and she was going to Halifax and we were able to share part of that frustration. They weren't just there to teach you your English, they were there to be supportive of what you were going through in society and she shared her [problems].... So I developed some friendships.

This personal relationship gave her confidence and made it easier to ask for help when she needed it:

> You felt comfortable in doing it because they were so open.

Being around other women with the same problems was important for many of the women. They made friends and realized that they were not alone with their problems. Women could feel more confident working with others who shared the same problems and were in the same position. A couple of women who were in individual tutoring spoke of what they felt they were missing. In a group they would have been able to get together and help each other and feel less isolated:

> You'd do it sort of like together, learning from each other, you're not the only one with this problem. There's other ones with the same problem. When you're in with [the tutor] alone you feel like you're the only one with a problem.

Seeing the importance of the social aspect of program participation, it might be assumed that the women "really" wanted some sort of social group, perhaps a "kitchen table" chat where

neighbours gathered together to talk and discuss their lives. But that conclusion ignores how strongly many of the women spoke about their fear of being exposed to their neighbours, and disregards the intertwining of the social and educational in the words of the women as well as the aspirations the women have expressed. The idea of an alternative gathering also ignores the household power dynamic. Even though many of the women's husbands did not accept their education, attending a program gains legitimacy if it is considered necessary for their role as wives and mothers. It is the process of taking part in the course itself that offers women social interaction.

Women's isolation in rural areas can make it harder to get out to a program, but it also makes an education more desirable. The dreams of what change an education might bring are varied. Women who are at home all day are keen to do something "for themselves" and to have something to do to stimulate their minds. Several women who lived in isolated situations spoke of the importance of the upgrading program. They hoped that participating in education would help them to feel better about themselves, would offer them something interesting to do to pass the time, and would eventually lead to a job, which would allow them to escape from sitting in the house every day into the world of paid work.

Education was also perceived as a route to escape the stigma of being "backwoods." Frequently, literacy workers spoke of the women who lived far from the town as being "in the middle of nowhere" and assumed that moving to town would be an advancement. The town seemed to be linked with civilization, superiority, modernity. Many of the rural women were aware of this pejorative description of their rural lives, and some of them shared it. Susan longed to get out and move to the city. Others wanted to escape the stigma through education alone. Maureen, who lives on a "back road" far from any community, was proud of taking on her education. She spoke of her sister-in-law as having no justification for acting superior to her, looking down on her "backwoods" life, as the sister-in-law too was from the "backwoods":

She thinks she's so good, and I said "Where in hell does she come from? She comes from the backwoods like we did when she met us. So what made her so good all of a sudden?"

Maureen would like her sister-in-law to visit so that she could tell her that she was doing upgrading:

> I'd go: "Hey, guess what? I'm taking my upgrading." I'd just love to rub it in her face, she thinks she's so good.

The dream of a better job, with meaning, is closely tied to dreams of escape from the rural Maritimes, from being "backwoods." Women spoke of the need to "get out," to leave the Maritimes. Susan said "I want out, man. I want out." She knew that she would not fulfil her dreams of getting somewhere in her small town:

> There's nothing here, you know. There's working in the department stores, that's about all there is, that and restaurants. That's all there is to offer in [town]. You need a city to get a job, to get somewhere.

Linda said that she wanted to live somewhere "a little more exciting." For some "the city" meant simply a city in the Maritimes, but many felt the lure of Ontario. The big city offered something different, a certain thrill. It was also a scary place. Mary was not too sure about visiting Ontario:

> I heard people saying "Toronto — it's a fast place up there," so I don't know.

Going with a friend was the solution for Susan, so that she could experience Ontario and a new life, with less fear:

> So I said, "We'll do it together and we'll go to Ontario together." I find Ontario has so much to offer. It's big and I just love it. I don't know why, I've got Ontario in the blood. If you go out of town you find more, half of Ontario's made out of [Maritimers] everywhere you turn.

She had been in Ontario earlier, before she improved her education. She spoke of that time as "running away." She had felt she had to come back home to get her upgrading and show that she was not simply running away, but rather "getting somewhere" in Ontario. Education was perceived as crucial to making the dream of escape from the rural, "backwoods" Maritimes into a real possibility.

Women dream of more than simply getting out of the house, or leaving the Maritimes; they dream of getting "somewhere." They want to become somebody and "do something" with their lives. They frequently see the lives they live as merely doing nothing and contrast this with a dream of "doing something," "going somewhere." Literacy and upgrading programs appear to offer the opportunity to do more than attend a social event: They offer the possibility of fulfilment of desires to lead a different life.

Betty contrasted how she felt when she was always at home and the sense of possibility generated by participating in the upgrading program:

> As it was, I wasn't going anywhere. I'm not going anywhere right now except for trying to study to get my grade twelve. But now I can actually see a light at the end of the tunnel. There is something out there; all I've got to do is work.

Jill also felt that, having left her husband, moved into town and started on an upgrading course, she was going "somewhere." She wants to "better herself," and sees this as becoming more middle-class, dissociating herself from others with little money:

> You get in with a low class of people like the ones that do go.... The first thing [my social worker] said to me: "Now you get in that trailer, don't go hanging around with people that think lowly of themselves because then you're going to think the same way." She said: "Get around with people that do things and think more of themselves and you'll feel that way." And you can see the difference: I

could hang around with [my sister], like I went out with her and I didn't feel like much and [the tutor] comes here and I feel different. You can tell when you're with a lower class and a higher class. You can tell people that aren't well off from people that are. Like I said, though I can't say for sure exactly what, I know I'm going somewheres. I don't know — it's all interesting anyway.

The women also frequently use images of being something when talking about aspirations. Jill explained that being something was connected to having money:

Well, I am something, but I mean I'm not going to be poor. I want to be able to support us myself.

Several other women spoke of their desire to "do something" with their lives. Susan was particularly fascinated with prisons. This seemed to be because looking at people in prison made her feel that she could do something with her life, that she didn't need to be "imprisoned" in her parents' home, and that she could work at her education and manage alone. She looked at people in prison and thought:

They're just wasting their life and that's why I really gave it a lot of thought when I was up there last year and I had to move away. And I didn't stay because I thought, I *can* make it.

Women saw upgrading as a first step to "make something of themselves" and were often proud of taking this on. They wanted to prove to themselves that they could do it. Thus literacy and upgrading offered a source of pride as well as escape from boredom. Education programs seem like a step toward escaping from the home and allow women to dream of achieving something in their lives. These women sought the challenge of a broader world than that in the house. As Judy made clear,

I'm even feeling better just learning, having something else in my mind besides the everyday.

The women wanted something other than "the everyday" from the literacy and upgrading programs. Although many said they got satisfaction from the challenge of participating in a program, programs are often directed at teaching women "functional" tasks, rather than striving to enhance the meaning in their lives. The promise of literacy programs may not be fulfilled.

"A Better Life for My Children"

All the women with children described their desire to improve their literacy skills as closely tied to their dreams for their children. Many have transferred their dreams for the future to their children. Susan, for example, said one reason for taking her upgrading was her daughter:

> I explain to her that I'm taking my reading, my upgrading for her — to help to improve myself for her and for myself too. It's also that people are starting to notice and it bothers me. My sister's ten and I can't read to her. I'd be reading — I don't know what words and I don't know the meaning of them. And I should, you know, if I want to try and get anywhere in life and try to raise her and read to her right and put a lot into it.
>
> [If it wasn't for my daughter] ... I'd just say if you don't like me the way I am that's tough.... Reading to her made me realize that I did need some help — if she wasn't there I wouldn't be reading to nobody. I could pick up a book and get the meaning — if I didn't know the words I'd just keep reading and get the meaning later on of what the word might have been.

If it weren't for the kids, Marion said she would "Work at

[a factory] or somewhere," but because of the children she thought about returning to school:

> I'd do it for my career, though. If it wasn't for the kids I wouldn't — if I had to go to school I'd just say no.

Several of the women wanted to help their children learn to read, to set an example, and simply to expand the range of activities they could share with their children. Susan described needing good reading skills to read to her child:

> There's an everyday need for [literacy]. I read to my little girl and there's words that I don't understand and I put in a make-believe word and she's going to catch on now. She's learning to read and if I can't read properly to her, she's not going to be able to read it.

She felt she should help her daughter to learn to spell:

> She's learning to spell in play school and she'll ask me how to spell this word. Or she'll go e-d-a-e-o or something silly like that: "There, that's how you spell it." That's what I mean, if I learnt how to spell it, sit down and print them out and learn her to spell the words. When she asks me and I don't know how to spell it, it's pretty hard to learn her how to spell it. And I can't even look them up in the dictionary because I don't know what I'm looking for.

If she could read, Susan felt she could do a lot more with her daughter. She had taken her to the wildlife park and couldn't read the names of the animals.

> If I can't pronounce the name of the animal, how is she going to know what it is? It looks like a fox, so you say fox, but there's many different kinds of fox. I just say it's another fox, I don't read things.

Susan felt she could take her daughter to the museum, to the library, to the park if she could read better:

> It would help me with her a lot more because if I could read stuff, if there's something going on like at the museum, if you can read stuff to her she'd understand it. If I understand it I could bring it down to her level, it would be easier.
>
> Reading I think has a lot to do with life. If you can read and understand what you're reading I think you can do a lot with it.

For many of the other women, the need for literacy was connected to homework, as their children were of school age.

Judy stressed the importance of being literate to provide a role model for her children. She felt she must set an example of reading, to show that reading counts:

> It's not good for them to think you don't know it — "So why should I have to learn it?" I'm pretty sure they would feel that way after a while.

Many of the women spoke of doing upgrading for their children. This meant more than the usual explanation that they want to read to their children, or that bringing up a child (often alone) makes a job that pays adequately a necessity. It also meant that having a child provided a break from the pattern of the work the women did and could have expected to continue to do.

Many of the women, often only in their early twenties, suggested that they had given up on their own goals and were now worrying only about the children. Some also spoke about what they wanted themselves, but they could not say often enough how important their children were. Betty simply said:

> With the grade twelve I see a better job, a better life for my children. That's all I'm worried about now — my children.... It's them that I'm doing this for.

Many women's hopes for their own lives are submerged in their desires for their children's future. In the discourse of mothering this is seen as natural. Literacy figures in women's hopes that their children's lives will be different from theirs.

They dream of offering them a comfort-filled childhood and that they will succeed in education and live a different life. Literacy and upgrading programs seem to offer this possibility.

When women took part in upgrading and literacy classes they spoke of their goals as being both for themselves *and* for their children. Jill said:

> I am doing something for myself right now *and* for them; they're not in the way.

She saw herself as improving her educational level for them:

> Now I have something to do all these things for. I have them to do it for.... I think if I didn't have them then I probably wouldn't be where I am today, starting to get some [education].

It is the combination of improving literacy skills for themselves *and* for their children which is crucial. It becomes legitimate for the women to take time to study when it is not only for themselves but also for the sake of their children. For many women this makes literacy and upgrading programs one of the few acceptable reasons for them to leave the house. The fact that they can see literacy and upgrading as a benefit to their children as well as to themselves makes it seem worthwhile: Even if it does not really lead to a change in their lives, maybe it *will* change their children's lives.

Several of the women, mostly in their twenties or early thirties, felt that they were already too old to start on a literacy program. They felt that by the time they had completed the upgrading, gone on from that to a training, completed that and were ready to get a job, they would be too old. Mary, in her early thirties, worried about being too old, not so much for the time it would take to finish, but simply that it might not be intended for people as old as her:

> I asked [my tutor], "Maybe [I'm too old]." She said, "No." She says, "It's all right for you to take upgrading." She said, "A lot older than you might be taking upgrading too."

Many of the women have transferred their hopes for a better life to their children. Many have ceased to believe that life can really be different for them, education or not. Instead they look to their children to live out the easier life, which will be more comfortable and more meaningful. The longings from their own childhood direct what they feel their children "need." Steedman (1986, 6) described this process:

> My mother's longing shaped my own childhood. From a Lancashire mill town and a working-class twenties childhood she came away wanting: fine clothes, glamour, money; to be what she wasn't. However that longing was produced in her distant childhood what she actually wanted were real things, real entities, things she materially lacked, things that a culture and a social system withheld from her. The story she told was about this wanting, and it remained a resolutely social story.

The women who experienced hard childhoods want their children to have a different sort of childhood from the one they experienced. They want them to have a joyous play-filled childhood and to have many of the special things that were denied them. When some of the women spoke of their own childhoods they spoke of neglect and abuse. Pat, whose mother ignored the serious illness Pat had suffered from since birth, said:

> My childhood was not the happiest — very abused, abused physically by my mother and rejection, total rejection from birth.

The women fear repeating their mothers' mistakes. Jane explained:

> But I think like when you're brought up to be abused you're always afraid that when you have children you're going to do the same thing. And when you don't know nothing about love you think, well, how am I going to teach my children love if I don't have anything to go by.

Like their mothers, many of the women do not have supportive partners to share the work of parenting, or a partner at all, and usually have few resources to make the task easier. Several of the women saw the importance of literacy as to obtain a job and be able to afford to offer more to their children.

Pat said, "I'm living my childhood, I never had a childhood." She wanted to be able to give her daughter opportunities to have fun and be happy. Marion wanted her daughter to have the opportunities of the traditional middle-class girl that Marion herself had not had, like figure skating and learning the piano. Jane wanted her daughter to be able to go to Brownies, to own a bike and skates:

> Seeing her with things like that makes me [feel] as if I had them.

Jane, too, had the desire to make middle-class possessions and activities available to her daughter. Susan particularly wanted not so much for her daughter to be able to have fun, but more to take her to the dentist, to specialists, to an "eye doctor," the things she lacked in her childhood. But she complained that the expense of those things was impossible while she was on welfare.

These women, alone with young children, did not blame the children for ruining their lives. Instead they told me again and again how important the children were. They saw themselves reliving their childhood through their children. The children gave the women a reason to challenge themselves, to look for better work and to take on their education.

The desires many of the women had — to own a house, a car, and a range of material comforts which make life easier — were desires for the sake of the children as well as themselves. Marion described this dream:

> I'd like to get a real nice, good career going that I could go out and make money and then go out and get a loan for a nice little three-bedroom home, with a yard and a swing set and a merry-go-round and a climbing frame, and then

have a nice little car. I'd like to have a career when they finally leave home.

Susan's dream was similar:

> I'm going to get a good job where I can further myself, make the money [so] that I don't have to fall back on ... [my parents], but I can buy a little house and have a little car instead of either walking them in the cold or in the rain.

Betty too wanted a house for the sake of her children:

> That's all I ever think about, owning my own home so that my kids will have a permanent place of residence for as long as they want. I mean I'm not going to see my children leave home at eighteen just because it's a legal age to leave home.... With the grade twelve I see a better job, a better life for my children — that's all I'm worried about now, my children.

Steedman (1986, 43-44) describes how important the dream of owning a house was for her mother:

> There are interpretations now that ask me to see the house ... the one my mother longed for through the years, as the place of undifferentiated and anonymous desire, to see it standing in her dream as the objects of the fairy-tales do — princesses, golden geese, palaces — made desirable in the story simply because someone wants them. But for my mother ... the house was valuable in itself because of what it represented of the social world: a place of safety, wealth and position, a closed door, a final resting place. It was a real dream that dictated the pattern of our days.

For the women in rural Nova Scotia, their dreams of owning a house also seemed to represent security.

The means to these goals for the children are the literacy and upgrading course and then the job that improved education will enable them to obtain. For women with partners, any

job will help out the family budget, but for women alone, a "career" with a salary above minimum wage is essential. As Jill said,

> I know, to own my own house I'll have to have a *good* job.

These dreams are reinforced as possible consequences of upgrading and further education, by program workers in some of the programs. For example, one worker said of her program:

> Maybe you'll be able some year to have a vacation and maybe you could even take your kid and go somewhere for a week. Maybe some day you could ... have a car. Maybe some day you wouldn't have to live in an apartment building like this. Because when you look at all of the things they've got to overcome to get the education or training, there's got to be something good out there to make it worthwhile.

All of the women hoped that their children would not quit school early and experience the same problems in life that they had. They dreamt their children would get good qualifications and have opportunities for careers. Frieda said:

> They're not quitting school, not until they're eighteen years old and they've got a grade twelve certificate or they take a trade.... But they're not coming out of school in grade six or seven and that is that.

Betty similarly didn't want her daughter to quit school early:

> No, I don't want her quitting. No, I'm afraid it wouldn't go over too good if she had quit when I did. I know how hard it's been to find a job and stuff like this myself. So I can imagine just how hard it's going to be when she does turn fourteen for her to find a job.

The women look eagerly for signs that their children are bright and doing well in school. Betty was very proud of the fact that her daughter "could have graded in the second term" (could have gone up to the next grade before the end of the

year). Frieda spoke enthusiastically of one of her daughters who wanted to be a special education teacher. Marion was glad her kids were smart, but as her daughter suffered from continual ill health she felt good health was the real priority. Of her son she said:

> Like I'm glad he's got the smarts so that he can do something with his life, but I don't make a big deal out of it.... I don't worry too much about him — he's healthy anyway.

Several women spoke about hoping that the school would push their children and make them work hard so that they would have the chance to "make something of their lives." Many critiques of the school system indicate that the role played by the schools is one of "training people to take allotted positions in a structure of inequality," which suggests that school may not be as much of a "great equalizer" as the women hope (Fine and Rosenberg 1983, 261).

For many of the women who are single parents, their social isolation means that their daughters become their closest friends. Susan, for example, was alone with her daughter for much of her day. She has few resources to get out of the house and few friends, her mother has rejected her and calls up only to speak to her granddaughter. Susan spoke of her four-year-old daughter as her "best buddy" and wanted to take her out to lunch regularly so that they can chat and have a treat together. Jane got a job but had spent many years alone in the house with her daughter. She spoke enthusiastically of spending time playing with her daughter and says her daughter tells her:

> Mum you're my best friend, Mum you're my Dad.

Because she feels cut off, simply working and bringing up a child alone, her daughter is an important link to the world for her.

The dreams the women have for their children's future may also be tempered by fear that their children will move away from them and enter a different social world if they "succeed."

Thus the dreams of a different life for the children are tinged simultaneously with desire and fear for both mother and daughter. For the daughter, as Walkerdine suggests, speaking of her own childhood, "winning in one place is simultaneously always a loss," as success leads to the pain of belonging neither in the working-class world of your childhood nor the middle-class world of the professional or, for her, academic life. She describes the conflict:

> I felt split, fragmented, cut off from that suburban semi, where I couldn't tell my mother what was happening. Where nobody knew what academic work was.... I felt in the old place, as in the new, that if I opened my mouth it would be to say the wrong thing. Yet I desired so much, so very much, to produce utterances which, if said in one context, would not lead to rejection in the other. (1985, 64)

This conflict and pain may make it harder for a child to fulfil her mother's desires, both that she remain close and that she become "different" and lead the life of her mother's dreams.

Corrigan (1987, 21-22) has described this process of displacing dreams onto children and its effect:

> A whole range of adjunctive activities are oriented to schooling as The Way to Get Ahead. It is all the more dominant in a period when children are increasingly seen as bearers of futures denied to their parents, a form of social projection "destabilized" by the same children.... That is, increasingly refusing a logic in which their acceptance of subordination or giving obedience now, will yield up superordination and encashable knowledge later.... The active contradiction here is between the displacement of their own social selves by parents "into" their children which shatters on ... those same children's own historical experience — their parents as what they do not want to be and schooling as a highly negative experience.

The women themselves experienced school as a place that constructed them as stupid, and they became shy and silenced.

When they became mothers many did not want to be like their own mothers. They dreamt of living a different life, of escape from jobs of drudgery into a career with meaning and a salary which would free them from day-to-day worries about survival. They dreamt of having the money to buy the material goods that would provide their children with a different childhood from their own. Many said they were doing everything for their children and dreamt of their children entering a different life. Many of the children were still small, but the possibility remains that they, too, may in their turn reject their mother and that they, too, will find school a place that silences them and makes them stupid, rather than enabling them to achieve their mothers' dreams.

The promise of the literacy and upgrading program is for the children and for the women themselves. The women feel they benefit in many ways from simply getting out of the house and taking on the challenge of improving their education.

> Frieda: Us women can use it, even if we don't carry it any further than grade twelve ... because our children will benefit.
>
> Sandra: And you will too, and it gets you out of the house once a week and you get your own education.
>
> Frieda: And I'm getting my own education and I can stand up and say I have a grade twelve certificate. You want to see it? There it is.

But above all, education offers the women hope that they can change the situation of their lives, or, failing that, their children's lives.

"It All Comes Back to the Job"

Literacy and upgrading are part of a dream of independence. Women on welfare dreamt of getting employment to escape from being controlled, and struggling to survive on welfare. Women with partners sought their own income and

independence from their husbands. Women sought an improved education to enable them to achieve a job. The women's experience suggests that grade twelve has become an entry-level requirement for any job. Women without grade twelve are often labelled illiterate. But the women also resisted the dominant discourses. They lived the contradiction of believing that their training would prepare them for work, while also acknowledging the lack of jobs in the area and the lack of relevance of training to enable them to do the work.

Most of the women who participated in education programs were eagerly looking for any job. Others sought a better job, one with meaning that paid an adequate salary. Some perceived literacy and upgrading courses as the basic requirement for any job:

> I'm getting so that this GED course seems to be the only way out for a better job. You know — *a* job, period. I don't care if it's a better job, I just want a *job*.

Betty felt certain that all problems came back to the lack of a job. In conversation with Barb, she said the main problem in her life was "Well, money..."

> Barb: For one thing it takes two to work to make a living, to have your own home. We were paying out $450 a month for a bank payment. It took two of us just to pay that.

> Betty: ... and jobs, and living, just ... living is tough. If you don't have a job you don't have the money. If you don't have the money you don't have a place to live. If you don't have a place to live, well...

> Barb: If you don't have a down payment, you don't have a place to live.

> Betty: And if you don't have a job you don't have a down payment. It all comes back to the job.

Betty saw education, money and jobs as interdependent. She

believed that education would make the difference in getting a job — any job — but especially one that paid more than minimum wage. Betty believed that education would lead to a job, even though she knew that there were few jobs for anyone in the area. It was her sole hope of getting off assistance.

Judy was almost scornful when she explained why she was going to upgrading class:

> Do you know how hard it is to get a job?

She knew grade twelve was essential to getting a job. Certainly she knew that without her grade twelve she wasn't getting anywhere. She could only hope that when she succeeded in getting her grade twelve *that* would turn out to be the missing ingredient.

In this Nova Scotia county the level of credentials necessary for employment seems to be rising. Many of the women knew from their own experience that without grade twelve, they would not be hired for a job that they had previously held. Betty said:

> It's changed so much, you know. I've gone out looking for jobs. Before, I went to [the clothing factory], they didn't care, they hired you. But now it's changed so drastically it's unbelievable.

Sharon explained:

> Now, ordinarily to get a job anywhere, you have to have a grade twelve education.... It's the same at the carpet factory — carpet factory, plastics factory, any of those factories. They want a grade twelve before you can get in.

The women were certain from their own experience that without grade twelve their applications would not even be considered:

> They won't even look at you. Unless you've got a grade twelve education, they're not even going to look at you; they're going to look at your application and see "grade ten" and they'll rip it up right in your face.

Over and over again women said that for *any* job you had to have a grade twelve education. But many of the women resisted the discourses that located their problem of lack of a job in their lack of qualifications. They knew that grade twelve was not a guarantee of a job. Betty, who has been unemployed for more than five years and for whom grade twelve was simply a last hope, said:

> I'll have a fighting chance against all these other people who have their grade twelve and college. At least I'll be considered, instead of just sitting down and not even looking at my application. They say, "Well, I'm sorry, we don't need you." They ask me what grade I have, if I'm married or something like this. At least if you've got your grade twelve and you're married you've got a better chance than if you've got your grade eight — I hope.

Upgrading and the possibilities it might hold became the focus for the possibility of change. Betty said that employers either complained that she was married, not pretty enough, had no teeth, or did not have grade twelve. She couldn't do anything about the other problems so she felt she might as well work at her upgrading, but she was sure that, once she had got that, there would be another "reason" why she was not suitable.

Some of the women felt it was hopeless to look for a job without their grade twelve. But, even though they half-believed the account that

> there's probably plenty [of jobs] out there, but you need a grade twelve and qualifications and everything,

they also knew that even with qualifications there were few jobs. Others continued to hunt exhaustively in the hope that they might be lucky and find something. Several of the women said they were taking their upgrading classes so that they could get a job and then commented on the lack of jobs even for those with qualifications:

When you go in to get your education, there's a lot of people who still can't find work or get a job of any kind.

There are people who have gone through college, and they still can't get a job. So what's the difference? I don't understand it.

In particular, many of the women hoped to go on from upgrading to a business course and an office job. But although some of these women had the same qualifications the others desired, they, too, were unable to find work. Alice and Margaret had completed business college courses and had gone back to get computer qualifications when it seemed as if that might lead to a job, but they were still unemployed. Margaret was in her forties, with a family which had mostly left home. She had no shortage of academic education, training or experience. With experience in a variety of areas of clerical work, business training, and a recent course to bring her skills up to date with word processing, she had spent an extended period in a futile job search. These examples of joblessness challenge the view many of the women expressed: that a better education will lead to a better job.

Alice first took a one-year course at business college. After completing her business course she thought that perhaps grade twelve was the missing key to a job, so she took her GED and got her grade twelve. She said:

> The GED makes no difference to me, other than being able to say I have grade twelve.
>
> But what good are they? I still haven't had anyone answer me that. They're as good as the paper they're typed on and you can say "I have grade twelve."

Even with grade twelve, Alice did not get a job. When she was still unable to get employment she did training in word processing. The only jobs she had held were as a cook in a nursing home before she obtained any of her qualifications, and doing secretarial work on a short-term, minimum-wage project.

She was then offered another training program. In spite of all her qualifications, her problem is still presented to her by social workers as a lack of skills. Alice's real problem did not seem to be a lack of literacy skills or other qualifications, but the lack of jobs in the area. Her situation provides a contrast with the many women who were in programs seeking to obtain GEDs and planning to go to business college, thinking that these qualifications were passports to a job. These other women may also not find work at the end of their training.

Sharon's younger sister, about to graduate from high school with her grade twelve and a business course, explained:

> I've got a grade twelve education and I can't get a job, I've been looking for three or four years for the summers, but [I'm looking for] permanent now — secretarial if I could. What's the point in graduating with your clerical and your stenographics and your accounting and not being able to use them? I've written application letters, I've written covering letters and resumes and filled in applications and gone to see them and called them.

> Sharon: She's getting to the point where she'll even work in a store.

> Sharon's sister: And I'm not the only one. There's, well, say a hundred people graduating from [the regional high school] with their business certificates and then there's the people graduating from [business school] and they're out there. OK, let's say there's two hundred of them, they'll be lucky if fifty of them get a job and there's the ones from last year that still aren't going to get a job. What are we all going to do?

For women who have the required qualifications, lack of experience is the rationale for not hiring them. But, as Betty said, "you can't get experience if you don't get hired on." Sharon's sister knew that her job hunt would have to be exhaustive. She had the innovative idea that she could offer to work for nothing to prove herself in lieu of the experience usually demanded, but

she realized that whatever people are willing to do to get a job, only a few of the many graduates had a chance. One of the coordinators said that Manpower no longer funded training at business college because there were four hundred people with business qualifications registered as unemployed. In spite of the dominant discourse that all women have to do to get a job is get their qualifications, many of them know that, for the majority in this Nova Scotia county, unemployment is the bleak reality.

These women longed for careers. They wanted the sort of work that one chooses, work with meaning that pays enough to free them from cares about basic survival. Women who supported children alone dreamt of getting a job where they could earn more. Children were expensive, *and* women wanted more for their children. The children are part of the drudgery and the need to escape from managing on too little money, but are also part of the dreams of a completely different life.

Many women focused their desires on their children, hoping that they, at least, will be able to live a different life. As mothers, many women feel an obligation to be literate in order to be "good" mothers. Women dream that the literacy and upgrading programs will give their children access to a different life, so they desire improved skills.

Although, for many women, education programs are a key social event that permits interaction with a broader circle of women, the promise of literacy and upgrading programs is tied to aspirations. Women dream of "going somewhere" and "being somebody." As Alice said earlier:

> I want to work.... I want to work at something that I can enjoy getting up in the morning where I think I'm accomplishing something, *where I can get paid a reasonable amount to live on.*

CHAPTER THREE

Asking for the Moon and Stars: The Social Context of Women's Desires for Literacy

When Alice, like many other women, spoke of participating in an educational program because of her desires to find an interesting job, to be able to support her children, and to eventually own her own home, she articulated the promise of literacy prominent in dominant discourses. These discourses draw links between education and employment, and between unemployment and lack of education or lack of literacy skills. In the language of the media, employers and job training programs, a person needs grade twelve or a set of specific skills to obtain a job and do it adequately. Through these discourses, the Nova Scotian women came to understand that to get a job they must increase their level of education and their literacy skills. They also critiqued and resisted these dominant discourses in a variety of forms. Alice knew that education would probably not mean that she would get the job and home she dreamed of. She knew she was "asking for the moon and the stars and everything else." She had discovered through her own experience, as had so many other women, that the promise of literacy was tempered by the employment situation in the Maritimes, and the gendered labour market.

Interpretations of the problem of illiteracy frequently focus on an individualization of "the problem." "Illiterates" are described as failing to choose to stay in school and become literate, failing to choose to take on adult education programs and failing to be responsible parents. Even the judgment of who is illiterate becomes a label from outside which places blame on the illiterate and makes "them" seem other, outside the

humanity of the rest of us and responsible for "our" societal problems. The "other" is characterized by deficit and seen as less than human.

Defining Literacy

Many writers have attempted to define literacy or to critique existing definitions. This stress on defining the population of "illiterates," as if it were a clear-cut, either/or question, helps to strengthen the perception of illiterates as "other." According to Levine (1982; 1986), the history of the concept of functional literacy was first used during World War II, as a term to describe a higher level of literacy than signing your name and reading a simple message. From the start the concept has been connected to employment needs, first for the army and later for other occupations.

In Gray's 1956 survey of reading and writing, a first "functional" definition was offered:

> A person is functionally literate when he [sic] has acquired the knowledge and skills in reading and writing which enable him [sic] to engage in all those activities in which literacy is normally assumed in his [sic] culture or group. (24)

This definition is often identified as problematic in developing countries where little literacy is assumed in the culture, but it is similarly problematic when used with different social groupings and regions in industrial nations. The relativism of the definition makes it impossible to compare statistics across cultures. Because of these problems, Gray proposed that literacy should be measured by the number of years of schooling completed. This definition was adopted by UNESCO in 1962. School grade levels have remained in widespread use internationally as a rough measure of literacy and illiteracy.

Currently in Canada, grade eight is used as the standard of functional literacy, and grade twelve is becoming the minimum requirement for most jobs. The research literature provides little

to support the validity of grade levels as a measure of literacy. It is often mentioned that some people are literate who have no grade eight while others are illiterate even though they have more years of schooling. In spite of this, the grade eight measure continues to be used.

The lack of precision of current definitions of functional literacy have led to attempts to provide more detailed and concrete accounts of reading tasks required to function in society, tasks that can be tested. Examples are the Adult Performance Level Test, the Survival Literacy Test and recently the Southam Literacy Test. These tests, like so many others, embed a value judgment of selected skills necessary to function in society within an apparently objective measure. They focus on those "skills" which make people "good" and controllable citizens and consumers, uncritical of society (Caughran and Lindlof 1972; Griffith and Cervero 1977; Rigg and Kazemak 1984). Griffith and Cervero state this strongly:

> The Adult Performance Level (APL) approach exemplifies a philosophy of adjustment to the status quo rather than an active inquiring attitude compatible with the notion of responsible citizenship in a free society. By glossing over the value position which undergirds this approach to curriculum development, its developers have not revealed its essential nature to its potential users and may have misled uncritical ABE [Adult Basic Education] personnel into believing that the approach is entirely objective and value-free. (221)

Rigg and Kazemak also draw attention to the value judgments implicit in the "functions" which are *omitted* by the APL test:

> The Occupational Knowledge goals and tasks listed tell a person how to get and "neatly fill out" a job application form, but nowhere does APL suggest what to do if you're not allowed to fill out a form because you're Black or Brown or female. Nor are there any tasks or suggestions on what to do if your job is unsafe or unhealthy. (5)

Aronowitz reveals these implicit assumptions when he offers a different account of what it means to be "functionally literate":

> The real issue for the "functionally" literate is whether they can decode the messages of media culture, counter official interpretations of social, economic, and political reality; whether they feel capable of critically evaluating events, or, indeed, of intervening in them. (in Freire and Macedo 1987, 12)

Some educators have rejected general definitions of functional literacy and have tried to provide a more contextualized definition of literacy requirements for particular situations, or for certain jobs (e.g., Kirsch and Guthrie 1977). However, De Castell et al. (1981) reveal the conservatism inherent in that approach:

> [It] can be seen to be inadequate for use in Canadian educational research on at least two counts. First its specificity (defining "functional literacy" for an individual exclusively in terms of literacy demands of his [sic] particular occupation) fails to provide for social and occupational mobility. The implicit conservatism of such a definition functions to reproduce existing societal stratifications.... Second, with respect specifically to the responsibilities and obligations of members of a democratic community, participation in the political process implies not only the ability to operate effectively within existing social and economic systems, but also to make rational and informed judgments concerning the desirability of those systems themselves. (15)

Carman St. John Hunter, in a speech to literacy practitioners (Hunter 1987), identified three approaches to defining literacy. The first was functionality, which, like many of the writers considered above, Hunter saw as particularly problematic. She observed that skill levels are not narrowly related to job requirements, but rather that schooling requirements are set by employers in relation to the available pool of labour. As educa-

tion requirements are raised, those with the least schooling, even if they acquire more qualifications, are in the same place relative to others and still cannot get jobs.

The second approach Hunter described as "humanistic." This defines literacy as the necessary foundation for a higher quality of life. For those who espouse this view, there is no objective form of measurement; the person's own judgment is the only authority. She cited her own definition (Harman and Hunter 1979) as an example of this type:

> The possession of skills perceived as necessary by particular persons and groups to fulfill their own self-determined objectives as family and community members, citizens, consumers, job-holders, and members of social, religious, or other associations of their choosing. This includes the ability to obtain information they want and to use that information for their own and others' well-being; the ability to read and write adequately to satisfy the requirements they set for themselves as being important for their own lives; the ability to deal positively with demands made on them by society; and the ability to solve the problems they face in their daily lives. (7-8)

The third approach focuses on the social context and views illiteracy as a reflection of structural and political realities. Those who place importance on the social context of illiteracy do not see literacy as the only social good that people lack. They assert that for illiterates to acquire skills of literacy alone is insufficient to change their lives in any important way. Hunter suggests that as well as suffering material poverty, poor and illiterate people may also lack the cultural information to make sense of what they read. She thus draws attention away from the search for better ways to judge who is "illiterate" and focuses instead on the broad spread of definitions. She argues that significantly different programs will be created depending on which definition is followed.

Exploring the literacy skills of these rural Nova Scotian

women — the reading and writing tasks they could not do or wanted to do better — and their educational needs revealed conflicting ways of understanding literacy. When it became clear how extremely competent the women were at managing with their limited literacy skills or how well they reported that they could read and write, it seemed that perhaps they were not "real illiterates." Yet clearly, to seek the "real illiterate" would confirm a circular definition of illiteracy: Illiterates have trouble functioning; these women do not have trouble functioning, so they cannot be illiterate. The focus of this book is not to decide whether the women were "real illiterates," nor to create the perfect definition of illiteracy, but rather to explore the way a unitary concept of illiteracy is socially constructed. This concept then creates a belief held by professionals, as well as by the women so labelled, that the problems in the women's lives are "caused" by poor literacy skills, leading to the conclusion that education is the change that is needed.

Each woman spoke about her grade level. These varied from grade four to grade ten and included several "not known." Many of the women were unsure about what level to report. Should they give the grade level they had almost spent the full year in, or the one that they had last passed? Should they explain that they had skipped several grades in school and struggled after that? Should they acknowledge that they knew their English or their math was below other subjects? Should they give the grade identified through later tests or the grade achieved in GED exams? Program coordinators suggested that this vagueness was due to embarrassment. But it could equally have been from a sense of trying to describe this slippery concept of grade level accurately, along with a wariness about the messages the grade level they identified might give about their ability to "function" or their intelligence or stupidity. Susan tried to explain:

> I dropped out in grade ten, halfway through my eleven. I got my ten basic but as for my reading and writing, maybe seven.... I don't even know if my grade in English is a ten,

but I know the rest of it. Something like a grade ten makes it sound better than a six or seven.

It soon became clear that even identifying grade level does not produce the clarity the definition suggests.

In Canada, the achievement of less than grade nine is frequently cited as the basis for statistics of functional illiteracy. Although this measure is generally regarded as inadequate, international and national figures on illiteracy are still collected using this definition. The school grade levels of the women did not appear to explain much about their reading abilities. The grade levels frequently conflicted both with their own reports of their skills and the literacy workers' reports based on reading tests.

Sharon's mother, Dorothy, had grade six schooling but spoke of being a "whiz at reading and spelling and stuff like that." She said she was a "reading bug" and top in her classes in everything except math. She reads books for pleasure and said "I can pick up the newspaper and read it just in a flash; it's easy for me." In contrast, her daughter with grade nine and two years of vocational school was tested by literacy workers and judged to have less than grade six. Sharon described herself as having a lot of trouble reading, and although she felt able to write application forms because she had filled in so many, she was unable to read the newspaper or novels.

Sandra had grade nine and reported having no trouble with reading and writing. Jill, with grade nine, also spoke of enjoying reading anything she could get her hands on, especially mysteries. In contrast, Maureen, who also had a grade nine education, said she found reading very hard. She said she used to read the "stories," written accounts of soap operas, but:

> There's a lot of words I have to break down into a syllable to see if I can get the syllables all together to get the word.

Several of the women were unclear about their grade level because they had skipped grades in school. They described these grade changes as mystifying and seemed to have no idea

why they had happened. Josie, according to her report, was taken out of grade four, spent only a few days in grade five, missed six completely and then just scraped through seven, eight and nine. However, she said that when she thought about returning to school after her baby was born she was tested as being at a grade four level. Josie said people are surprised by her poor reading ability, given her grade level:

> They don't understand why I have grade nine and this reading ability. I said, "In my time of going to school, if you did good in everything else you passed ... " and I said, "I was pushed from grade five to seven."

Others said that in their day you were not promoted unless you passed every subject. Maria is a graduate of a school for mildly retarded children. Before attending this school she seems to have jumped from grade four to grade seven. Although she says she passed grade seven, the staff in the adult program she was attending judged her skills to be more limited and placed her in Laubach, the program for learners with less than grade five.

In most of the programs, the workers tested all new participants to judge their literacy "level" and to provide an indication of what material to use to teach them. Some workers regarded this test as diagnostic and were uneasy about the possible demoralizing effect on new participants of undergoing a test when they embarked on a program. One program worker said that doing the test was devastating for many participants and that afterwards "they don't want to see you again." Others spoke of the grade level achieved in tests as quite unproblematic. The examples of Sharon, Josie and Maria all indicate the differences between the school grade levels reached and the grade levels indicated by adult basic education tests.

Even more problematic is the difference between the grade level and the women's own estimate of what they felt able to read and write. Mary, for example, was diagnosed by program workers as almost totally illiterate and was described as being at a grade two level. But she gave the impression that she was

able to read most things she needed to in her life. She described herself as reading the local newspaper regularly and having no trouble doing this. Mary reported that she had no trouble reading the guarantee when she bought a new steam iron and figuring out her rights about replacement, or reading the agreement for the purchase of her new fridge. She assured me that she had read the small print in the purchase agreement. She explained, resorting to her tutor for corroboration:

> Like [my tutor] told you ... my reading's pretty good.

This contrasts with the coordinator's report of her reading level and the tutor's report of her work on the Laubach books. Her tutor implied that working from this elementary course book was not easy for Mary:

> We never do more than one lesson. Sometimes we don't [even] do one lesson, if it's kind of difficult we sort of will stop halfway and leave it till the next day.

In contrast, Mary reported finding the books easy, and that she read them quickly.

Some of the women felt they needed to improve their reading and writing skills to be able to carry out "functional" tasks. Josie had a list of items that she had trouble reading or writing, such as advertisements and grocery lists. But often literacy workers felt the women were unable to carry out functional tasks that the women themselves felt quite competent to do. One training program instructor spoke of Maria as presenting problems in the program because she was unable to shop and to follow recipes. Maria, however, described these tasks as "no problem at all." She said she would like to "go back to school" to complete her schooling rather than for any functional tasks that she thought she would be able to do better:

> It probably would help me a lot more, English and reading and that.

But when asked what it would help with, she couldn't think of anything. Finally she said "anything at all, really."

Literacy workers felt Mary needed to learn to deal with functional tasks such as writing shopping lists, cheques, and letters. In contrast, Mary saw no use for these tasks in her life. There is a gap between what Mary felt she needed to read and write and what other people believed her needs to be. Although Mary tried very hard to think of things she had trouble reading and things she might want to read when she improved her skills, she was unable to think of anything. She did not seem reluctant to be honest about the limits of her skills, nor did she downplay her literacy need because of embarrassment. Mary's response to questions about why she decided to participate in the literacy program did not throw any light on what skills she lacked:

> I don't know ... 'cause like people said, it's been a long time since I'm out of school.

She said there was nothing that she was unable to read that she wanted to read. She could not think of anything she wished she could write better either. Instead, she was participating in the program because she wanted some social contact and felt a lack of meaning in her life.

When "functional" literacy is spoken of, there is usually an implicit assumption that a set of tasks that are functional for all Canadians can be agreed upon. There is rarely reference to the value judgment involved in the selection of tasks included. The assumption that completing all these tasks makes someone "functional" creates a unitary measure of functionality, or failure to function, which is not explanatory when considering people's everyday lives. Barb reported that there were many things she couldn't read. However, she had taken her driving test and read most of it, seeking help only with the "long words." She spoke repeatedly of how easy the Laubach reading books were and said she could read them easily straight through. But she did have difficulty reading forms, and so her sister-in-law helped her with those. Sharon also read with difficulty but, unlike Barb, was able to read and fill in forms. She felt this was because she had seen so many in her long hunt for a job.

Many of the women desired literacy less for easing the functional tasks in their lives, the "everyday" tasks, and more for accomplishing their dreams of a different life or reading about a different life from the everyday. They spoke of wanting to read romances, mysteries and science fiction. They dreamt of careers. Sharon stressed that she could manage to get by with her limited literacy skills but spoke of needing better skills to enhance her life. She described her reading:

> I have a little problem reading; I read really slow, but I get by. I can get by with what I read.

But she longed to be able to read the comics and horoscopes in the newspaper and romances or science fiction stories.

Some of the women did not feel that they had trouble with reading and writing, but their low education was interpreted by professionals as a literacy problem and in turn "illiteracy" was seen as the cause of other problems in their lives. Maxine had a grade nine GED, having left school after grade seven. Although she said she did all the paperwork in the household, filled in forms and did the books, she was seen as illiterate by her counsellor and tutor. This illiteracy was then judged to hamper her participation in a training program and her children's achievement in school.

Because a low education level has meaning in this society, and women know they will be judged as stupid, it can have an effect on their ability to read and write. Pat left school with a grade four and then raised that with a GED pass. She spoke strongly about being able to read anything she wanted:

> I can sit down and read a psychology book and understand it.... It's only because I've kept reading all my life, that I am.

She stated on several occasions that she can read, but when her friend suggested I interview her, she described her as having grade four and a literacy problem. Because she has limited schooling, Pat is haunted by doubts that maybe her reading is not "up to par" or her spelling correct. She fears that her

poor handwriting, caused by a muscle problem, will show her up:

> I am able to read, and I know I'm quite educated, even though I haven't got the paper to say it; but there's times when my writing's not good—I lose my confidence in myself, and I just don't feel that I'm educated, even though the muscular [disease is what stops me writing] ... I still don't have all that much confidence in myself.

Many of the women wanted to make sure it was understood that they *could* read but that their problem was simply with reading the "long words." Betty explained it most clearly:

> I can read pretty good, pat myself on the back, I did learn to read.... It's not that I find anything hard; it's just like some words I come across — it's like "What's this?" You know, one of these great big gigantic words; I just don't know. I try to pronounce it out, things like this, I just can't do it. But like everyday reading and things like this [I can do].

Similarly, Jean mentioned long words as her problem area for reading and contrasted that with being *unable* to read:

> I can read but it's not something I enjoy doing.... If I don't understand a word it throws the whole paragraph off. I can read; like I'm not [illiterate]. You learn how to read when you're in a lot younger grade but it's not that good, particularly long words.

When women gave accounts of the occasions when they could or could not read, they suggested that knowing the context of the material they were reading was very important. This highlights the problem with an absolute definition of reading. It also suggests the relational nature of literacy. Barb drew attention to how much the ability to "read" material is linked to an understanding of the situation. She spoke of getting help for her unemployment insurance claim from her sister-in-law or brother, because "they've been through it,"

whereas her mother, who could read, could not "read" the forms and interpret their demands. Jean said she could not read well and did not enjoy reading, but then clarified that she does enjoy reading "love books."

These women used a narrow definition of illiteracy. They stressed that they were not illiterate as they *could read*, and asserted that the problem was simply excessively long words or their lack of knowledge of the context of the material. In contrast, the trend in the media and professional literature has been to expand the definition of illiteracy through the use of the term "functional literacy" which has become a more inclusive category. The claim is made that people are illiterate if they are not able to read a range of items in everyday life. The women's claim for a narrower understanding of illiteracy shows the value judgment involved when a broader or narrower definition of "illiteracy" is chosen.

It does not seem possible to determine any exact literacy level. Many of the women, although judged by others to have a literacy problem, felt that they were literate. The way others described the women is inconsistent with their own reports of what they could and could not do. There is also the question of what constitutes "reading OK." Although people might judge this differently and professionals may expect a higher "level" of performance, it seems in the final analysis that we must fall back on the person's individual judgment of effective performance. What each interviewee said about the things she could and could not read and her grade level, compared with literacy workers' accounts of grade levels obtained from tests and their judgment of the women's skills, made it impossible to reconcile the different bases from which a judgment of "functional illiteracy" or literacy might be drawn.

Images of the "Other"

In contrast with the women's accounts, the recent attention to the problem of definitions of illiteracy has tended to broaden the definition and to seek a clear-cut unitary measure of il-

literacy. Every attempt to define the illiterate population creates a larger and larger body of "illiterates." It has been estimated recently that there are five million "illiterates" in Canada (Southam Newspaper Group 1987) and twenty-three million in the United States. Cook-Gumperz (1986) cautions that as functional illiteracy is more broadly defined, the numbers of illiterates increase and the negative associations of these illiterate "others" become stronger:

> The new "functional literacy" also contains certain social judgments about abilities specific to advanced technological societies. As literacy becomes ever more precisely yet expansively defined, the notion of illiteracy takes on a new specificity as the absence of all such "functional" skills and so makes the negative association with limited ability even more likely. So that no matter how carefully technical the definition, it is likely to contain implicit evaluative and prescriptive elements. (20)

Few educators seek to describe the situation of those who are labelled illiterate from the "illiterate's" perspective. As Harman and Hunter (1979) observe,

> Most of the material is presented from the point of view of researchers, professional educators, administrators, and policy makers. The perceptions, views and attitudes of clients are notably absent from the bulk of the literature.

Some of the literature that attempts to describe the experience of the illiterate strengthens the picture of the illiterate as "other." Kozol (1980; 1985), for example, attempts to provide a vivid picture of the "illiterate" in American society. But this picture is created from the perspective of the *literate*, describing the horror Kozol imagines of living "outside" society:

> A terror of that moment when, much like an animal surrounded, the man or woman finds himself/herself exposed to general humiliation — this terror often leads

adult illiterates to a complicated series of deceptions, obviations and evasions. (1980, 8)

He goes on to depict, in dramatic fashion, the life of one illiterate young man:

> He did not dare to leave his father's two-room flat for days on end. When he did go out, it would be only to the corner store and back. (He lived, during most of the years I knew him, almost exclusively on precooked frozen foods and soups that came in cans. He memorized the labels, so that he could pick out what he wanted without asking.) His isolation from the daily patterns of the outside world came, after a while, to be virtually complete. Night turned into day for Peter. Stereo music and an average daily diet of twelve hours of television became his sole reliable companions. His mother was dead. His father, nearly illiterate himself, was seldom home. His father's girlfriend was illiterate as well. Four or five friends from grade-school days would come by now and then to say hello. They were, for the most part, illiterate too. Those who could read and write had long since disappeared into that world of hope, employment, aspiration which Peter regarded no longer with longing so much as with alarm. (1980, 10)

The implication of Kozol's account is that the life this young man lives is a result of his illiteracy. Those with literacy skills are assumed to have not only hope, but jobs. Peter is described as living like an animal trapped in his den, isolated from the literate world.

This discourse of the "other" influences the beliefs of literacy program workers, program participants and the public in general. One powerful example of this influence on an educational worker can be seen in her account of the "illiterate":

> Now there's low-functioning people, they can't read a recipe. I sent them to the store to get ham — well, they

Chapter Three • 137

knew ham was a kind of pinkish colour so they came back with meat and onion loaf. It kind of looked like ham — well, it was fine, I could get away with the meat and onion loaf, but depending on what they want, some time you could send them for a pork chop, they'd come back with a T-bone steak. They can't read — sending them to the grocery store, everything is *foreign* to them.

She speaks as if people with limited literacy skills live in a different world from the rest of us and never shop. This expansion of the problem of illiteracy helps to create the image of an outsider, unable to function in this society.

It seems that the issue here is not illiteracy but the particular experience the women have lived. Perhaps they don't know what ham is. Many people in rural Nova Scotia would call all cold cuts "bologny," not because they cannot tell the difference, but because only bologna is available in many areas, and it has become a generic name for cold meat. Or perhaps the women did know the difference, but made a decision that meat and onion loaf and T-bone steak were better. When shopping, the key to identifying the correct item is the experience that tells you approximately what you are looking for. Unless you have this knowledge, literacy skills will not help you to find the item; certainly the confidence to demand help in identifying and finding the item would be helpful. Thus a different life experience or a cultural difference from the instructor is interpreted as the lack of reading skills required to read labels. Illiteracy is considered to create "foreignness." This expansion of the problem of illiteracy helps to create an image of an "outsider," unable to function in this society.

This creation of an "other" has impact on our common interpretations and on those judged illiterate. There is a common assumption that an individual who fails to become literate by adulthood, especially after many years of schooling, must be stupid. Literacy is endowed with a greater moral imperative than most other problems, and many of these women felt this judgment. Women with limited literacy skills were aware that

they were judged incompetent and "other." As a result, some of them tried not to let strangers know how limited their literacy skills were. Several of the women spoke of pretending to read papers when they were in groups:

> You feel so stupid you let on you're reading it.

Because they felt embarrassed to admit their limited reading skills, they avoided situations where they could possibly be asked to read. Although they were aware that others judged them as stupid, they resisted taking on the judgment themselves:

> It makes you feel like a dummy. Reading and writing is an important thing in life. If you don't have it, I feel you're classified as a dummy.

Women were embarrassed when they felt they couldn't spell well or read out loud. Even though those skills were not requirements in their lives, their lack of command of them embarrassed them. They were also concerned in their dealings with professionals if their literacy skills were poor, feeling that they could not speak well and present themselves to educated professionals.

In this society, where it is assumed that literacy is acquired through schooling, those with little schooling are assumed to be "illiterate." Pat felt there was a barrier between her and educated colleagues because of her lack of education:

> You get the feeling, people know that you're uneducated they treat you that way. There's a barrier there: oh, well, she's not educated, she can't ... I may be judged — she's unable to carry on conversations of — maybe what's happening in the world or society, she's too [stupid].

Later she expanded this point:

> I am able to read, and I know I'm quite educated, even though I haven't got the paper to say it.... There's times when I get pretty bogged down and think, "Well, I'm *not*

educated, and I'm *not* this, and I'm *not* that." I still fight that to a certain extent.

Although Pat says "I am able to read," she is still embarrassed and fearful that her literacy skills are not good enough. Her lack of education, even though she feels well educated by her experience of life, leaves her vulnerable to the extent that she feels she is "not" everything she *should* be to function in this society. She lives the sense of otherness of being illiterate.

This discourse of the illiterate as "other" is like the creation of the "foreigner," "Black" person, "disabled" person or "mentally handicapped" person: Each is seen as a unitary characteristic, which separates an "other" from the norm. Through what we are not, the "normal" is known. The illiterate is seen as lacking education, and is considered either stupid or as failing to exercise the will to become literate. Thus the illiterate can be blamed for her or his lack of literacy. This focus of responsibility on the individual to improve her or his literacy obscures the structural inequalities which influence who becomes literate and who does not. The academic literature influences and to some degree is influenced by the media, literacy policy and literacy programming. These discourses form the subjectivity of women who are judged or see themselves as having limited literacy skills: The women come to consider themselves stupid or blameworthy.

In the media, the illiterate is often depicted as suffering from a hidden disease. For example, in 1985 many U.S. papers carried this advertisement for volunteer literacy tutors:

There's an epidemic with 27 million victims. And no visible symptoms. ("There's an epidemic")

In the media, images associating illiteracy with sickness and disease abound, and the invisibility of the disease seems to be of great concern.

Betty, who was participating in a program and searching for a job, explained how the media had influenced her to believe

that education and jobs are linked. She believes that a higher grade will lead to a better job:

> It's more or less what grade you have nowadays. You hear it on the TV all the time: the better the grade the better the job and, oh, it's stuck in my head — I get a better grade I get a better job — one job, it doesn't matter; just as long as I get out to work, things would be a lot easier on [my husband].

Many media accounts link illiteracy and unemployment. *The Toronto Star* editorial headline ("No literacy" 1984) is a good example of this:

> No literacy means no jobs.

The article goes on to say:

> It is no accident that the highest rates of unemployment, for both men and women, in all age groups and all regions of the country, are for people with little schooling. The unemployment rate in February for those with Grade 8 education or less was 14.8 per cent, or considerably higher than the national rate of 12.3 per cent. (A20)

The implication of this article is that those with limited schooling are unemployed because they are unable to work. There are countless media accounts of this sort. The media rarely goes on to look at *why* employers use grade eight, or higher, as a way of excluding job applicants or to question whether this grade level is actually essential for carrying out the work. They do not write about a scenario where all those who are "illiterate" suddenly become literate and assess whether there would actually be jobs for them all. And they do not analyze the varying access to jobs based on such factors as race, ethnicity, gender and age, which may have more impact on job access than "illiteracy."

Frequently the argument for why literacy is needed to gain employment is strengthened with references to "new technology." Much writing about the impact of technology makes it

appear as if it is an inevitable advance. As *The Chronicle-Herald* ("Computer revolution" 1985, 1) describes:

> Computers and other tools of automation are replacing people in a variety of unskilled and semi-skilled jobs.

Such accounts do not mention the people who decide to introduce computers and to lay off workers.

It is often assumed that more complex technology creates jobs that require more advanced skills. *The Globe and Mail* quotes John Cairns:

> You can argue about the statistics, but the fact remains that we're heading towards a society in which an increasing amount of education and skills will be needed merely to participate in the mainstream of life. (Laver 1983, 2)

The situation in the workplace is affected not only by the introduction of new technology, but also by the decisions which are made about how to divide tasks. These decisions also contribute to whether jobs require more or less skill. This connection is not made visible in articles which assume an automatic connection between new technology and higher education demands.

Media accounts often describe "economic costs" of an illiterate work force. Even though they are unclear about the exact cost, they are certain that there is a cost:

> How much is illiteracy costing Canada? Pick a number, any number.
> ... there's the finding of the Southam Literacy Survey that Canada's 4.5 million functional illiterates are twice as likely as literate adults to be long-term unemployed.
> Putting a nationwide cost on illiteracy seems to be the equivalent of calculating the incalculable.
> In the unpublished Secretary of State study, consulting economist Monica Townson calculates the extra income that theoretically might be earned if all three million-plus adults with less than Grade 9 schooling were suddenly

being paid the same average wage as workers with some high school education.

However, Townsn warns that her $7.4 billion estimate of lost income "must be treated with extreme caution," since upgrading education won't automatically produce higher income. (Calamai 1987a)

In spite of the warning that "upgrading education won't *automatically* produce higher income," the implication is that those who are unemployed and illiterate are unemployed *because* they are illiterate, not because there are no jobs.

"Canada's illiteracy bill" is itemized by Calamai (1987a) using data from the Southam Press Literacy Survey, carried out by The Creative Research Group:

- Unnecessary UIC payments
- Inflated consumer prices to cover mistakes
- Extra medical and worker compensation charges
- Tuition fees lost by illiterate students
- Dwindling revenues for publishers
- Subsidies for industry retraining
- Wages lowered by illiteracy
- Jail for frustrated illiterates
- Lost taxes
- Reduced international competitiveness
- Blighted, unhappy lives for millions
GRAND TOTAL: $BILLIONS

The assumptions behind the citing of each of these different items as part of the "cost of illiteracy" are curious, but all depend on a belief that illiterates cannot get work because of their illiteracy, or that if they do have jobs they are less efficient than a more literate worker. But statements such as "Wages lowered by illiteracy" draw attention away from the questions of *who* lowers wages and *why*. The assumption that illiterates on the job are a health and safety hazard ignores realities of workplace hazards and why they exist. Do workers become injured because they can't read the instructions to put down

the safety guard between operations, or because the way the work is set up and the speed at which the line moves make it impractical to put down the guard every time? Assigning the cost to illiteracy diverts attention away from an exploration of these assumptions and the varied causes of each factor and places the blame on the illiterate.

Motivation

It is often assumed that people leave school because of a lack of motivation and must be motivated to return to adult literacy and upgrading programs in order to improve their literacy skills to a functional level. That improved literacy skills are needed in their lives is seen as indisputable. Thus a woman who does not attend a program is seen as inadequately motivated to address the problems in her life. The dominant discourse does not consider a woman's material circumstances, and fails to acknowledge either her own understanding of her problems or her judgment that literacy will make little difference to her life. Fitzgerald, for example, studied working-class people who expressed no desire to attend literacy programs and who asserted that the programs had little to offer them (1984a). She argued that "illiterates" do not have the right to make such a judgment. She is so certain about the "staggering burden of illiteracy" that she advocates that adults should be obliged to become functionally literate:

> The adult who leaves a trail of financial encumbrances does not have the right to remain illiterate in a society in which literacy is available to all citizens. (1984b, 199)

Literacy workers often try to motivate people to "admit they have a problem of illiteracy" and to encourage them to address the problem by attending a literacy program. Recent media accounts (e.g., "Life without literacy" 1987; "Literacy in Canada" 1987) based on the Southam Press survey have

stressed the difficulty of getting people to acknowledge that they have a "problem" and go to a program to remedy it. As a Southam Press representative stated,

> We have a huge motivation problem ... [large numbers of those identified as functionally illiterate] are not willing to concede they need help. (Media image workshop 1987)

Many literacy workers, in a variety of programs, spoke with concern about the material circumstances of women's lives. But they would shift from this concern to language which described the women as not sufficiently "motivated," having a "bad attitude" and as less than "serious" students, which seemed to ignore all the material barriers they had described earlier.

The academic literature on motivation and adult learning looks primarily at psychological factors as barriers to motivation. Some authors who address the question of why "hard-to-reach" adults do not attend programs assess "poverty of life circumstances" as creating more pressing needs than literacy (e.g., Fitzgerald 1984a; Glustrom 1983). This work is unusual in referring to the social context of students, and also in speaking of potential students as autonomous individuals. There is, however, no reference to gender or networks of power and relationship and the impact of these aspects on life experiences.[1]

The silence about the gender of potential students is particularly interesting, as a general impression suggests that fewer women than men attend literacy and upgrading programs, although Canadian literacy statistics — inadequate as they are — suggest that similar numbers of men and women are "functionally illiterate." These theories do not acknowledge power differentials, in particular the authority men may wield to prevent women who live with them from participating in programs, as well as patriarchal power relations which define women's roles as mother and wife. As a result, these theories

1 See K. Patricia Cross (1981) for a survey of the literature on motivation.

are unable to deal with women's participation in programs. Rockhill (1987b), in contrast, explores the chasms between women's desire to attend literacy programs and the language of motivation, focusing on issues of power and the lived experience of women's desire for literacy.

Discourses of "motivation" lead to an assumption that material circumstances should *not* be allowed to affect women's participation in educational programs, and hence to the identification of some students as not really serious.

But attention to the material circumstances of women's lives and the social dis/organization that women live leads to questioning the assumption that participation in adult programs is a matter of "choice" which women make based on their degree of motivation. Rather than women making an active "choice" to start a program and continue until they had met their goals, it seemed that they moved in and out of programs depending on the situation in their lives at the time. In contrast, discourses of "motivation" assume an agent who attends a program through her own individual act of will, and so contribute to the picture of the individuality of the learning endeavour.

The question of dropping out of a program is usually considered from an institutional perspective, rather than the perspective of those who drop out. Drop-outs are seen as insufficiently motivated and as wasting program resources. Attempts are made to identify potential drop-outs in advance, so that program resources are not "wasted" and those "at risk" can be counselled. Most writers on drop-outs do not consider issues of the social context which might make it necessary for participants to drop out. Nor do they consider dropping out as a sign that either the participant has achieved what she or he wanted from the program and is now ready to move on, or is discontented with the program and has decided that the program does not meet her or his needs.

Rockhill (1983) argues that there are risks in "approaching participation as a problem in motivation." She suggests that these include:

reif[ying] motivation at the expense of situational factors that also bear a heavy influence upon the event of participation. The event of participation is looked at as though it were an isolated act in the person's life rather than as an integral part of the person's life situation and social context. (23)

She goes on to argue for "understanding non-participation from the perspective of the non-participant, as well as the broader social dynamics that so influence the formation of that perspective" (27).

Although the public discourse on literacy speaks in terms of "motivation," women have made it clear that this discourse obscures accounts of their lives. We need a different way of understanding how it is that women come to leave school early *and* how they come to take part in literacy programs at any given time in their lives — ways that can take into account the social organization of women's lives. The ideology of "choice," so pervasive in an advanced capitalist society, moves the blame to those who are judged to be illiterate on the basis that they could have "chosen" otherwise. The school drop-outs and "illiterates" of society are blamed for having failed to "choose" to stay in school and work hard, and then for failing to return to school to remedy their past failure. This allocation of blame is one part of the process of creating the "other" in our understanding of society.

Each of the women gave detailed accounts of the complex reality of their lives that was a backdrop to their participation or non-participation, and yet they frequently described their action within the discourse of "choice" and "motivation." Women could give an account of all the constraints in their life and the tasks they had to fulfil, but still describe themselves as failing to "choose" to participate in a program. They described how they had to leave school and then proceeded to blame themselves for being so foolish as to fail to make a good "choice" to stay. Dorothy's reflections on her life revealed the inadequacy of the discourse of "motivation":

> You'd work 8:00 to 4:00 and the next week you'd work 4:00 to 12:00 and the next week you worked 12:00 to 8:00. You switched around from week to week, and it was hard on the nerves. And then they switched us over to twelve-hour shifts, and then you worked from 12:00 at dinner time to 12:00 at night — that's a long day to be working in a place like that when you're working so hard.... It was heavy work, you take a spool of yarn — everybody says a spool of yarn, but those were spools about this big around [demonstrates with arms wide apart] and you had to lift them above your head and put them on the beam.... With the hours that you put in, it was a long strenuous day, and I had kids [at] home to look after. I couldn't go home and go to bed and sleep. You never got your sleep, that was the big thing, you never got your rest. Then when I left there I was sick.

As well as doing this heavy factory shift work she had seven children of her own, and fostered another child. One of her children was paralyzed with polio, and she and her husband carried out a concentrated and time-consuming course of therapy that they devised to get him to walk again. Another child had a brain tumour which resulted in a long stay in hospital many miles away. They had financial difficulties due to the many medical expenses. Through it all, she had to feed and clothe her family and do all the housekeeping tasks usually expected of women. In spite of this lived reality, she was critical of her failure to go into an upgrading program while the children were young:

> I *could've* went back to school and took some kind of an upgrading, I *could've*. I thought about it, but then the children were all small and I never did get around to it, but I usually say you shouldn't use that for an excuse. There could've been somebody to look after them, it's no excuse at all really.
>
> Well, I had three small ones right after the other, they were

just like steps and stairs. I'm sorry now I didn't go to school. I often wish that I could go back, but you can't turn the years back.

Although her own account of her day-to-day reality tells her that she could *not* have gone to school as well as cope with everything else in her life at that time, it seems that her subjectivity is also formed by the discourse that tells her that if she did not attend a literacy program she must not have been motivated enough. When Dorothy refers to the need to find somebody to look after her children if she were to take part in a class, and describes her children as like "steps and stairs," she speaks of the materiality and social organization of her life. In this way she resists the judgment of "lack of motivation" offered by the dominant discourse. But a discourse that takes account of the social organization of her life lacks legitimacy, and this shapes her understanding of herself as failing to "choose" to attend a program and obscures the contradictions which she lives.

Jean also described the exhaustion and monotony of working evenings in a restaurant, coming home at two in the morning to sleep for a little while before her husband went to work, leaving her to care for several pre-school children. She described a life that would not easily have accommodated taking on a literacy program. But she, too, blamed herself:

> I could have had ... [an education]. If I'd really wanted an education it shouldn't have mattered about kids. But I think if I'd really wanted it, I could have done it — no matter [that] I was married.

She also acknowledged that, at present, getting her upgrading will not make a great difference in her life, as she already has a job. She did still feel the need to do her upgrading one day, but as she said:

> An education's not that important to me right now. I know I could get an education if I really wanted it.

She dreamt of an interesting career but realized that upgrading would not really change her life. But within the discourse of "motivation," she can only see herself as failing to take up the opportunities that she should have made for herself. She cannot consider the possibility that literacy would not make a difference in the life she currently lives and that when her children were smaller literacy was *not* a viable option that could have made any real difference to the struggles in her life. She also seemed to be speaking from within the ideology that suggests that everyone can have anything they want if they only work hard enough.

The discourse of "motivation" makes invisible the social organization of women's lives and the contradictions within the ideology that "anyone can achieve anything if they are only motivated enough." Unless women can articulate alternative discourses which expand the ways in which they can see their own participation in literacy programs or lack of it, they are left blaming themselves for their lack of motivation.

The Labour Market

Many of the women who were taking a literacy or upgrading course were doing so in order to earn enough to support their children in the future, but in the interim they continued to endure the "shame" of being on welfare. The women would have appreciated recognition from the social workers that they were trying to get off welfare. They felt they were judged as irresponsible for failing to take care of their children. But, as Linda said,

> I'd just love to be supporting [my daughter] myself.... She doesn't have to make you feel like you're a second-class citizen because you have to ask for help, you know.

But Linda did not like to complain about the problems in getting her provincial benefit, because she also felt that the existence of benefits had given her the opportunity to study to improve her level of education:

> If I can get a chance to better myself and do something I really want to do, I'm going to take the chance. No, I would never have been able to do all these things if the government hadn't been there. So in a way it's really good in that way because they've let me go and get my education. But it's hard, it's hard to take in sometimes.

She captured the bewilderment that several of the women seemed to feel about why they should feel so bad when they were on welfare, when they were doing all they could to become independent. She, like many of the other women, saw herself as working hard and trying to do what was best for her children. She was pursuing an education in an effort to alter her life.

Several of the women spoke in the dominant discourse when they described other welfare recipients as people who just got pregnant to get assistance, lived with men when they were on assistance, and didn't take good care of their children. These women thought *they* were the exceptions because they were pursuing their education and felt they should get credit for this:

> It's not like I'm somebody that wants to live on it and won't do anything for myself and wants to have a good time and spend all the money. I'm just not that way and they knew it because here I was going for my education and wanting to get something and better myself.

As Susan said,

> if they just tried to be a little more understanding and helped the ones that really are trying, and not the ones that are just being a goof.

Only Jill felt she was given credit for pursuing her education and not seen as irresponsibly taking welfare. But the praise she was offered seemed more for her attempt to approximate the worker's version of middle-class values than for her education:

They're speaking highly of me in there ... [my tutor] was telling me the other day, she said my [welfare worker] ... said she just loves coming into your home, it's so nice and clean and you look after the girls so well. And they're all saying you can tell that [Jill] won't be on assistance long, she's trying to better herself.

The women on assistance are pressured to take part in education and training programs by their social workers, and the women themselves see such programs as the only way they can escape from living on welfare. But the interaction with these programs may not enable them to escape from feeling bad. The structural situation that makes it difficult for women who must support their children is not often acknowledged. Women's individual lack of education, or "laziness and irresponsibility," are seen as the cause of women's reliance on welfare; thus the individual is blamed. But when the individual "tries" to get off welfare through improving her education, her effort is often not acknowledged.

Women are blamed for their children's failures, because they are judged to have inadequate literacy skills. This discourse, that literacy is important to be a "good" mother, is "validated" by an "empirical" social science "data" base that demonstrates that the terminal educational achievement/age of the mother is the best predictor of the educational achievements of the child.[2] As Smith has observed (1986, 34), however, none of the studies question the system that declares it "the family that makes the difference" in school achievement. Thus blame for failure is assigned to individuals rather than to structural inequalities.

Women's lives are organized through discourses of mothering in which the idea of taking "responsibility" for children is central. The discourses of mothering establish what "normal" mothers should do. As Oakley (1981) states: "putting the baby

[2] For example, J.W.B. Douglas's longitudinal study (1964).

first is perhaps the primary definition of normal motherhood in modern industrialized society" (84).

Although every woman wanted a better life, above all, for her children, several saw themselves as unusual in this.

> Betty: I want to take care of my children. I don't think I have heard that for I don't know how long, since anyone, any mother, has said "I want this for my kids." It seems strange, like all my generation — the twenty to twenty-five age bracket — none of them say anything like that. It's more "I want this money so that I can go out to drink." And I don't really care for that, I can have an occasional drink...
>
> Barb: At least when we go out there's food in the house first and the bills are paid, and then what you've got left is yours to do with what you want.
>
> Betty: I have seen so many children going without because of the mothers. [They say]: "I — well I'm going to party and I don't care about the kids."

These comments were inconsistent with the accounts the other women gave of their children. They were *all* prepared to give up a great deal for their children and seemed to focus their lives on their desires for their children. The women frequently described staying at home to be with their children all the time, only going out perhaps once a year. It could be argued that these women were exceptional, or that they said what they wanted heard about their commitment to their children. However, the women, although not completely destitute, were often extremely poor, on assistance and living in substandard housing. It is exactly such people who are frequently described as "feckless" and irresponsible. But *all* their accounts showed a strong commitment to their children, which the women could not have easily lied about. The discourses of mothering that demand that mothers be perfect and deny their personal desires perhaps frame Betty and Barb's accounts of other mothers. To

want to have any personal life is to be judged as not caring about one's children, and to be seen as irresponsible.

The state's assumption of the right to intervene to preserve the safety of children reinforces the power of the dominant discourses of mothering. The criticisms of the women fit into a long tradition of the discourse on mothering which stigmatizes working-class women as bad mothers. They have been seen as irresponsible, incompetent and in need of education. Rarely has there been any acknowledgment of how poverty and inadequate resources limit the ways in which they can bring their children up.[3]

Griffith and Smith (1987) have studied mothering as a discourse to examine the way in which mothering "work" is specifically linked with the school process. They highlight the way in which the "complete" middle-class family is seen as the normal family, making mothers in any other situation inadequate. As they explain:

> The discourse of mothering supports a standard family organization: the complete nuclear family. No concessions are made to variations in the practical and material contexts of mothering work or to the realities of a mother's ability to control the school situation in which her child works during the day. Exposure to guilt, invidious comparisons, and anxiety: all are constant hazards for mothers participating in the discourse. The child who does not read on time, who does not behave in ways that fit the classroom order ... who does not fit in well with her peers, who is going through a difficult time for whatever reasons, invites — via the discourse — her mother to scrutinize her own mothering practices for what is wrong....
>
> Discourse, in seeking to standardize parenting practices in relation to children's schooling, articulates to a class structure. Its recommendations do not recognize what mothers

[3] See, for example, the work of Anna Davin (1978) and Jane Lewis (1980).

do as work, hence do not attend to the material and social conditions of that work as modifiers. It enables the standardization of curriculum in ways that ensure the reproduction of class differences in children. The discourse of mothering defines the boundaries of the school's responsibility for the child's education, concealing the parameters of the educational budget and its allocation. The paradigmatic mothering of the discourse matches middle-class, not working-class, resources. (97-98)

This lack of "concessions ... made to variations in the practical and material contexts of mothering work" can be readily seen in the Nova Scotia women. The particular situation of unemployment, poverty and nervous breakdown in Maxine's life are not "noticed," and she is easily blamed for failing to provide adequate help with reading. Her daughters' school problems, however, are far outside her scope; they encompass a process whereby her children have been labelled "retarded" and sent to special schools. Maxine has had no control over that process or the way in which the children are taught in their special school, but she is still blamed for their school failure. Josie's account of the words of her children's teacher illustrates the way in which teachers are skilled in allocating the blame to the parent even though parents' power over the school process is limited. And as Smith concludes in her popular account of her study:

> The real conditions of the work which mothers do, the time and energy they have to pick up where the school leaves off, the lack of supports for their work, such as affordable childcare with flexible hours, is in practice part of the system's procedures for sorting out children in relation to their futures on the labour market. (1986, 34)

Although the connection between education and work is commonly perceived as unproblematic, the social construction of the labour market sets many constraints on what work will be achieved with or without education. The dual labour market

creates a category of exploitable workers, and the gendering of the labour market ghettoizes women in underpaid areas, justifying low wages for women's work and categorizing it as requiring little skill. However, skill levels are determined within a social context and are not an abstract measure. In addition, there are so few jobs in the Maritimes that many workers leave to work in Ontario and return when markets are slack. Thus, women in the region, even those with an education, are unlikely to obtain a job at an adequate wage.

Alden (1982) draws attention to studies which characterize the labour market as a dual system and notes that the demand for higher qualifications creates artificially high barriers between the primary and secondary labour markets. He quotes from a 1977 National Council on Welfare report:

> For example, previous experience may be called for even though any competent person could learn the job in a few days, or a very specialized skill might be demanded although it's not used in the work. Even when the applicant is perfectly capable of doing the job, if he [sic] can't meet the inflated requirements, he [sic] won't get hired. (quoted in Alden 1982, 176)

He then suggests that "the perpetuation of a mass of dependent and exploitable 'surplus' workers" is useful, primarily for employers but also for unionized primary-labour-market workers.

There has been much debate about how to characterize women's position in the labour market and women's concentration in low-paying "women's work." Women have been described as part of a reserve army of labour — called up when more workers are required in the work force and returned to the home when no longer needed. This pattern was evident during the Second World War, when women were encouraged to enter the work force as their patriotic duty and enabled to do so by the provision of such services as childcare. When men returned from the war, women were urged back into the home as their "rightful place," and services were closed down. Push-

ing women back into the home was justified in terms of women's role: Women's right to work had not been granted during wartime; instead women had been asked to sacrifice for the war effort and return to their "natural" work when it was over (Pierson 1986). During this period the discourse that reminded women that their rightful place was in the home became all-pervasive.

When women work, they are encouraged to enter particular work areas where the wages are lower. The lower wages have been made possible as a product of the traditional family form and justified on arguments that women work only to supplement the "family wage" earned by a male breadwinner. Women's rights to equal pay and an "equal right to work" have been challenged, based on arguments that men are responsible for a dependent wife and children and that women, because they are responsible for childcare, are less reliable workers. The issue of the "family wage" is problematic for feminists. It has been fought for by trade unions but conflicts with current demands for equal pay for women (Barrett 1980). For sole-support mothers with no man's "family wage" to depend on, the woman's wage is likely to be far less than adequate.

In the dominant discourses, women are seen, by virtue of their "nature," as best suited for the service or "caring" professions — work that replicates the domestic and childcare work which women have traditionally done in the home.[4] In discourses of mothering and childcare, this work is seen as women's primary responsibility. Work of this form is then seen as natural to women and regarded as requiring little skill and little training.

Women have not had the power to define their work as skilled, or to control access to training, as have many male-dominated trades.[5] Lower pay for women's work has also been

4 Barrett (1980) discusses the gendered labour force, assessing many of the earlier arguments put forward. Armstrong and Armstrong (1977) provide an extensive study of women's work.
5 The work of Jane Gaskell (1981; 1987a and 1987b) and Nancy Jackson (1987) has been particularly valuable in this area.

justified by arguments that women's work requires lower skill levels, proven by the fact that only short training is required. But, as Gaskell (1987b) has observed in relation to clerical work:

> Our notions of what constitutes skilled work are socially constructed through political processes that have been played out in the workplace as well as in educational institutions. Those political processes are constituted by class as well as by gender and need to be brought back into focus in order to get away from the reification of a notion of "skill"....
>
> Clerical skills become part of every woman's skills, along with ability to manage her personal appearance, support the men around her and handle interpersonal relations. The training does not appear scarce, long and arduous but easy, taken for granted (as long as you are female) and thus no skill at all. (141-46)

A similar process can be identified within much of women's work: The skills that are necessary for the work are regarded as skills that women naturally have, and thus not valuable or requiring lengthy training; and women have not had the power to restrict entry to women's professions or raise those professions' status.

Skill hierarchies and skill breakdowns are used to clarify the skill involved in individual jobs. Psychological assessments are used to make these measures appear "objective," as Hollway has shown (1984). But Hollway argues that no such objective measure can exist, because the interdependent nature of jobs means that they cannot be isolated from each other, nor can they be measured independent of the job holder. Hollway illustrates the way "objective measures" are supplemented by people's subjective judgment of fair status, based on existing pay differentials, to arrive at a designation of skill level for each job. In this way, current inequalities in pay and status, based on so-called "skill levels," are usually not only perpetuated, but justified with an overlay of "objectivity."

In the Maritimes, for both men and women, there are few jobs. For women there are few jobs in the primary industries of fishing, forestry and mining. Women were looking for work in restaurants, stores, motels and factories. Most of this work pays no more than minimum wage and is often seasonal.

It is a traditional Maritime pattern for men to move to Ontario and further west in search of work, sometimes with their families, sometimes alone. Veltmeyer (1979) has argued that the underdevelopment of the Atlantic region provides a reserve army of labour for the industrial sector in central Canada. Connelly and MacDonald (1986) summarize the Nova Scotian situation:

> The Nova Scotia economy has a weak manufacturing base oriented towards the export of semi-processed raw materials (fish, pulp, lumber) and characterized by extensive foreign ownership. Major employment sources are service industries, including government, and primary industry, especially fishing, forestry and mining. The province has high unemployment and subemployment and acts as a labour reserve for the rest of Canada. When labour demand is high elsewhere, there is a large out-migration, but to some extent it is a revolving door. (60)

Recently, social workers have suggested that there has been a pattern of people returning home to the Maritimes, as opportunities elsewhere in Canada have closed down and they are unable to find work.

One of the tutors implied that the problem of women's unemployment would be solved if the women were only willing to move, but said "they won't." Such comments from tutors contrast with many of the women's statements that if they could find a secure job they would be prepared to move away. They also ignore the material constraints: Women with partners who work are not free to move. All women may find it difficult to move away from family supports which provide help with childcare or during crises. Women with children and without a partner may be particularly dependent on these family sup-

ports to survive and especially vulnerable in a strange city. For someone on welfare or unemployment benefits, the expense and upheaval of moving would often be prohibitive. Grants to help with moving expenses have generally been paid only after bills are submitted, which would not be practical for anyone with little money. The common suggestion that people should be prepared to move in search of a job also blames unemployment on the unemployed.

From their numerous attempts to seek work, the women knew that employers insisted that education qualifications were necessary to do most work. The connection between having grade twelve and being able to do the job is often presented as self-evident. Employers speak of the demands for certain education levels as based in the skill "needs" of the jobs. Personnel workers in one factory, where many of the women looked for work, spoke clearly of grade twelve being necessary so that a person "can do" the work:

> I guess the ones coming in, the reason we ask for ... [grade twelve], unless they have a really good job record, is that a lot of our jobs require putting things on paper, calculations and doing up small reports in certain areas. And we have found that at least if they have grade twelve, they can do that. Plus too there's always chances of advancement, foreman or forewoman, and if they have a grade twelve they can do that.

Having suggested that grade twelve was seen as essential, personnel workers then said that they did not insist on grade twelve:

> We've also never said when they've come in for an interview you have to have grade twelve education ... and we have hired people that haven't got grade twelve and they've turned out to be very good employees, but it's certainly an important factor.

Although grade twelve was seen as "an important factor," when personnel workers named a particular "illiterate" worker

they said that she did her job well. The "illiterate" worker was able to function because someone else completed her record-keeping. Personnel workers also described others with lower qualifications as "good employees."

The introduction of new technology is often given as the central reason why employees need higher education. Personnel workers in the same factory said that they were currently introducing computers for the record-keeping carried out on the shop floor, and this necessitated high education levels. But the description of the computer record-keeping suggested that it might actually simplify the work:

> We're hoping that certain departments by having certain programs set up, it will make the documentation in that area a lot easier and cut down on errors. The programs that they have are very easy and usually the computer will beep to let you know you've made a mistake. And I think they're even putting in, I'm not sure what you would call it on the computer, but to get them to check twice before the computer will accept it. Like it will give you a prompt saying "Have you checked this?"

The personnel workers also said that the older members of the work force, frequently those with less formal education, were learning the new procedures with no problems. There seemed little evidence that grade twelve was actually necessary for the job — people without it had done well and were mastering the use of the new technology. Even the illiterate worker was not a problem — her records were well kept, even though they were completed by another worker.

Levine, in a 1986 study carried out in Nottingham, England, where he interviewed personnel officers of several local firms and explored their literacy screening policies, found that many jobs were set up in such a way as to need very little literacy. The main need for literacy was to read the information provided on workers' rights and benefits, which was neither legible nor straightforward and clear. He argues that literacy is demanded primarily because schooling is seen as an indicator

of a disciplined work force, where workers will stay in the job for a long time. He also found evidence that the larger, more bureaucratized firms were most likely to exclude illiterates. He speculates that this is because those doing the hiring have less knowledge of the actual job and whether it does or does not require literacy.

The women resisted the notion that grade twelve prepares a person to do a job. They were sure that grade twelve is simply an artificial criteria for the jobs rather than encompassing skills that are necessary in the work. As Betty put it,

> People seem to like to have a person with a grade twelve or college or university or whatever you want to call it. They seem to prefer that to somebody with a grade seven, eight or nine.
>
> ...I don't know, they think you're smarter, they think you can wait on people faster and easier if you've got a [grade twelve].
>
> I don't think it [makes a difference].... I don't know, it seems to make them happy if they get a person with a higher education.

Dorothy described her own experience:

> These days they really stress grade eleven anyway, and there was a job in there that came up, I would've liked to have. It was in the lab, working in the lab with dyes and stuff like that, making dyes up for carpets and stuff. I worked there for a week and I really liked it, but I was only there helping the other woman because she was alone. They were going to hire someone else on for the job but you needed a grade twelve education for it.
>
> ... I could do the job, but they stressed that you needed a grade twelve.
>
> You had to keep records of all the colours that you had used. They dye their yarns. It's not washed or nothing, it's

just wool and you have to wash it and dry it and dye it and everything like that. So we kept records of all the dyes that we used in all the carpets and stuff.

[I could keep records], because I was keeping them, but they just felt like I wasn't qualified. So they hired somebody else on for that job.

Dorothy could see from her own experience of the work that she was capable of doing the work, but she was labelled "unqualified" and so not offered the job on a permanent basis.

Betty was certain that having grade twelve would not make her a better waitress. It might simply mean that she would be able to get a job as one, or even that she would be paid a little more, like her friend:

She got a better job, she was paid something like $6.90 to $7 an hour, so she got a good job, a regular job, a regular everyday job, but for more money because she had the higher grade. She was a waitress, but for more money.

The dominant discourse implies that if you have no job it is because of your inadequate education. As grade twelve becomes more prevalent as the minimum requirement for jobs, those without it are labelled illiterate and are also judged ineligible for training programs. Thus basic education becomes something that must take place outside, or as an extra to, the real matter of training. Women seek to improve their education level and continue to look for jobs, but they resist the discourse. They know there are few jobs even for those with qualifications, and they are sure that qualifications will not make them better workers at "everyday" jobs.

The discourses of literacy suggest that illiteracy leads to isolation and dependence and that improving literacy skills will free "people" from dependence. But for many women the dream is illusory. The organization of women's work in the home and in the public realm makes women dependent on a man's wage or social assistance. Only a few women are able to

obtain work that pays an adequate wage to free them from this dependence.

The discourses of mothering and of women's role in the household lead to the belief that it is "natural" for women to work in traditional ways. Pressure from professionals and the media, suggesting that good literacy skills are essential to being a "good" mother, blames children's failures on women and diverts attention from the material circumstances within which they mother and from the structural inequalities of society.

A woman in rural Nova Scotia requires more than educational goals and a simple effort of will to obtain a job that pays enough to support herself and her family. The skills involved in much of women's work are not acknowledged or paid for, but lack of adequate education and necessary skills for work are often offered as the explanation for refusing to hire people, and thus for unemployment. The media and employers participate in a discourse which tells women that they need education to perform most jobs adequately, and that training programs have been set up to provide the skills needed in the work force. Women hope that participating in these programs will help them escape from minimum-wage jobs into a "career" — work with meaning that pays an adequate salary. They hope to fulfil the promise of literacy, but they also doubt that this promise is real.

CHAPTER FOUR

Training Programs: Caught in the Social Services Net

The Nova Scotian women sought to participate in training and literacy programs to escape dependence and change their lives. They found that, instead, the programs embedded them more firmly into the social service net and the everyday they sought to escape. Educational programs and social services are intertwined, both in the women's lives and institutionally. Social workers frequently directed women to literacy and training programs to improve their literacy level or gain more education, encouraging them to believe that this would enable them to get a job and end their dependence on welfare.

Being dependent on welfare is often an experience of being controlled and shamed. Many women mentioned this as contributing to their desire to improve their literacy skills and get a job. But upgrading, training and job preparation programs are enmeshed with social services in a variety of ways. Most educational and training programs were started at the initiative of social service workers, based on their "diagnosis" of their clients' educational needs. The programs operate within the institutional framework of social services and thereby within social service discourses. Rather than escaping from being controlled and dependent on welfare through participating in these programs, women become more deeply enmeshed in a process that attempts to define for them what it is to be "good."

Fitting Workers to Technology

Social services influence the way in which upgrading and training programs operate. These educational programs appear

to be part of the process by which the working class is controlled through the very institutions which seem to and occasionally *do* offer an entry into a different way of life. As Thompson (1980, 96) says of those in the caring professions:

> Their responsibilities demand that they address themselves to relieving the deprivation, alienation and inequalities which accompany the prevailing economic practice of capitalism, dedicating themselves to the general enhancement of human development and fulfillment.... But ... they leave unquestioned the deep-rooted political and economic structures which make their aims impossible to achieve.
>
> In addition, their naivety and energy serve as excellent methods of social control. Their benevolence and sense of vocation encourage them to work harder than they are paid to do, and their reputation for being "good people" neutralizes the hostility of their "clients" and renders objectionable, subversive, or jaundiced the challenges of their critics.

Thompson goes on to speak of "the limitations built into the notions of 'functional literacy,' 'role education,' 'coping skills' and 'basic education'" and makes it clear that, in spite of the good intentions of the teacher and program organizer, the discourses of basic education create a sense of the literacy student as a limited human being, rather than as someone who has knowledge and exercises autonomy. Thompson suggests that all these terms "serve to reinforce the restricted expectations that teachers frequently have of those labelled "disadvantaged" (106).

The problem does not lie with the individual social service worker or educational program worker, for the work of social control is carried out in the structure and discourse of social work and educational programs. This does not mean that the system is monolithic — individual social workers and program

workers create opposing discourses. Although this resistance may have limited impact, it does create the possibility for change.

The Nova Scotian women took part in a variety of programs, some focused on upgrading and the GED, others on job search skills or job skills. Which program they were directed to depended on what was available at the time. Because of the close connection between one job search program and the town social service office, many of the women on municipal assistance were referred to that program. Similarly, the association between the county office and an upgrading tutoring program meant that women on county assistance were referred there first. One rehabilitation officer, whose job was to get those "with barriers to employment" off welfare, said that because there were few jobs in her area, offering upgrading was the only way she could provide women on welfare with something concrete to do.

Many of the women were involved in government-funded training programs and job preparation programs. These programs, drawing on the discourses which link work and education, claim that women need training in particular skills designated as required for jobs that are currently unfilled. During the 1950s, the idea developed that there was a mismatch between the education levels and skills of the work force and the demands of new technologies (Morton 1985, 3). The development of upgrading and job training programs in Canada has been based on this belief.

The Technical and Vocational Training Act of 1960 aimed to move unemployed workers out of the labour market and into training, thus reducing the rate of unemployment (Alden 1982, 26). In 1967, the Adult Occupation Training Act was passed, establishing the Manpower Training Program, designed to augment "the mobility, training and information of unemployed workers" (Alden 1982, 28). The Basic Training for Skills Development (BTSD) was a part of the Manpower Training Program aimed at providing upgrading prior to job training. In 1972, Basic Job Readiness Training (BJRT) was added to the

Manpower Training Program, to teach basic education skills and motivate clients.

The Parliamentary Task Force on Employment Opportunities in the Eighties (1981), popularly called the Allmand Report, further articulated the discourse on the need for adult training to address the "mismatch between existing skill levels and the new skill requirements of employers" (Morton 1985, 6). The National Training Act of 1982 developed from this report, but ignored its recommendation that basic programs in literacy and pre-training should be continued. Instead, academic upgrading was eliminated from BJRT and the length of the program was reduced. BTSD programs were discontinued for those at lower levels and support was cut back for other levels. In 1986, when this research was carried out, federal funding for BJRT had been discontinued and BTSD had been severely cut back in the region.

The Canadian Job Strategy, introduced in 1985, shifted the focus of government funding to "employment training." Much of the training is carried out on the job, on an individual basis. The program continues the narrowing process of the National Training Act, offering little provision for adult basic education (Breault 1986, 14). The omission of basic education contributes to a discourse about illiteracy, for its practical consequence is that literacy, or basic education, is required as a condition for acceptance into training programs, rather than included as a necessary element of training.

Another result of program specificity and fragmentation is the continuing ghettoization of women in the labour market. As Breault notes with regard to the Entry/Re-entry programs, which are a major initiative for women in the Canadian Job Strategy:

> Traditional clerical training communicates to students their subordinate role in production and reinforces the relations of the workplace: it justifies the division of labour. In this approach, students have no space to question and challenge the devaluation of women's skills, the

lack of opportunities for advancement and unfair working conditions. (1986, 14-15)

The Canadian Job Strategy program has been criticized for privatizing training and thereby funding the short-term needs of businesses by providing job-specific skills training. The program frequently trains women in traditional occupations only (Dance and Witter 1988).

Two of the programs in which the women participated were part of the Canadian Job Strategy. One is a work activity program which serves youth, single-parent women, and offenders. The second is a "Re-entry" program aimed at training women to return to the work force after prolonged periods outside it. The particular focus of the local program is training women as homemakers or home aids — work in the labour force that duplicates their work in the home.

Many of the women were preparing for the General Education Development examination (GED). The GED classes, which are taught extensively in the Maritimes, aim to give academic equivalency to those who have not completed high school. All candidates take the same tests — in social studies, natural science, literature, English and mathematics — and, depending on their score, are assigned a grade level. Four of the programs these women attended offered instruction in the GED, and two programs saw the GED as part of their job-training mandate. The tutoring program focused on the GED. The continuing education program offered GED preparation classes at several locations.

The GED test was originally created in the United States, but for the last few years it has been drawn up in Canada and the standard for the test set in comparison with Canadian graduates. The GED textbooks are still American. One instructor commented:

> Have you ever seen a GED textbook? I never use them; I never give them to anyone. I have one over there on the shelf. That's enough to discourage anyone. I wouldn't want to do that.

Others relied totally on the book to prepare their students. Questions are often raised about how valuable the GED qualification is.

Students in the programs seemed frequently to see the GED as important because they felt it could wipe out their earlier school failure. The sister of one student was puzzled about how the grade levels could be achieved in so short a time, when a full year was needed for each grade level in the regular school system. It led her to doubt what was being done in the regular school year. More frequently, the ordinary person's reaction seems to be to doubt the value of the GED and assume, as one shopkeeper did, that it is simply "mickey mouse."

The distinction between literacy and upgrading is usually assumed to be self-evident. Upon close examination, it becomes less evident. Many of the women were in programs identified as job training or upgrading, but were working with volunteers on Laubach literacy materials. Literacy is usually assumed to be the most basic level, with beginning students seen as literacy learners. In the Maritimes, literacy learners are often defined as those with zero to grade five levels, and upgrading as grade five to grade twelve. With functional illiteracy measured as up to grade eight, a learner in an upgrading program could be defined as functionally illiterate. Moreover, as previously indicated, grade levels are inadequate to delineate a learner's level of reading and writing skill.

Just as grade twelve has become the required credential for a job in Canada, it is also frequently cited as the minimum requirement for job training programs. This has led to suggestions that anyone with less than grade twelve is illiterate. A wide variety of programs that are aimed at people without a high school diploma are often spoken of as dealing with "illiterates."

The common assumption that there is a clear-cut distinction between literacy and upgrading programs may be partially based on a distinction between more informal volunteer literacy programs and adult education classes usually called upgrading. In this distinction, there may be not simply a dif-

ference in level, but a difference between learners with personal goals such as learning to spell or read specific texts and learners "re-doing" school to achieve grade levels. Because of the widespread use of Laubach for all beginning reading instruction in the Maritimes, the distinction between informal and formal instruction does not seem to exist. Instead, the term "literacy" is often used to refer only to the most basic level, which seemed to be seen as "pre-upgrading" or "pre-GED" instruction. The assumption that this material was the only way to teach beginners was so widespread that learners at the beginning level were frequently referred to as "Laubachs."

Laubach Literacy is now a national organization, but for many years Laubach Literacy in Canada was a part of the organization in the United States. Laubach Literacy was founded by Frank Laubach in Syracuse, New York, as a missionary organization to support literacy work worldwide. The organization pioneered the "each one teach one" method, in which every new reader would teach another person to read using a simple primer. The system has gradually evolved into a formal plan for training literacy teachers to use the set of Laubach primers. Tutors are taught to start all learners on the first book and to work through the whole set. Some of the tutors also use other material to stop the learners from finding the Laubach material boring. One instructor said very firmly:

> I agree with the Laubach technique.

Then, in a tone suggesting heresy, she criticized the materials:

> I shouldn't say this too loud, but I don't stick to the Laubach method. It's boring.

In the Maritimes, Laubach is in the unique position of being both a program and an approach to literacy. Workers in all the programs used Laubach to teach those they evaluated as having a literacy level below grade five. The approach is so widely accepted as the only way to teach literacy that all the literacy teachers were trained in the Laubach method by certified Laubach trainers.

Programs aimed at job training and GED tutoring used the Laubach literacy materials. The job training program brought in volunteers to teach beginners. The GED program simply trained its own staff in the Laubach method. The Continuing Education Program offered classes for people with grades five to eight. Below that level, they referred people to the Laubach Council for volunteer tutoring in their homes; above it, to a GED preparation course. One literacy program, set up as a result of a job orientation program, was the only literacy teaching in the area which did not focus on the Laubach Literacy materials. As the coordinator explained:

> It worked very well for some people but didn't work at all for others. So we had to incorporate other things into the programs that would work for different people.

The coordinator of the local literacy council explained the prominent place of Laubach in Maritime literacy as the result of Lutheran Church women looking to the Laubach movement in the United States "about seventeen years ago," to help them address a perceived need in Lunenburg County, Nova Scotia. They then sought help from the Department of Education to cover the costs. The Department appointed regional literacy advisors and has continued to provide the Laubach books used by volunteers and to pay the cost of training throughout the province since that time. As a result, Laubach and literacy have come to be seen as one and the same. The Department of Education provision of Laubach materials has continued to entrench the use of Laubach as *the* way to teach literacy, and its materials as the only reading materials for the task. As a volunteer movement, Laubach allows literacy to be addressed at very little cost to the government.

In some areas, Laubach volunteers are extremely concerned about confidentiality for learners. They described a process in which no one is to know the coordinator's identity; she is simply a phone number, and when people began to suspect who she might be, it was time for the person to give up the work. Potential learners would call a referral number and be

told a tutor would call back within two or three weeks. There is no personal contact beyond this anonymous phone call. The coordinator stresses to the caller that coming forward for help is the most difficult thing they could do. The coordinator felt this secrecy was necessary in a rural area, where learners would not want to feel that everyone knew they had called the program, or that they would be speaking to a neighbour. She did, of course, frequently know the caller, and said that probably some of them would recognize her number or her voice. This insistence on secrecy is reminiscent of Alcoholics Anonymous and perpetuates the idea that illiteracy is shameful. The potential participants are not asked whether they want such secrecy. The emphasis on "admitting you have a problem" assumes that there is general agreement on the level of limited literacy skills that constitute a "problem."

The volunteer Laubach Literacy Council and the Continuing Education program were the only free-standing educational services in the area. All other programs were located within, or in some way connected to, the Canada Employment and Immigration Commission, social services or Children's Aid. Three of the programs operated out of social service offices and, although not funded directly by the social service system, operated in tandem with it and were identified with it by users and participants.

The Social Service Net

Many women had embarked on upgrading courses through the influence of social service agencies. Several of these women believed that if they did not take part in the literacy program they might become ineligible for benefits. They developed this idea through remarks made by social workers to the effect that they should do something about their education "in case" there was no longer assistance. They felt certain that, although the demand was not made explicit, they were supposed to "upgrade" themselves or their welfare would be cut off. Marion said:

They asked me if I wanted to further my education in case they ever stopped [welfare payments] ... and I'd have to get a job.

I'm glad I did take it, but I said [to them] you can't really cut [assistance] off, what would you do with the kids? But they made it sound like that. They should have put it another way, instead of trying to [pressure me].

Betty spoke several times of how this pressure had affected her participation:

Well, we were forced into starting the GED.... If we had've said "No, we don't want to do it," we would have been taken off assistance before we were.

But, she said, this was not made explicit:

My husband was told in a roundabout, beat-the-bush way, like, well, the assistance depends on the GED program. As it was, a month after we started taking the GED they cut us off. It didn't matter one way or the other.

At the point that welfare was cut off anyway, Betty almost decided to quit, even though she did feel the program was valuable, or at least a last hope.

I was going to quit when we were [cut] off the social assistance. So that's when I sat down and really started thinking about my life, where I was going. As it was — I wasn't going anywhere. I'm not going anywhere right now except for trying to study to get my grade twelve, but now I can actually see a light at the end of the tunnel — there is something out there. All I've got to do is work.

She had absorbed the idea that to get a job "all" she had "to do is work" and take upgrading. This makes it appear that the problem is the woman's, to be remedied by her hard work, and not in the organization of society.

Betty was keen to take upgrading, but felt blackmailed by social services into taking part in the program. Jill felt less

humiliated about having to take welfare after she started upgrading. Many of the women did not feel that participating in education gained them more approval from welfare workers. Rather, they felt that their workers disapproved of them whatever they did. All of the women experienced welfare as controlling and oppressive.

Some women did not know what courses were available and so were glad to hear from welfare officials that opportunities existed. When Mary was told about the upgrading and literacy program, she was quite sorry that she had not known about it earlier.

> One day the social worker came out to visit and she asked me if there's anything I'd like to do, and I said "I didn't know there was anything I could do," and then she was telling me about this and some other course. Well, I was telling Dad, and Dad said "Tell her you'll take some upgrading." And that's what I done.... They knew about it, but nobody told me nothing....
> Like I told [my tutor],... I could've started last year.

Some women heard of programs and courses from their friends, but workers in social service agencies are a more common source of this information.

The link between social services and literacy and upgrading programs is problematic because it suggests that women are in need of assistance because of their inadequate education level, and makes invisible the conflicting demands on single mothers: that they be at home full-time with the children and simultaneously at work supporting their family. It also makes invisible the scarcity of jobs in the region and the inflated educational requirements for them. Women are made to feel that if they work hard enough, they will reach the "light at the end of the tunnel." But no amount of schooling will create daycare or jobs.

To be eligible to attend many of the programs, a woman must be referred by her social service worker. The intertwining of program and social service agencies puts the women in a

double bind. They are referred to programs, and believe that their welfare will be cut off if they do not attend. One program worker thought that when welfare workers sent the potential participants to her program,

> It's their way of saying, "Hey, we can't give you welfare any more. Now you have to go out and work. Now you have [to get some] skills and you have to look for work."

But, at the program, women are told they must "make a commitment," not just "come here because you have to." In one program, education workers felt that because the program was free and many of the participants were directed to the program by their social worker or counsellor, commitment was reduced and problems created. In another program, participants are selected from those referred by social workers, based on an assessment of their "barriers to employment," including lack of work skills or not knowing how to find a job. The selection panel apparently tries to identify the "needs" of the potential participant, as one program worker explained:

> They score people ... on needs. If they're on social services [their] ... need is very high to find a job; if they don't have education [their] ... need is very high; motivation level [is important] — even coming in for the interview, this kind of thing [shows motivation].

But it was not clear whose needs were being evaluated — social services' "need" to get a person off their "rolls," or the woman's "need" for a job. Although lack of motivation might be seen as a barrier to employment, it seemed also to be a prerequisite for potential participants in a program. This ambiguity puts the women who participate in the programs in the wrong: they *must* enter the program, but must be committed; they must have motivational "barriers" to employment, but must also be motivated. Referral by social workers to education and training programs establishes a "worker/client" interaction in the program. Like the doctor/patient relationship, it relies on diagnosis and prescription external to the learner.

One program worker explained that her program's close link to social services meant that participants expected the educational program workers to be like social workers:

> They expect when they come in here ... that we're going to set them across from the desk and that we're going to say: "What have you done about this? What have you done about that? And are you going to do this, and if you don't you are not going to get any more assistance."

The participants expect a worker/client relationship, where they will be obliged to perform as directed. This relationship has implications beyond the individual success or failure of the client/worker encounter.

In one program, educational workers try hard to develop a relationship based on equality. They insist on separating themselves from the social work institution, even though their office is located in the social service building. They explained:

> We say very quickly that we are not social services. We are not social workers. We are not social service people. We disassociate ourselves from them.

Program workers felt the need to free their students from the feeling of being "clients" and always in the wrong. The program workers were, themselves, "battling all the time working in this [social services] building" so that the students in their program would feel more comfortable.

One of the program workers said that, no matter what workers tell them, the "clients"

> still expect that someone is going to be really angry with them if they don't perform the way someone has suggested.

The program workers feel that this control is what the women who participate in their program have experienced from the "men in their lives ... the legal system, the social service system, the health system." As one program worker said,

They don't look at the woman and say, "We understand when you are having a really difficult time it's hard to think and make a plan." They say, "You do it and you do it before such and such a date and you know we're giving you *x* number of dollars and you have to be here at this time and there at that time." And if they don't follow through, then they meet such opposition and snarling faces. They expect that when they come here.

These program workers fight hard to achieve a "peer relationship instead of an agency relationship" and to build up "trust" through shared honesty. They, too, had experienced much that their "clients" were going through.

Do you know why it works so well? It's because we've been there. We can almost anticipate anything they are going to say, and it's no big shock, you know, when they tell us things.

While it is apparent that the workers did achieve much of the trust and friendship they sought, it was in spite of the institutional influence on their relationship. Susan said of a program worker:

She doesn't listen to that building. She's got her own beliefs and she's sticking to them.

On another occasion she spoke of how this education worker inspired her:

We talked, and I got off the phone thinking, "Wow, I didn't have it as bad as her. Why am I like this? She made it — I'll make it."

For Susan, the information that the program worker had pulled through her hard times was encouraging. Nonetheless, this information could also have become another way of making the participant feel guilty for being depressed and for not "making it." The equality of a "peer relationship" is difficult to

achieve, and more often than not the "client" relationship is preserved.

This client relationship is "oppressive and controlling" in spite of the worker's intentions to make it otherwise, as Buchbinder (1981) argues:

> The function of social control which is exercised in the production and consumption of social services is expressed in the relationship between worker and client. The flow of available resources, whether financial or emotional, is channelled through an authority relationship — the patient or client abiding by the rules of the game. These relations are oppressive and controlling for the consumer, regardless of the intentions or motivations of the worker.

Even the decision to try to make the relationship less hierarchical is in the hands of the worker. The power differential between worker and client always remains in place. Buchbinder mentions financial and emotional resources, but the same can be said for educational resources.

The location of programs, the contradictory messages, and the link to social services were not the only elements that placed the upgrading and job training programs in the social service model. The language of social work pervades the programs. Even program workers who were careful to separate themselves from their milieu were caught in a language of "clients" and "cases," of "opening and closing files on clients" and writing up referrals. When a friend of one of her "clients" expressed interest in the program, the worker immediately had to ask what benefits the woman was on and who her social worker was, and "write up a referral" which would enable the woman to participate in the program. This language indicates the bureaucratic framework within which social work and these adult upgrading, job preparation and training programs are located. Referrals must be written up, files opened and decisions about clients made and documented.

Several programs held "case consultations" to discuss a

particular "client": what is going on, what help they need, how best to work with them. This social work/medical discourse turns the participant into a patient who is to be prescribed the best medicine, in her own best interest. Several education workers spoke of occasions when they decided at a "case consultation" to "drop a woman off the case load." The "client" is powerless in this bureaucratic process. The workers, in consultation, make judgments about which clients are serious and motivated. They decide who to drop off the case load and who to keep. This contrasts with a consultative relationship in which the participant gives input into educational decisions affecting her life. Program workers use this language of "clients" and "case loads" as part of a professionalization of literacy work which gives it more status: It becomes "serious, not social," and professional judgment is required to establish the appropriately motivated client. Ultimately, this discourse contributes to the way in which the program is structured and how the participants are perceived to interact in the program.

The social service foundation of educational programs frames adult education interactions within a social service type of relationship, affirming the power of the "worker" over the "client." It reinforces the inequality of much adult education discourse and creates a client whose problems need to be cured, rather than a knower who can select the education she requires. The client's "needs" are identified for her. Armstrong (1982) argues that "needs" are usually spoken of as if they have an objective reality, in order to justify particular programs and program curricula. Both social service and education programs claim to meet individual needs, but there is no way to demonstrate that they have done this. The claim to meet needs is ideological and based in competing value judgments.

The "need" for the education or training programs is frequently identified by the social workers. One program had been identified as a "need" at a "client study" meeting. At these meetings, representatives of various social service agencies discuss "problem" clients. This meeting led to the identification of

a particular kind of service that the social workers felt would meet the "needs" of this and other "clients."

This social-work-based interpretation of "need" may be the catalyst that initiates the creation of a valuable program. But because this interpretation is framed in the discourses of social work, it influences the potential participants' understanding of their need and locates the problem in the welfare recipients rather than in the inequalities of society. Keddie (1980, 57-58) states that this formulation of the problem

> avoids any mention of social class and that the concept is contexted, as in initial schooling, within a social pathology which separates the problems presented by individuals from the social and political order which creates these problems. For if the obverse to educational success is educational failure, so the obverse to individual achievement is the individualization of failure.

As Keddie observes, this individualizing is also prevalent in adult education programs generally, and not only in those which are closely intertwined institutionally with social services. Monette (1979, 90) observes that the "needs" which are identified tend to be for the learner to "accommodate or adjust" to the social system, rather than to understand and change the system.

One education program was initiated by a social service administrator in order to meet a "need" which she identified. She became aware that unemployment was high throughout the year and felt this was because employment opportunities in other provinces were declining and people were returning home when their employment benefits had run out. She decided a program was needed to increase the education level of those people enough to learn a skill. She thought the push to hire youth was also a disadvantage to slightly older workers. This analysis of the situation locates an explanation of unemployment in the lack of jobs in Canada and in government programs which give a preference to certain age groups.

Offering an education program is perhaps the only thing

that the social service staff can do to address the unemployment problem, and certainly education may help some unemployed people to get a job. But for some women, training programs in themselves become a form of "job placement." Alice, for example, has been directed to various training programs. She has a wealth of qualifications, but over several years has simply moved among training programs, short-term work projects, and provincial assistance. A focus on the training needs of those on welfare tends also to divert attention from a structural analysis of unemployment, and leads to an assumption that the problem is the educational deficiency of those without jobs, rather than the limited number of job vacancies.

Redefining "Need"

The education and training programs which are set up in connection with social services are not monolithic. Many program workers work within the social services institution to change the program goals and contest the right to define needs. One program was set up based on an identification of the "need" for single mothers to get off welfare. The program workers altered this identified need. Although they still conceived an individualized need, they saw education as crucial to women getting a job that paid sufficiently to support a family and a more advanced education as the key to change for women. The program workers saw the value of participants' sharing their experiences with each other and discovering the commonalities of their problems, in order to preserve their self-esteem.

> Education worker: A lot of people still come feeling they are the only ones in this situation. That amazes me, you know — "I'm the only one that's having these problems and I'm suffering alone."
>
> Program coordinator: I think [talking in a group] takes away a lot of that feeling of almost being ashamed — of being embarrassed — because more often than not there's

one person in the group who spills her guts, and that's great because she'll talk about the time she didn't get any maintenance and she didn't have any money, and that's fine because then someone else can talk about that because they've been keeping it [quiet]. They don't want anyone to know that they've ever been in that embarrassing situation.

The potential of the program is contradictory. It is less individualized than some programs, as it pays attention to participants' need to share accounts of their experience and identify the commonalities. However, it puts the onus for change on the individual effort of will, through which a woman can gain qualifications which will lead to a job.

The workers in this program encouraged participants to treat being on benefits as an education allowance. They encouraged the women not to feel condescended to, but to see assistance as a grant, a temporary stage which is simply a practical means to an end. One worker said:

> Look at it as something positive. Look, you're getting this assistance while you are being trained, your rent is being paid, you're getting your grocery money. Think of it as a plus. It's not nice to be on it ... but think of it as a plus, at least you have this income coming in while you're being retrained. And you know it's going to come in and you're not going to be there forever.

This strategy directs attention to the need for proper long-term support for women participating in education. Although welfare is not a grant and cannot be turned into one purely through an attitude, the approach of seeing assistance as a practical means to an end helps to free women from self-blame and shame.

These program workers create a space where women can dream dreams and pursue goals of a career. The workers in one program encouraged the women to dream of getting an education so that they could get a higher-paying job:

> We will not encourage women to go out and get jobs as waitresses. If they tell us that's exactly what they want to do, that it is their dream job, or we realize that's probably their potential, or they're not interested in spending x number of years gaining more education and training — but generally speaking we will not encourage them to go and work at those jobs. We try to encourage them to upgrade their education through the quickest, best possible means they can, get some training, at least a year of something, [so] that you've got a skill you can market. Preferably a four-year university program, and if you've got potential you go for it because you're not going to be any worse off living on assistance for another four years if you're studying and getting some skills training than if you don't do anything, because you're going to be in the same position four years from now. If you're working in a restaurant you might have a job and you might not, and you're going to be working for minimum wage and you're going to be working nights and weekends, you're not going to have time with your kid.

One program worker explained why they encourage the women to take on more education:

> See, [when] we get someone coming in who wants to go to work, we don't say, "Well, we'll get you the job at K Mart or Tim Horton," because you can't support a family on an income from there. So it's just like putting them back where they were before, because they'd probably have to get ... a bit of a subsidy from family benefits to keep them within their budget.

They encourage the women they deal with to dream and acknowledge why they should wish to escape from the drudgery of heavy, boring work and continual worry about survival:

> One of the first things we ask them is "If you had a choice, no matter how high falutin', how far-flung it might seem

to you, what did you ever think you wanted to be?" Well, when they tell us, "Do you see it as being a possibility? Because if you wanted to be that, this is what you would have to do and how long it would take."

But encouragement to dream is not approved of by those who support the originally identified "need" for women to get off welfare as quickly as possible. The program coordinator described the "need" for the participants in the program to get more education:

> We will not encourage women to go out and take minimum-wage-paying dead-end jobs simply to be able to say "Look, our project has gotten these women into the work force and off assistance." ... If I've got a woman who's got some ability to do one more grade level, or if she's got the potential to go to university, that's where I'm going to encourage her and support her to go.

When she said this to one social service administrator,

> The gentleman stood his full six feet and he said: "But we are not attempting to fill the boardrooms of the nation."

His objection was that the program workers are "trying to have these women reach beyond what they should legitimately expect."

The original understanding of "need" aims to send the participants into the work force as quickly as possible, so they are no longer an expense to the state. In contrast, the program workers encouraged participants to pursue educational goals and create a better life for themselves. Program workers told several "success" stories of women who had embarked on higher education and were training for professional work. Although women from the program valued the sharing and the challenge of the program, several were less certain that education would lead to major changes in their lives. It is unclear how many of them will be able to carry out their plans for education and major change. Nevertheless, the dreams encourage women

in the program and allow them to resist the definition that their "need" is for any job which consists of hard, soul-destroying work for minimum wage. Encouragement to dream leads some women to embark on a long process of education. For some, this is exciting and challenging, but others are unable to take on so much, and subsequently feel at fault for their continued unemployment. The dream may simply entice the program participants, encouraging them to believe that one day a better education will open the door to a different life. And it may be that such dreams simply lead women to continue to accept the status quo now while hoping for change one day. On the other hand, dreams can also be the basis for women gaining the strength and courage to work for the sort of changes that *will* make a different life possible. Even the encouragement to dream may provide, in itself, a temporary escape from struggling with the everyday.

An English magistrate, writing in 1806, saw a "need" for basic literacy for the working class, but saw education that created dreams of change in the social structure as subversive. The male social services administrator's criticism of the training program for wanting to "fill the boardrooms of the nation" could be an echo of the magistrate's words:

> It is not, however, proposed by this institution, that the children of the poor should be educated in a manner to elevate their minds above the rank they are destined to fill in society, or that an expense should be incurred beyond the lowest rate ever paid for instruction. Utopian schemes for an extensive diffusion of knowledge would be injurious and absurd. (quoted in Donald 1983, 39)

The encouragement to dream, in the program for single mothers, may also seem to be utopian, but perhaps it, too, could be "injurious" to the status quo.

One program coordinator tried to change her program's definition of needs by taking issue with the assumption — held by many who teach the Laubach materials — that all those with limited education "need" to change their lives. She pointed out

how patronizing this assumption is by describing how those who feel they have the right to change the lives of "illiterates" would not expect to be pressured to change their own lives in the same way:

> What changes are *they* [the participants] looking for? You see, I don't think you have any right to assume you can come in here and change my life. Maybe you think it's a dull boring way to live and I should do something about it, and you're certainly within your prerogative to suggest things that I might like, but not the things that I *must* do, and that is what we tend to think.

She also drew attention to the lack of job vacancies in the area and suggested that it is dangerous to tell women that all they need do to prepare for jobs is to learn more.

Because she didn't think that increasing their skills would help participants find a job, and because she believed that people should not be told that they "need" to change their lives, this program worker identified a different "need." She suggested that literacy is needed to enhance the quality of life. But as she talked about enhancing the life "you like," she seemed to suggest that people should be satisfied with a merely enhanced status quo:

> I think we have to go in and say literacy enriches this lifestyle, literacy will help you with better parenting, literacy will show you how to make that welfare cheque or your husband's minimum wage go farther, through literacy we can show you how to build a garden and do it in a fun way so that you can do it with herbs and seeds and cook with these things. In other words, we'll enrich the style of life that you like.

There is, in this formulation, the danger of concluding that "illiterates" cannot parent adequately, manage their money, or take care of a garden. It can also lead to women being offered a program that will teach them to do the "everyday" better, when they are seeking to pursue dreams of a different life.

Nonetheless, this position offers an alternative to the assumption that "illiterate" people *should* change their lives, by suggesting that they may not *want* to change their lives.

Even when participants attend a program it does not show that their needs have been correctly identified; it may simply mean that their options were limited. The identification of needs, by social workers and education workers alike, generally locates the problem in the individual. The individual is seen as needing an education, and she must change to remedy the problem. As Keddie explains:

> The issue is not whether individuals have needs nor whether they should be met but how those needs are socially and politically constituted and understood, how they are articulated and whose voice is heard. (1980, 63)

Women seek education to get a job and to fulfil their desire for a different life. Women who are unemployed are directed to literacy, upgrading, job preparation and training programs. The aim of many of these programs is to get them off welfare. The training offered by the programs is often gendered and locates the women's problem of unemployment in their "bad attitudes."

Some of these programs provide individual tutoring at home. Others bring groups of women together. Some programs encourage women to discuss their experiences and recognize their shared reality. But they do not appear to lead to challenge of the dominant discourses or to assist the women to realize that even with more education it may be impossible to get a job, let alone earn good money. Alice could not find work even though she had skills. She was so desperate that she began to think about working in a factory or shop even though she had business and computer skills. But the other women continued to work at their upgrading, and planned to get a business qualification, dreaming of the office job they would get when they finished.

Too "Illiterate" to Learn?

A key focus of the upgrading course, which prepares women for the GED exam, is English grammar. Women who were participants in upgrading programs frequently complained about how useless they saw this work to be. Yet they were often told that learning "correct" grammar was important because speaking "correctly" would help in their job search. Women resisted this implication that their failure to find work was due to their inability to speak correctly. Marion said:

> The teacher said, "It will help you talk." And I said, "I'm going to talk the way I do all the time." They said, "If you go into an interview you're going to know what word to say that would fit." I go, "Look, [that's ridiculous]."

As Corrigan (1987, 30) states, the teaching of "proper" language is significant, for "learning a language is learning social relations; learning esteemed, approved and proper expressive forms; understanding obedience, respect, acceptability." The GED is a prerequisite for jobs, but having it does not mean that a woman will be able to get work or a career that will change her life situation.

One employment counsellor, who specializes in advising women on the training they need to prepare for work, spoke about "choice" and "careers." In a workshop for women who wanted to return to the work force, she used such phrases as "choosing something interesting," "choosing an occupation," "doing work that you like to do." When speaking about the careers they might "choose," she frequently used the throwaway phrase "all things being equal." As she spoke, it became clear that all things were not equal and that she was focusing more on "choosing" — "a job that's going to be in demand in [the area]." Gradually, her emphasis shifted from the dreaming of choices and possibilities to the harsh limitations of a job search. She spoke of the "little tricks" to make a good first impression and the need to go back over and over again to ask for a job, because perhaps that way you could

convince an employer that you were "motivated." She was practical enough to deal with the real lack of jobs in the area, but her workshop did not simply say "the only jobs are ... so this is what you must do." It is also clear that the talk about "choice" disguises the reality that for most people there is no "choice," there is simply one minimum-wage job or another. It reinforces the belief that, if you can only make the "right" choice, there is a whole different world out there to be enjoyed.

During the workshop, the employment counsellor also encouraged the women to identify the skills they had already acquired from work in the home and as volunteers. This opportunity to value themselves as skilled and acknowledge their work in the home seemed positive. As Morton says, "for one to question and examine power relations, one needs to have a sense of personal value and power." But the recognition of skills needs to be augmented by a recognition that these skills are devalued in the labour market. As Morton suggests, women could benefit from exploring the

> context of the social relations and power structures that benefit from the individual who does not value or recognize her contributions.... She is learning techniques of extracting from her experience, knowledge and talents which she can sell herself to others (that is, employers). Using such techniques without an understanding of the political economic processes leaves only herself to blame when she does not overcome her low self-confidence or when she fails to convince herself or others she is valuable.(1985, 171)

One job preparation program combined upgrading, job skills and "life skills." The program itself taught the skills of a "good worker," such as punctuality, proper dress and attitudes, through the rules and structure of the program. The program was organized to get the participants to acknowledge that they have "barriers" to employment: they must learn "appropriate" behaviour, appearance and communication. One counsellor said that many of the students need to learn "anger manage-

ment." This meant learning to conceal anger and control their responses. Morton identifies this same tendency in the BJRT programs and suggests that taking away a person's anger takes away her power. Although controlling anger may sometimes be a strategic response to cope with an immediate situation, unless "the object of the original anger is kept clearly in focus, it is likely that the woman will come to be blamed for having reacted inappropriately" (1985, 177).

One counsellor's description of a woman she felt was doing well in the program showed how her analysis linked success to an acceptance of gender roles. When the student was learning how to care for her face, do her make-up and her hair, and dress appropriately, the counsellor thought the student "felt better about herself." She was given positive reinforcement in the form of regular pay raises based on attendance, punctuality, effort and attitude. Another learner was criticized for her "bad attitude," because she was "defensive, angry and took offence." She was described as being overweight, with poor personal hygiene and dreadful make-up. Although the counsellor said the woman had no money because she was forced to give her earnings to her abusive husband, she seemed to feel that the woman's attitude, rather than her material circumstance, was the key problem. The counsellor's attitude was framed by the social work discourse. She did not see the woman's abusive husband or the abuse as the central problem; instead, she located the problem in the woman's attitude and poor communication skills. As the counsellor explained, "part of the problem was in her own head": She made the husband into a "monster" when "in fact" he took her out to dinner and bought her flowers. Concern with appearance and attitude may seem appropriate to the program workers, because such things can make a difference to whether the trainees have a chance of obtaining a job. But stress on attitude takes attention away from the circumstances of the women's lives and the realities of the labour market.

Morton has shown that focus on attitude is a way of personalizing the women's problems rather than addressing

structural inequalities. Many program workers appeared to feel the tension between their acknowledgment of material circumstances — women's home lives and unemployment in the region — and an explanation of the women's problems as grounded in their attitudes. Emphasis on traditional femininity forces women to accommodate to traditional gender roles to succeed. Some of the women said they did feel better because of the programs. They enjoyed improving their make-up and their dress. The program gave them permission to focus energy on themselves instead of on their families — but, most important, it gave them the opportunity to get out of the house.

But some women do not get out of the house, for the "needs" of basic literacy students are often identified as ones that cannot be met in upgrading and basic training programs. Instead, they are offered tutoring in literacy by a volunteer, often in the student's own home. The Basic Job Readiness Training Program excludes participants who do not reach a grade six reading level on a test. One of the training programs was considering excluding participants with less than a grade eight, and another was considering testing potential participants and setting a minimum standard for entry to the program. Frequently, students who need to work on basic literacy are accepted into a program and then judged as having needs which cannot be met within the program. Volunteers are brought in to work with them using the Laubach Literacy materials. Thus literacy learners' needs are judged as too basic to be included within the institution. Instead, these needs are to be met by volunteers. This process of exclusion conveys a strong message of failure to the participants. One of the instructors explained the problem:

> For some of these, this place is their last hope and if we start saying that [they can't be in the program], they're going to say, "Oh boy, am I in trouble, because there's nowhere else to go." Some of them really need that training, some of them really need a job, once they have a job even [as] a dishwasher then if they want to continue their

academics they can go to upgrading class ... or have a tutor or something, but the number one need when you're an adult is to get out there and earn yourself a living.

This instructor was caught in a contradiction, knowing the message conveyed by exclusion and aware of how little money the program had to run on. She believed that her program ought to pay tutors to focus on basic literacy, but she also accepted the "shortage" of money and the assessment of priorities which sees basic literacy as an appropriate topic to be taught by volunteers. Omitting basic literacy from the institutions of basic training and upgrading and placing it in a realm where volunteers are judged appropriate to handle it is a powerful way of stating that this education is not a basic right but a gift of charity.

Separating literacy tuition from training programs defines literacy as a subject to be dealt with *before* the real task of education and training can take place. It is a secret, shameful and private matter, addressed in the learner's own home, alone with a volunteer who does not expose the learner's inadequacy to public view. This privacy may be chosen because of consideration for the learner, but it also separates literacy teaching from real education and puts it into the realm of social work where individual, shameful needs are addressed.

Volunteers provide teaching at no cost. They can also be an important element of a program, carrying out innovative teaching methods while learning about the issue of illiteracy themselves, thus freeing the student from perceiving the teacher as all-knowing. But one underlying reason for providing inexpensive basic literacy education is to ensure that the illiterate is really "serious" before she embarks on "real" and costly training. One justification for this free programming is that those who have already been to school and failed to benefit there should not, at a cost to the state, be given the same education again. Instead, they are offered catch-up teaching as a favour from a volunteer.

Two of the programs operated on temporary short-term

grants, and much energy was expended at regular intervals — usually every six months — to write proposals seeking new project funds. One program aimed directly at literacy had already ceased to exist. It had failed to get its latest proposal accepted and was seeking further funds to start up again. The other program has subsequently failed to receive funding and has had to continue on a volunteer basis.

Volunteers have traditionally been the core of literacy work in Canada. Even where there are some paid staff, the part-time hours paid do not usually meet the actual hours worked in the program. One program operated as if the "staff" were paid employees, but the grant they were operating on was the Volunteer Initiative Program, which paid a supplement to Unemployment Insurance for those who were receiving benefits.

The rationale for excluding literacy learning from training programs is reflected in one instructor's opinion that low-education-level participants would be unable to benefit from her program and would therefore be unemployable. She argued for excluding people until they had studied Laubach:

> My personal opinion is that nobody should be in here that's a Laubach student. I can't think anything less of them. I've got four Laubach people right now but I just don't think there's that many jobs for them, I think they need to be through their Laubach. If our program was, say, two years in length, they'd be no problem, but we only have six months.

The program worker is identifying here the importance of the length of a program and the impossibility of achieving everything in the limited time allotted. But a key question is whether it is possible to teach skills to someone with limited literacy which will make her or him employable, or whether literacy must always be learnt before other skills, and before employment can be obtained.

In one program, the criteria for acceptance of women into the program were their "need" to obtain a job and the evidence of their inability to do so based on their lack of skills. Two

women in the program had limited literacy skills. The coordinator praised how well they coped with the classroom work, each with the help of a "buddy" who provided support, and praised particularly their achievements on the job placements. But she was still uneasy that these women were not gaining what they should from the course. In consequence, she was recommending that, in future, women should not be accepted in the course with less than a grade eight.

> People who have a low education level should do some upgrading before they enter the program because their chances of getting the most out of it will be better if they have the education level. I'm not trying to be mean and I'm not trying to exclude those who have a low education level, because I want them.... I would just like them to do some upgrading and that's available to them in the community for free.

But the program she referred to provides "volunteer" tutors, usually once or twice a week, which may not be often enough for a woman to improve her skills very rapidly. She suggested that someone with limited skills might not be employable at the end of the course. Although she stated that someone with a limited education would not benefit from the program, she also felt that those actually in the course with limited literacy skills will definitely be employable. She even spoke about the particularly powerful effect of the program on one of the learners she classed as having a low education level:

> She was from a very secluded world, she hadn't been out very much, I don't know whether I should say naive, she never went out and lived her life until she actually started making money and being in this program. She started to buy herself clothes and there were so many changes, so many positive changes, and I can tell she's much, much happier.
> ... I would say we probably took her from, not being not employable, but having difficulty on employment. But

> now when you look at [her], someone who would take her in and interview her would get a much better impression because of her self-confidence. You can see the improvements in her. I wish I had a film strip of [her] when she first started. I'm telling you, some good changes.

There is a gap between the assumption that literacy must be a first step, a prerequisite to the training and education which is necessary before a person can be employable, and the actual experience of the trainer in the program. She is caught in a contradiction, believing that those with limited education have made great gains in the program, but also that those with limited skills will be unable to benefit from such a program until they improve their literacy skills.

The director of this training program was adamant that it was necessary to exclude illiterates from the program. He had an elaborate plan for teaching literacy through the Laubach approach, using unemployed teachers as "volunteers" who would be obliged to "volunteer" and paid the equivalent of the unemployment benefit. Except for the scale he envisaged, this was similar to one program in the area in which unemployed teachers were paid a supplement to their unemployment benefit to teach literacy. As with most existing literacy programs, his proposal saw basic education for adult illiterates as something to be accomplished at minimal cost. The exploitation of unemployed teachers through enforced volunteer work was perhaps more explicit than many such schemes. But he, too, judged that literacy education must be carried out by volunteers or surplus teachers at no real cost to the state.

Program rules which exclude people with less than a certain grade level contribute to a process whereby literacy is not seen as a part of education. Literacy "education" is moved into the realm of a charitable enterprise where altruism (or, as one advertisement for tutors described it, "a degree of caring") is the only requirement to be a teacher. Social work, not education, is emphasized as the model.

But Are They "Serious" Students?

The construction of women as shy and stupid, identified earlier, means that they have not been permitted to build self-confidence or to demand space for their needs. They may need more encouragement than men to increase their confidence so that they can participate in programs. Their earlier experiences of school, their male partners and the media have often combined to construct the women as "stupid" because of their limited literacy skills. As Judy's niece said,

> I'm just another dumb housewife, don't know nothing.

A tutor described one couple: The man quit because he thought he was too clever, but the woman quit because she thought she was too stupid. Maria, too, had little confidence. After her mother died, she had spent her childhood in a series of foster homes. She spoke of the foster fathers being mostly "strict disciplinarians"; one, she said, "used to take every stitch of clothes off me and beat me." She left school in grade seven when she became pregnant. The violence and control of her childhood experiences seemed to have been replaced with a similar violence from her husband, whom she married when she was pregnant. She had recently left her husband after six years of marriage and after they had given up their daughter for adoption. She said that her husband was easily able to undermine her confidence in herself:

> I think if I stayed away from him ... I might feel a little better about myself.... He puts me down.

The lack of confidence that many women experience makes encouragement particularly important to enable women to take on the challenge of an educational program. Women frequently described how important it was to have friends and relatives go to a program with them, or take tutoring at home with them. One of the women participated in the program when her brothers and sister-in-law were taking the class. When asked whether she needed the upgrading for her job, she said:

> No, I just wanted it because everybody else was, so I figured I might as well try it. It didn't cost anything.

Her comments initially gave the impression that, as long as she could get someone to help her, her limited literacy skills were not a problem to her, but she said this was not the case:

> No, I get so fed up, disgusted, I get right mad at myself, not knowing some words. Nobody's around and I can't read it, it don't sound right if you have to read a sentence and stick a word in and go on to the next one — it don't sound right. Probably that word is the main part of the story or something.

Even though it is a problem to her, she still says that she doesn't think she would have taken the class if the others had not done it too.

> Going in for a course or something — I like to have somebody with me. I don't know why, it's just the way I am.

Literacy workers interpreted Barb's participation in the course as half-hearted and saw her as not "really" motivated. But Barb, like other women, was very committed to participating in a program, although she could only imagine going to a class along with a close friend or family member. One group of learners had formed because one woman became interested in having a tutor come to her house. As she described it, immediately "all the rest of them down the road wanted to do it." Her sisters and sisters-in-law live on the same road. Because the tutors operate within the discourses of "motivation" for the serious work of education and of education as an individual rather than collective process, they do not see how important it is to the women that a friend or neighbour participate in the program.

Family and friends often encouraged the women to keep going on the course, even when it seemed too difficult or the women felt they were too stupid. Usually sisters-in-law, nieces,

aunts or women friends played this role, rarely husbands or other men. Jean, however, felt that without her husband's encouragement and support she would not have undertaken the course she completed.

> No, I thought, I'm happy where I am.... I was scared I might get into something [where I wouldn't feel comfortable].

Though Josie saw herself as a strong woman — not a "quitter" — her husband's support was crucial as well:

> He explains everything out so clearly, so that you can really understand. He helped hold everything together for me, everything that I've done so far.

She described him encouraging her to do what *she* wants:

> He more or less helps me, he doesn't force me to do it, he just helps me get through it a little easier.

Betty and Barb were cynical about men's support for their wives. Betty felt her husband had been supportive of her continued participation in the program after the others dropped out, but only because

> He knows what I'm like. If I want something I go after it, whether someone's behind me or not.... When he did realize that I really wanted to study and get through this he was right behind me — one hundred percent. I was behind *him* one hundred percent, of course. The woman is always supposed to be behind the man.

The two women went on to show their sense of the primarily sexual nature of their interactions with their men by playing on the meaning of "support." In chorus, amidst much laughter, they said:

> The only thing men support women in is the bedroom.

This contrasted with the warmth of the way they described their friendship and the kind of support they could count on

from each other. Support involved providing practical help with childcare, assistance with schoolwork, encouragement and humour. Susan described how her friend Marion helped her:

> She's been my support, she's been my "lean on," and she can read and write. She don't mind if I phone her and say I'm having problems. I spell out the words and she'll say them back, she laughs with me about it, because we sort of make a joke out of it. She helps me.

Another friend was also supportive:

> She came up last night and she phoned and did spellings. My sentences weren't like what they should have been, they were quite the opposite. I felt right stupid, and she said don't feel like that, so you're bad in English, [Marion's] bad in math, so that way, it's really good [we can all help each other].

Support to encourage the woman not to feel "stupid" was important for many of the women.

The support women receive is usually gendered and familial. Mostly, it is women friends and relatives who tell each other about programs, go together to classes and support each other during the often painful process of returning to school and participating in training programs. They help each other with childcare and with homework and encourage each other not to give up and not to see themselves as stupid. They also make the work "fun," they can "have a laugh" together. In that way, participating in a program can be both social and educational, rendering it more than an individual, isolating event.

But a woman who has started a literacy program because a friend is going or because a neighbour has brought a tutor out to her house is often seen by literacy workers as not motivated. She is thought to be there solely for a social event, to have a good time, not to learn. This judgment can easily be reinforced. If the friend drops out, the other woman may not feel able to continue alone. She feels too shy; she no longer has

transportation; she no longer has the support to do the homework or to brave her husband's opposition. If she drops out also, she is likely to be seen as never having been really motivated, as only having gone to class because her friend did.

If Marion, for instance, doesn't go on with her education because she stops being friends with Susan, or Susan moves away, Marion will be judged never to have been serious about going back to school or to have been simply dependent on Susan. This may be true, but it may also be that without the many ways in which her friend provides support she is unable to cope with school. This need to go with a friend is an *interdependence*, in which the two women provide each other with the support and company which makes education a social act, and learning a process to be carried out collectively.

Literacy workers described women in self-selected groups, like Frieda, Maureen, and Sandra, as not "serious" students, not really there to learn. In contrast with the women's reports of the value of the supportive relationships developed in groups, the common assumption was that these groups of women were not "serious" students. As one tutor said:

> I guess as I taught them I realized the only reason they had me here was so they could bake cookies and have tea and a social group. And one group, they never ever wrote their GEDs, they came about three times and they wouldn't write them. And we kept going out and going out and they just didn't write, so we dropped them off our case load because we came to the conclusion that they were there just basically [doing it] so that I'd come out and a couple of neighbours would come over and they'd have tea and cookies and they'd learn, but...

This judgment was contradicted by the incredible eagerness with which the participants described their enthusiasm to get their grade twelve. Of course, if Sandra did quit and the tutor ceased to come out, the others would quit, confirming the picture that they were not serious, when perhaps the social organization of their lives made it impossible for them to

participate in a class anywhere except on their own street. Maureen described her eagerness to complete the program:

> I said, "I dropped out once — I don't care if it takes me ten years, I'm having a grade twelve diploma and I'm not quitting this time. I'm going to work.... I'm going to work at it until I get the diploma."

When a woman's decision to start or drop out of a program seems not to have been made as an autonomous individual "choice," she tends to be judged by literacy workers, and even to judge herself, as not "serious." Earlier, Betty described how eager she was to take part in upgrading and how pressure from welfare actually made her start in a program. When welfare withdrew her assistance, she almost dropped out. She had almost believed that she was not a "serious" student.

"Seriousness" seems to be contrasted with "socialness," so that only doing the work individually seems to count as really working. Tutors frequently distinguished between the social time, the chat, before the lesson started, and the *real* lesson. They spoke of trying "not to get off track too much" and getting the students "into their work" as quickly as possible. The distinction between what is social and what is learning seems to differ from the intertwined sense of learning *as* social that the students appeared to want. Some instructors, when they observed the importance of the social nature of the interaction, judged that learning was not really going on, whereas learners' accounts were often of literacy and education *as* social. Perhaps the instructors were too embedded in their own school experience, where "learning" is only deemed to take place in silence and isolation, to appreciate the demand that education should also be social.

The constraints in the women's lives often made it impossible for them to attend classes. Frieda explained how important it was to her that she was involved in an upgrading program where the tutor came out to her:

> [If she didn't come out] I'd just have to drop out; I really wouldn't want to.

She said she wouldn't be able to go somewhere else to a class.

> No, unless I travelled in [to town] with [my sister-in-law], and she works, [so] I'd have to stay [in town] all day.

Yet tutors did not acknowledge the constraints the women experienced. One tutor said:

> I find that most of the people from down the way there [aren't reliable]. I had reserved two afternoons, three hours each last summer for this class that I was supposed to have and twice two of them showed up out of five and after that I never heard nothing from any of them. They didn't phone or nothing. They just didn't bother.

Several of the participants criticized the tutors for being unreliable:

> Sandra: She didn't even come for two weeks and this is three weeks.
>
> Frieda: And we're supposed to be writing our GEDs in November.
>
> Sandra: We waited. She said she would ... meet us in [town] after work ... for our lesson and we waited and waited and waited and she never came. We waited there for an hour and we could have been home.

The tutors seem to see the women's absences as unreliability and an indicator of insufficient motivation, rather than caused by circumstances in their lives. The tutors felt that if the women had to pay for the classes they would be more committed. Women are blamed for what is perceived as a failure of will.

Upgrading and training programs seek to fit women into a pre-existing framework and change their attitudes. Many of the programs do not encourage a dialogue which will help women to see the commonalities of their situation with other women,

and to see that, even with qualifications, many women are unable to find work. Women are encouraged to "choose" a job, but the lack of choice available to them is not discussed. They are encouraged to value the skills acquired through their work in the household, but not assisted to examine who benefits from the situation where these skills are not acknowledged. Encouraging women to accept gender roles, to dress well and do their make-up personalizes their problems and conceals and ignores structural inequalities.

Where women *are* encouraged to dream and are helped to strategize to achieve their dreams, as well as to identify commonalities with other women's experiences and develop a critical analysis, potential for change exists. But it is not easy to hold together the contradictory tasks of striving for short-term change while examining the structural constraints of achieving such change.

Often it is social service agencies which identify the "need" for programs. This frames the need for education in a social work definition of the problem. "Meeting needs" is also part of the discourse of adult education. The concept of meeting needs seeks to make the process of selecting program content objective. But this process obscures the value judgment involved in identifying individuals' needs rather than seeing a "need" for society to change. Where programs encourage women to create their own definition of needs, they support women in challenging the discourses which individualize their problems and define their needs in ways that fail to challenge the status quo.

The discourses of training programs demand a literate participant. Basic literacy students are excluded from training programs because literacy is considered a prerequisite to participation. Training programs rarely seek to explore how they might serve those with limited literacy *within* their programs. Instead women must make use of literacy programs in which they meet with a volunteer once a week. The use of volunteers for this tuition can characterize literacy work as charity rather than as a right women can exercise. This process stigmatizes literacy learning as an individualized, private and shameful

process to be undergone in one's own home. For those women who are excluded from training programs and must study at home with a tutor, the promise of literacy may not be fulfilled: The literacy programming, far from changing and challenging the everyday, more firmly embeds them in their daily life, not offering even a way out of the house to meet with other women in similar circumstances.

CHAPTER FIVE
Conclusion

This book has examined "discourse" and shown ways in which the dominant discourses preserve the status quo. These dominant discourses locate the blame for inequalities in the individual — in her or his lack of effort or will. But there is resistance, and potential for resistance, within discourses. Foucault (1980) illustrates the way in which discourses are not simply dominant or imposed, but embody possibilities for resistance:

> Discourses are not once and for all subservient to power or raised up against it, any more than silences are. We must make allowance for the complex and unstable process whereby discourse can be both an instrument and an effect of power, but also a hindrance, a stumbling-block, a point of resistance and a starting point for an opposing strategy. (100-101)

The Nova Scotian women appeared to resist the power of discourses to define them as outsiders, as incompetent and stupid. Rowbotham (1985) speaks of a subordinate culture as "problematic potentiality" which, she argues,

> means we avoid regarding oppressed people as either helpless victims determined by social structure or as possessors of an idealized virtue in permanent rebellion. Instead we can focus on how to create the conditions in which people are best able to express potential needs. (51)

These discourses of resistance contain a "problematic potentiality." Literacy programs *can* "create the conditions in which people are best able to express potential needs."

Earlier, the power of the discourse of choice and motivation

was illustrated when Dorothy spoke about why she had not gone to a literacy program:

> I *could've* went back to school and took some kind of an upgrading, I *could've*. I thought about it, but then the children were all small and I never did get around to it, but I usually say you shouldn't use that for an excuse at all really...
>
> Well, I had three small ones right after the other, they were just like steps and stairs. I'm sorry now I didn't go to school. I often wish that I could go back, but you can't turn the years back.

The suggestion that she *could* have gone, and her tone of blaming herself for her foolishness, speaks within the discourse that it is "a matter of will" to attend a program and that she is at fault for not having done so. But her description of her children — "like steps and stairs" — contrasts the dominant discourse with a resistant discourse that includes her lived experience of mothering. Her comment "you can't turn the years back" does not dwell on self-blame, even though she seems to view not going to school as her own failure of will.

Mary provided an example of one way in which women can resist the definition of their needs imposed upon them through the discourse of "functionality" and continue to seek their own meaning through a program. Mary's tutor frequently described the skills Mary had learned as "functional," even though Mary clearly did not identify these skills as useful to her. The tutor's approach is framed by the materials she has been taught to use and by the discourses of literacy work. When Mary tried to explain her participation in the program in terms of a desire to read, it became clear that there was nothing she wanted to read. Her tutor gave examples of functional reading tasks she had learnt:

Tutor: You learned to write a cheque?

Mary: Right.

Mary said she had never written a cheque before, but she didn't feel it would be useful to her:

> No, we have a bank account, but it's not cheques, it's more or less a savings account.

When Mary was asked whether there were other things that she "had to learn" or "wanted to write," her tutor replied:

> In these [Laubach books] there's a lot of things about day-to-day living. Today's lesson, even though we didn't finish it, had a grocery list and different things like that. What else? We learned to write thank you notes.

Her tutor also seemed to think that letter-writing might be a useful skill, but Mary herself didn't give that impression:

> Tutor: When Steve was in Ontario he used to call.
>
> Mary: Right, yes.
>
> Tutor: Then he came home too quickly. Do you remember when we were doing the letter and where you put the name and I said, "Oh good, now Steve's gone you can write a letter"? But he came home.

When Mary was asked whether this would be useful or whether she preferred to call, she said:

> No, like I told [my tutor], he used to call me.

But when it was suggested that perhaps letter-writing was not useful for Mary, before Mary could comment, her tutor said:

> If he had stayed away longer ... but he came home quicker than you thought.

Mary is seen by others as "functionally" illiterate, but her motivation for attending literacy class did not seem to be to carry out any "functional" tasks. Labelling Mary as illiterate says little about how literacy skills operate in her life, or what *she* identifies as the "need" which brings her to a program. It appears that Mary has practical strategies for all the items that

others might assume are functional needs for her: She does not need to write letters because the boy she brought up phones her; she does not need to write a cheque because she has no chequing account.

But Mary stated clearly that she was looking for meaning in her life. She wanted something social to do to fill her day. She spoke of being "bored," of having nothing to do, of seeing few people. Mary seemed to meet some of her "needs" through the program and spoke with pleasure of her participation in it, in spite of the "functional" focus of the program. Although Mary did not challenge directly the tutor's account of what her "needs" were, she built in social time to her meeting with the tutor, by serving tea and pie. During this interaction she was able to chat with the tutor about her life. The literacy program, although it defines her "need" as becoming "functional," also served Mary's own "needs" for something interesting in her day, something to do, a social interaction and a challenge.

Mary continued in the program but resisted the program definition of her needs. Barb dropped out as her way of resisting the message directed at her in the program that to bring up a child adequately she must be literate. Like Dorothy, she spoke within the dominant discourse when she described herself as dropping out because she was "lazy," but through leaving the program she resisted the judgment of stupidity.

Barb's tutor attempted to make the reading material useful for her by bringing in materials on pregnancy. This, however, made it clear to Barb that the tutor thought she was unable to "function." As Barb said, with emphasis: "She must have thought we were dumb." The tutor either did not "hear" Barb's statements that she knew how to bring up a child or did not believe that someone illiterate could know.

> If she hadn't found out that I was [pregnant] I don't think she'd have brought [information on pregnancy] in. But I had a younger brother and I looked after him since the day he was born and I told her that.

As noted earlier, Barb realized that the tutor was convinced that she must "need" to learn about pregnancy and childcare.

> She figured because I didn't have that much of a grade in school I wouldn't know anything about how to look after an infant ... I *told* her I'd looked after [Patrick] [since] the day he came home from hospital.

But, as Barb said:

> I admit I can't read very good. I *can* read, but there are some words that I can't understand and I can't figure out what they are.... [She thinks] I *should* read these [pamphlets on childcare] ... but I don't have to read anything to look after [a child].

Betty explained that Barb's attempt to define her own needs and the speed at which she felt comfortable working was ignored:

> When she first came out and gave Barb the Laubach program — I mean Barb could do everything that was in the book. She could have done the whole book in the one day that she was here. She said, "We'll do two or three — three or four pages here and there, [I'll] come back next week and do some more." A person could tell Barb was getting upset with it.

No one listened to Barb's own judgment that what she really needed was math. She saw this as valuable for work:

> You use a lot of numbers at work, to add up your time sheet, or your piecework. I could use a lot of math work.

Barb was given the Laubach reading set and expected to start from the first book and do a set amount each session. She was very upset by this.

> Betty: [It] looks like kindergarten.
>
> Barb: You should have seen some of the stuff I had to do; it was unreal.

Betty: I was sitting here and going through the session with Barb — it's unbelievable, it makes a person feel about so tall.

Barb: I didn't know much reading, I admit that, but that was for [first] grade.

She found the whole process depressing and upsetting and so exercised the one power she had: She dropped out.

I wasn't expecting it to be like that or I wouldn't have done it at all.

It was too depressing, boring and upsetting, stuff like that. Some nights I couldn't even get to sleep.

Her experience with the literacy program made Barb feel stupid and robbed her of her sense that she *could* read, even if her skills were limited. The books made her "feel stupid because the words were so easy."

Barb left the course. Although her explanation for giving up was laziness, she resisted the judgment that implied she was stupid, and she asserted the value of her experience. One of the coordinators said that students lacked motivation when they dropped out of a course with the explanation that their tutor was not doing what they wanted. But dropping out may often indicate a student's resistance to the program definition of her needs. Similarly, Fine (1985) argues that dropping out from high school should be considered "a symptom of social resistance" (50).

Sharon was able to resist the implication of stupidity offered by the elementary materials while continuing to use them. The tutor encouraged Sharon to question the materials, and Sharon acquired a sense of power from her ability to criticize them. She was able to use the elementary material to give her the strength to wipe out her school failure. Sharon's tutor's encouragement to question made Sharon feel in command and able to learn from the material. She said, with satisfaction, "It's easy work," which contrasted strongly with Barb's disgust and

sense of being judged as stupid. Yet both women were using the same material. When Sharon criticized a sentence, she reported that her tutor had said:

> "You're right, Sharon. You know it would sound a lot better if that was the way."

Sharon said she felt good about doing the relatively easy books, even though her sister had criticized them. She said:

> Yes, so it's easy. But if it's catching me [up], if it's making me read better, why not work on it?

She was able to go at her own speed.

> I'm halfway through the second [book. My tutor] can't get over how fast I'm going on the book. She assigns homework to me and we usually get two or three lessons done a day.

Asked if it was easier than she needed, Sharon replied:

> But like [my tutor] says, "Go over these ones and then get them down pat, then by the time you get to the big ones you're all right," and so I enjoy it. I've finished one book already; I'm on my second one, I'm halfway through it.

Sharon felt it was good to "start at the bottom and work your way up." She was not ashamed of using the simple material and thoroughly enjoyed her tutoring sessions. With her tutor's assistance, Sharon was able to resist the message of the material. She felt good about herself and confident in her ability to learn to read.

In different ways, Mary, Barb and Sharon all resisted the discourse that defined them as "functionally illiterate" and designated their needs. Mary met her own needs by creating the interaction she wanted, Barb left the program, and Sharon was able to use the program to feel strong and learn.

The women with limited literacy skills experienced being judged as stupid because they could not read and write well, not only from the materials they were given to read in literacy

programs, but also in daily life. Several of the women spoke of their rejection of this judgment. Sharon did not consider there was any reason to be embarrassed about being unable to read, though she did say that some people would "laugh at you" for going back to school. She described a friend who was embarrassed and "scared to ask for help," but she felt there was "no sense in being ashamed":

> There's nothing *wrong* with having a problem reading! You can fix it! I know some people that won't talk about it at all.

As she said,

> A lot of people have a problem — there are just different problems that people have. Why be ashamed of it? Because everybody's got a problem, I don't care who they are, everybody makes mistakes.

Josie said that others judging her as stupid or incapable of doing certain work used to make her angry but now it no longer did:

> I'm not stupid. I'd tell them, "If you think I'm stupid, I'm not." I'd say, "I can think." I say, "I understand."

Many of the women resisted the label of stupidity by stressing the value of experience. Although women spoke highly of the value of education, they also reflected on the limits of education for acquiring "real" knowledge. Women realized that their love of children and their empathy with people who have particular problems actually made them far more fit to work with people than some others with educational qualifications. Pat stated strongly the case for experience over education:

> I feel that they've taken all their degrees, OK, but when it comes down to it, their degrees are useless compared to my life experiences. And they know that, and it's a threat to them.

Although she expressed confidence in experience, on other

occasions Pat was unable to resist the dominant discourse so firmly, and she spoke of feeling inadequate because of her lack of education.

Sharon's younger sister also made it clear that she saw her father as "educated":

> It's funny, my father only has a grade six education and I have a grade twelve education — but if I have a problem he's the one I go to for help.

Some men were described as being "self-educated." When women looked to their husbands they saw that being officially illiterate was not the same thing as being stupid or even being unable to "function." Sandra spoke of her husband in the same way as several other women:

> He's more or less educated himself over the years. There's nothing he doesn't know about. He's a really smart person.... He educated himself through the road and the news.... He only had a grade six education, but he's not stupid. He's learnt a lot since he got out on his own.

The women were not so well able to resist the dominant discourse when they thought of their own experience. Their experience never seemed to count for as much as men's and they more frequently put themselves down for their limited literacy skills and incomplete education.

This claim for the value of experience is similar to the findings of Fingeret (1982; 1983b). She identifies illiterates who see themselves as having common sense and worry about losing that valued skill if they acquire too much "book learning." She suggests that unlike highly educated adults, many illiterate adults "consider common sense to be the highest form of problem solving" (1983a, 22). But the tendency of these women to claim the value of experience and common sense for their men while doubting their own knowledge suggests that this resistance is harder for women to invoke on their own behalf.

The theme of literacy as part of a dream of a "better" life

emerged in this study. Women frequently spoke of "light at the end of the tunnel." Initially these dreams seemed to be, not resistance, but part of how people continue to accept the status quo. They endure the struggle in the tunnel because they believe that one day soon, they *will* reach the light at the end. It seems as if literacy can make dreams of a different life come true.

Like playing the lottery, literacy helps keep dreams alive. Through both there is the hope that another life can be achieved. Like a lottery ticket, literacy does hold the possibility of a different life. Some people do win lotteries, and through literacy some poor women do achieve a different life. Like the lottery, it is true that if you don't play you can't win; you won't get the "career" if you are not literate. But even if you become literate you probably won't win. Perhaps, instead, you are more inclined to continue to endure life as it is, because you can continue to hope to win one day.

At first the dreams offered through literacy appeared to me simply to help preserve the status quo, without offering any possibility of real change. But these dreams are more complex and contradictory. Dreams of a different life make it possible to hope and to envisage change. Yet dreams are constrained by the limits of our imagination. As Rowbotham (1985, 50) says,

> The wants and desires of those who are oppressed are necessarily formed within the existing order.

Nevertheless, these dreams of something other than daily life as it is lived have a validity and a potential for change. For the women interviewed, literacy was the focus of their desires for change, but they were also aware of its limitations in accomplishing significant change. The women spoke of getting an education in order to get a job, but almost in the same sentence said there were no jobs. Without denying the validity and subversiveness of the hopes the women have, it must be said that the way the dreams are embedded within capitalism distorts and dilutes them. Seabrook describes how people's

dreams for their children become distorted when they are channelled into desire for material goods:

> By pouring goods and money down children's throats, you get them to expect more of the same, you tie them more securely to the system. The only thing that develops is their appetite for more. We want to give them a better start than we had, God knows, but the only way we feel we can do this is to shovel into them as much as money can buy. Of course giving, material things, it's a good instinct. It's only our way of doing it that's wrong. Working for future generations is a good socialist principle, it's another idea that capitalism has pirated, deformed and sold back to us. It's counterfeit, because you're serving profit first, and children second. (1978, 268)

Dreams of change can tie women firmly into the dominant discourses, but they also have the potential to be subversive, a site of resistance. Literacy and training programs are part of a process which classifies people as deficient, individualizes their problems and offers them a remedy that ensures the status quo is maintained. But the aspects of programs that women identified as valuable appear to offer them opportunities to resist dominant discourses.

Women spoke over and over again about how important the social aspect of a program was. It was valuable for them to get out of the house and to talk to other women. They spoke of being isolated and trapped in the house, of rarely going to a social event. Many of the women had been isolated in childhood, had not made friends in school and now did not trust neighbours. Others had left friends behind when they moved to a new location with their husbands. They spoke of being bored at home and enjoying the stimulus of a literacy program to help to fill that void. But they also spoke of the importance of the social interaction. Some interacted only with the tutor who came to their house. Others, in groups, spoke of the group becoming like one big family. They enjoyed working together and helping each other, and the opportunity to dis-

cover that their problems were experienced by other women was particularly important.

Another valued aspect of the programs, for many of the women, was the challenge it offered to think of something other than their daily life. As Judy said,

> I'm even feeling better, just learning, having something else in my mind besides the everyday.

But as discussed earlier, the escape from everyday life is also a dream which is unlikely to be fully achieved through literacy. Programs often simply prepare women to fulfil their roles better and embed them more firmly in their everyday world.

For some of the women the challenge is to get a GED diploma, to overcome their earlier school failure. When women first talked about the content of the upgrading programs, they seemed to be saying that they found it irrelevant to their lives. They spoke of doing grammar and called it "garbage" and "stupid" and didn't believe, as they were told, that it would help them to speak. But there was an underlying theme, they also said: "It was like that in regular school as well." They were eager to start "from [the] primary [grade] and learn right up.... " The upgrading program seemed to be valued as a re-run of school. It was not surprising that it was boring. School was also boring, and the requirement was not so much that the upgrading be relevant to the current lives of the women, but more that upgrading should repeat school, so that completion of the upgrading and a grade twelve pass would mean that the past school failure disappeared.

Women described upgrading as "kind of bringing ... [back] all [the things I'd forgotten from school]." Frieda said:

> It's interesting to get back [to school]. It's just like you've lost, and you're going to regain what you've lost, by going back to school.

Women were eager to go as high as "you can go in high school" and get the certificate that proved they had done it. It was

important not to quit this time around. Maureen, when asked whether she would like to do the upgrading, said:

> I said I'd just love to have a grade twelve certificate. So we just kind of got into the knack of it and all got together and decided we'd all try. I said, "I dropped out once. I don't care if it takes me ten years, I'm having a grade twelve diploma and I'm not quitting this time. I'm going to work. I'm going to work good and hard after all these years, because you forget so much and I'm going to work at it until I get the diploma."

Much of the challenge of the upgrading program seemed to be to be able to say they had finally achieved something they failed at earlier, often after many years away from school. As Frieda said:

> Well, you're doing something for yourself, after you quit school at fifteen and you're forty years old. It's a big thing to have a grade twelve education. And you earned it, you didn't just say "I can do that, I can do that and give me my certificate." You earned it, you worked to get it, and it's satisfaction and everybody needs a little bit of satisfaction in their life. That's the way I look at it.

Overcoming past failure is part of the challenge and satisfaction the women achieved through participating in the upgrading program. Many spoke enthusiastically about the challenge of doing their upgrading and the satisfaction of feeling "you can do it." Linda said:

> I wanted my grade twelve, I wanted to say I had my grade twelve.

It is doubtful, however, whether the GED actually does have the same symbolic value as grade twelve gained in the regular school system, either to employers or to the general population. The promise of erasing earlier school failure may not be fulfilled for many women, even if they achieve their grade twelve in the GED.

Some of the women saw challenge in working to meet their own dreams. For several, these desires were connected with how they were viewed by other members of the family. Josie wanted to write to her sister.

> I would sit down and write my sister a perfect letter. Really she's always wanted to see a perfect letter from me that my husband didn't dictate.

Sharon wanted to be able to read better than her younger sister who was about to graduate from high school. Whatever the goal, there is potential for literacy and training programs to provide women with a challenge and with the satisfaction gained from taking on something besides the "everyday."

Although there are problems with the "myth" that literacy, upgrading and training programs will lead to employment, for most women, educational programs are also the only possible route to a job that pays more than minimum wage. It would seem that the minimum requirement for any job is now grade twelve. There is little option for women but to attempt to do upgrading and hope that through obtaining the necessary qualifications they will be able to get a job. As Judy said, she is doing her upgrading

> for work, just to say that I went to school long enough to get that bit of paper. It's what they expect.

Some of the women saw the training programs they were participating in as more of a respite from the job search than as a preparation that would actually get them a job. But others considered the potential of education to offer a different and easier life — a middle-class life. Sharon's family were the most clear about this general value of education:

> I think it's good for her to have a good education, and besides, education doesn't only earn you money, education'll learn you to speak. They think education is just learning, but education is something that learns you all kind of different things. It's not just reading and writ-

ing and 'rithmetic, it's speaking and your appearance and stuff like that. Yes, it doesn't just mean one or two things — there's a lot education can do for a person.

Although literacy and adult education does not fulfil this promise for most women, for some it does.

Many women described the importance of learning to speak standard English. Without education, they felt that professionals didn't treat them well. Frieda explained:

> When you're speaking to someone with an education they kind of speak down to you if you don't speak as sophisticated. That's the way I find it.

The hope that education would cause women to be treated with respect by professionals might also be a vain hope, but, perhaps through the confidence gained in taking on the challenge of education, some women may feel able to question the power of professionals.

Advocating for Change

Carman St. John Hunter (1987) described variations in programming based on different definitions of literacy. (Her account is discussed in Chapter Three of this volume.) If we believe that illiterate people are childlike, incompetent, lacking in motivation, and unemployed because they lack skills or knowledge of appropriate behaviour, then we will believe that experts must assess the needs of participants and determine program content. But if we believe that those with limited literacy are adults, well able to judge their own needs, who left school because it was inappropriate to their lives or when conditions made it impossible for them to continue, people who will return to adult programs if they are appropriate and when the conditions of their lives make it possible, then we will provide programs which acknowledge the realities of adult

lives and make it possible for learners to determine their own "needs" *and* to identify the ways in which society "needs" to change. When women are assumed to have left school because they were not adequately motivated, their school and home experiences, which contributed to dropping out, are obscured. The discourses of illiteracy do not reveal the texture of the school experiences which are a factor in many adults' literacy levels. Research on school drop-outs focuses on their deficits. It is often assumed that, if adults had the opportunity to participate in schooling as children and failed to become proficient, they must be stupid. But the accounts of the women interviewed reveal the horrors or omissions of their school experiences. The common explanation of pregnancy as a reason for leaving is shown to be inadequate. Women left school because of pregnancy only when neither school nor home offered them support to continue. The women frequently described their "shyness" as a reason for leaving, but this does not reveal the violence of school or home which silenced them. The school, the family and the girls themselves often did not value school, as girls were expected to become wives and mothers. Many of the women were taken out of school early to help with the work of the household. They often experienced schooling as simply irrelevant, and so were eager to leave and support themselves. But the invisibility of such experiences in the discourses of illiteracy, and the prevalent explanation that the women "chose" to leave, leads to arguments that literacy programming should not be fully funded, because these adults have already been given one chance to learn. When the costs of literacy education of adults are considered, they should be viewed in the light of the failure of schools to offer these adults an adequate learning experience when they were children.

Volunteer programs can simply be cheap alternatives to using professional teachers. Where programs use volunteers unquestioningly, they can easily give the message that literacy is not a right but something offered as charity. But when programs seek to educate adults with literacy skills about the

literacy issue, and to help them to discover how to work with someone whose literacy skills are limited, then both adults learn: one improving her literacy skills, the other learning about the lives of those from whom she may have been long insulated. Both may discover commonalities. When those who have been literacy learners are trained to become literacy tutors, this can strengthen the commonalities and shared experience and further break down the barriers between teacher and learner. The relationship between tutor and student, at its best, can be one of growing respect and equality. A volunteer, lacking the confidence that she is a "teacher," may be open to sharing control of the learning process. And the learner may appreciate a relationship freed from the client role she experiences with social workers or mental health workers, where she can speak of her life to an outsider who is not in a position to tell her what she should do. For such a relationship to occur, rather than a "teaching" or "client" relationship wherein the volunteer struggles to do it "right," the education of volunteers must be a crucial aspect of the program. Not only will they need to learn about the processes of reading and writing, but they will need to understand racism, sexism and classism in society and their own location and complicity in these inequalities. When programs are designed to break down the separation between the tutor and the learner and give clear messages that the learner is a "knower," this can initiate a challenge to the traditional inequality of professional teaching relationships.

Many new literacy learners request individual tutoring, if it is available. For some, this may be because their school experiences were unsatisfactory and they consider that group work will not provide them with the extra help they need. For others, school failure and the experience of being judged as "stupid" has made them fearful of exposing themselves to ridicule. Individual tutoring seems a safer situation in which to begin formal learning again. But if learners are to find shared experiences with other learners and cease taking on individual blame for their situation, opportunities to get to know other learners are important. They could do this by participating in

group work as well as tutoring. As they become comfortable participating in a group, group work could replace tutoring. Other options include taking part in other activities at the literacy program, or two or three tutor/learner pairs meeting together on occasion.

Offering individual tutoring in women's own homes seems to address the practical problems women often have in attending classes. But this "solution" leaves the social organization of women's lives not only unchanged but also unchallenged. Unless opportunities to interact with other participants are structured into programs, women remain isolated in the home and denied social contact and the opportunity to discuss their lives critically.

Rather than judging women as unmotivated when they enrol in or drop out of a program because they were sent by a social worker, because their friend is going, or because of the ways in which their lives are dis/organized by others, programs should respond to the material circumstances in women's lives. This will help to strengthen discourses of resistance that make the social organization of women's lives more visible. Similarly, programs can support women to develop their understanding of their experience of schooling and awareness of how they came to leave school when they did. Programs can help women to articulate a discourse which resists the judgment that they left school because they were unmotivated or stupid or foolishly got pregnant and which reveals the material circumstances of their lives and the complexity of their experiences.

Programs which listen to women's own accounts of their needs and support them in questioning the dominant discourses of literacy will help to create spaces for opposition. When programs respond to participant drop-out as the student's failure, and see the student as not "serious," they are strengthening the dominant discourse that blames individuals and sees their participation in programs as a matter of individual will or choice. When programs create a situation in which participants can express their needs, demand the sup-

port they need to continue in the program, and enter and leave the program as necessary, they support the participants in their resistance to dominant discourses which judge them as incompetent and voiceless, unable to assess their own needs.

When program workers control the decision-making in programs, they take away from women the power to make their own judgments about their needs. When programs are set up to encourage women to take greater control over their own learning and over the program as a whole, the learning of literacy becomes, in itself, a tool for reflection and change. Literacy learners who have been encouraged to take a measure of power in their programs by designing their own curricula, sitting on committees and boards, and speaking out about their program and the literacy issue are beginning to question the extent to which they have significant power. They accuse some programs of practising tokenism, of being prepared to include learners, but not to change based on their demands, of wanting a spokesperson to help get funds, but not building broad representation which will reveal the breadth of differences among literacy learners. The challenge for literacy programs, which have begun to make space for literacy learners to express their needs and influence the development of programs, is to respond and develop, building on the strengths of all their participants.

For many women, social aspects of the program seemed to be crucial, and yet for many programs, program workers and funders, time spent socializing is seen as irrelevant and an inappropriate use of time. Many workers spoke of the need to curtail the chat and get down to work and disparaged those participants whom they felt were only in the program for a social time. For women, this chance to mix with other women seems fundamental to the value of the program. When programs seek to enhance the social aspects of the program and strengthen and expand the possibilities for meaningful interaction between students, they help to create a space for discourses which include women's shared realities. Programs that do not separate "work" and "social" time help to create a discourse

that contests the individuality of learning and makes it possible to see education itself as social.

Although women spoke of the value of the social interaction in their programs, one woman spoke about *not* thinking in the program, and many were clearly not encouraged to think critically about their lives and the commonalities between their experiences and those of other women. Programs that encourage women not only to share problems, but also to look critically at the location of these problems, create a space for discourses of resistance with the potential to lead to social change.

Many of the women interviewed spoke about the importance of the challenge of an educational program and the search for meaning in their lives: They wanted something in their minds "besides the everyday." Yet the main focus of many of the programs was on "functioning" and basic skills for their everyday lives. If programs create space for the discussion of issues and the meaning of literacy, this could lead to questioning the unproblematic connection between education and "getting ahead," and the nature of the challenge of literacy could be broadened. Setting up programs which respond to demands for challenge and meaning, and developing, in existing programs, the possibilities for broader challenges, would strengthen discourses which empower women to achieve new goals.

When programs teach "standard English" as unproblematic, they give a clear message about the inferiority of the regional or class-based language which the students currently use. They participate in the myth that "standard" English is simply correct English rather than, itself, a class-based language. When programs problematize "standard" English and encourage learners to speak and write of their own experiences, in their own language, they participate in challenging the white middle-class male control of language. When adult learners in community literacy programs are encouraged to produce accounts based on their experience in a variety of language forms, and these accounts are published, this disrupts the silencing of

the working class and contests the elite domination of "literature" in the standard language.[1]

Many of the women interviewed were attempting to prepare themselves for paid work. When women with limited literacy skills are excluded from training programs, and their needs seen as suitable to be met outside the program by volunteers, they receive a strong message of failure. Women are prevented from making their own judgments about what will benefit them most. Women need encouragement and support to make their own judgments about whether they can benefit from training programs when their literacy skills are limited. Alternative approaches to teaching practical skills, rather than reliance on written material, and innovative support systems must be adopted if women with limited literacy skills are not to be excluded from practical training programs.

Although programs cannot usually create jobs, they can encourage women to critically examine questions of the economy and unemployment and support participants in understanding that they are not to blame for their joblessness. When programs focus on teaching, questioning and critical skills, they will help participants become critical workers who will be able to assert their rights, rather than simply "good" workers who meet the needs of employers.

If programs and individual program workers see the participants in their programs as strong, competent adults, rather than "illiterates" who are other/childlike/silent, they will support women in creating a discourse that contests these images of what it means to have trouble reading and writing. To do

[1] In England, the Federation of Worker Writers and Community Publishers brings together a number of independent groups involved in this enterprise. In Canada, Toronto's East End Literacy Press publishes working-class writing by students in the program — mostly in a simple format for new readers. Other community-based literacy programs in Toronto are also beginning to publish. Most recently Parkdale People's Press has produced *She's Speaking Out* and St Christopher House has produced *Some People is Asking*.

this, program workers need to see participants' competencies, and to respect their realities, experiences and knowledge. Only through resisting the dominant discourses and refusing to interact with adult women as if they conformed to these derogatory images can workers break down the power of these images to create a subject who is constrained to understand herself as inadequate.

It is also crucial that program workers recognize the full complexity of the lives of the women who participate, rather than reducing the problem to simple terms and offering a diagnosis that locates the problem in the individual. A practice that enables program workers to resist discourses that construct the illiterate as "other," and which instead responds to those labelled illiterate as knowers, will support participants' own attempts to resist discourses that present them as powerless because they are poor. In this way, new discourses can be articulated which move away from the individualization of social problems.

It is not sufficient to say that literacy for women is a right, for that ignores the power of the social construction of what it is to be literate or illiterate. It ignores the variety of forces and factors in women's lives which make it impossible for many women to exercise a right to improve their literacy skills. However, because people are oppressed based on the judgment that they are illiterate, it is imperative that literacy programs are available for women. And it is not enough for them simply to be "on offer," unless the conditions of women's lives change sufficiently for them to be able to take advantage of such programs. The programs offered must open up possibilities for women rather than confirming inequalities and further embedding them in the status quo. Programming which assumes that women with limited literacy are the only ones who need to change is not adequate for those who are beginning to rethink the issues of illiteracy, as it will continue to lay blame on the individual. Instead, the image of the illiterate must be challenged and the issue of illiteracy reframed through the creation of new discourses and broader social change.

REFERENCES

Alden, H. 1982. *Illiteracy and poverty in Canada: Toward a critical perspective.* Unpublished master's thesis, University of Toronto, Toronto.

Armstrong, H., and P. Armstrong. 1977. *The double ghetto: Canadian women and their segregated work.* Toronto: McClelland and Stewart.

Armstrong, P. F. 1982. The myth of meeting needs in adult education and community development. *Critical Social Policy* 2(2): 24-37.

Barrett, M. 1980. *Women's oppression today.* London: Verso.

Batsleer, J., T. Davies, R. O'Rourke, and C. Weedon. 1985. *Rewriting English: Cultural politics of gender and class.* London: Methuen.

Breault, L. 1986. Turning a male training model into a feminist one: Canadian Jobs Strategy Re-entry. *Women's Education des femmes* 5(2): 14-17.

Buchbinder, H. 1981. Inequality and the social services. In *Inequality: Essays on the political economy of social welfare,* edited by A. Moscovitch and G. Drover, 348-69. Toronto: University of Toronto.

Calamai, P. 1987a (September 15). Counting the cost [Literacy in Canada: A special six-part report, Southam literacy survey, September 12-17]. *The Toronto Star,* A15.

———. 1987b. Women more literate than men. In *Broken words: Why five million Canadians are illiterate* [The Southam literacy report], 29-30. Toronto: Southam Newspaper Group.

Callwood, J. 1990 (January). Reading: The road to freedom. *Canadian Living,* 39-41.

Caughran, A. M., and J. A. Lindlof. 1972. Should the "Survival Literacy Study" survive? *Journal of Reading* 15: 429-35.

Clanchy, M. T. 1979. *From memory to written record: England, 1066-1307.* Cambridge, MA: Harvard University Press.

Computer revolution exposing illiterates. 1985 (April 12). *The Chronicle-Herald,* 1.

Connelly, P., and M. MacDonald. 1986. Women's work: Domestic and wage labour in a Nova Scotia community. In *The politics of diversity: Feminism, Marxism and nationalism,* edited by R. Hamilton and M. Barrett, 53-80. Montreal: Book Center.

Cook-Gumperz, J. 1986. *The social construction of literacy.* Cambridge: Cambridge University Press.

Corrigan, P. 1987. In/forming schooling. In *Critical pedagogy and cultural power,* by D. W. Livingstone and contributors, 17-40. Toronto: Garamond.

Corrigan, P., and V. Gillespie. 1977. *Class struggle, social literacy and idle time: The provision of public libraries in Britain as a case study in "The organization of leisure with indirect result."* Brighton: Labour History Monographs.

Council of the Nova Scotia Association of Social Workers. 1987. *How will the poor survive? A discussion paper on the current social assistance system in Nova Scotia.* Halifax: Council of the Nova Scotia Association of Social Workers.

Craven, J., and F. Jackson. 1985. *Whose language? A teaching approach for Caribbean-heritage students.* Manchester, England: Manchester Education Committee.

Crawford, T. 1990 (February 17). I can read. *Toronto Star.*

Cross, PK 1981. *Adults as learners*. San Francisco: Jossey-Bass.

Dance, T., and S. Witter. 1988. The privatization of training: Women pay the cost. *Women's Education des femmes*, 6(1): 8-14.

Davin, R. 1979. Imperialism and Motherhood. *History Workshop*, 5: 9-65.

De Castell, S., A. Luke, and D. MacLennan. 1981. On defining literacy. *Canadian Journal of Education* 6(3): 7-17.

De Lauretis, T., ed. 1986. *Feminist studies/critical studies*. Bloomington: Indiana University Press.

Department of Agriculture, Nova Scotia. 1986 (December). *Nutritious food basket*. Halifax: Department of Agriculture, Nova Scotia.

Department of Development, Nova Scotia. 1974. *Colchester County in perspective*. Halifax: Department of Development, Nova Scotia.

———. 1986. *Colchester County statistical profile*. Halifax: Department of Development, Nova Scotia.

———. 1987. *Northeastern Region statistical profile*. Halifax: Department of Development, Nova Scotia.

Donald, J. 1983. How illiteracy became a problem (and literacy stopped being one). *Journal of Education* 165(1): 35-51.

Douglas, J.W.B. 1964. *The home and the school*. Glascow: MacGibbon & Kee.

Eberle, A., and S. Robinson. 1979. *Illiteracy: The learners' experience*. Unpublished manuscript, Vermont.

Fine, M. 1985. Dropping out of high school: An inside look. *Social Policy* 16: 43-50.

Fine, M., and P. Rosenberg. 1983. Dropping out of high school: The ideology of school and work. *Journal of Education* 165: 257-72.

Fingeret, A. 1982. *Through the looking glass: Literacy as perceived by illiterate adults.* Presented at Annual Meeting of the American Education Research Association (New York, NY, March 19-23). ERIC Document Reproduction Service No. ED 222 698.

———. 1983a. Common sense and book learning: Culture clash? *Lifelong Learning: The Adult Years* 6(8): 22-24.

———. 1983b. Social network: A new perspective on independence and illiterate adults. *Adult Education Quarterly* 33(3): 133-46.

Fitzgerald, G. G. 1984a. Can the hard-to-reach adult become literate? *Lifelong Learning: The Adult Years* 7(5): 4-5.

———. 1984b. Functional literacy: Right or obligation? *Journal of Reading* 28: 196-99.

Foucault, M. 1980. *The history of sexuality, Vol. 1: An introduction,* translated by R. Hurley. New York: Vintage.

———. 1982. The subject and power. *Critical Inquiry* 8(4): 777-95.

Freire, P., and D. Macedo. 1987. *Literacy: Reading the word and the world.* Massachusetts: Begin and Garvey.

Gaskell, J. 1981. *The social construction of skill through schooling: Implications for women.* Unpublished manuscript, University of British Columbia, Vancouver.

———. 1987. Gender and skill. In *Critical pedagogy and cultural power,* by D. Livingstone and contributors, 137-53. Toronto: Garamond.

———. 1987a. Course enrollment in the high school: The perspective of working class females. In *Women and educa-*

tion. A Canadian perspective edited by J. Gaskell and A. McLaren, 151-170. Calgary: Detselig.

———. 1987b. Gender and skill. In *Critical pedagogy and cultural power* by D. Livingstone and contributors, 137-53. Toronto: Garamond.

Glustrom, M. 1983. Educational needs and motivations of non high school graduate adults participating in programs of adult basic education. *Lifelong Learning: The Adult Years* 6(8): 20-24.

Graff, H. J., ed. 1981. *Literacy and social development in the West: A reader.* Cambridge: Cambridge University Press.

Gray, W. S. 1956. *The teaching of reading and writing.* Paris: UNESCO.

Griffith, A. I., and D. E. Smith. 1987. Constructing cultural knowledge: Mothering as discourse. In *Women and education: A Canadian perspective,* edited by J. Gaskell and A. McLaren, 87-103. Calgary: Detselig.

Griffith, W. S., and R. M. Cervero. 1977. The Adult Performance Level Program: A serious and deliberate examination. *Adult Education* 27(4): 50-54.

Harman, D., and C. St. J. Hunter. 1979. *Adult illiteracy in the United States: A report to the Ford Foundation.* New York: McGraw-Hill.

Henriques, J., W. Holloway, C. Urwin, C. Venn and V. Walkerdine. 1984. *Changing the subject, Psychology, social regulation and subjectivity.* London: Methuen.

Hollway, W. 1984. Fitting work: Psychological assessment in organizations. In *Changing the subject: Psychology, social regulation and subjectivity,* edited by J. Henriques et al. London: Methuen.

Hunter, C. St. J. 1987 (October). [Definitions of literacy]. Presentation at the International Literacy Symposium, Toronto.

Jackson, N.S. 1987. Skill training in transition: Implications for women. In *Women and education: A Canadian perspective*, edited by J. Gaskell and A. McLaren, 351-69. Calgary: Detselig.

Kazemak, F. E. 1988. Women and adult literacy: Considering the other half of the house. *Lifelong Learning: An Omnibus of Practice and Research* 11(4): 23, 24, 15.

Keddie, N. 1980. Adult education: An ideology of individualism. In *Education for a change*, edited by J. Thompson, 45-64. London: Hutchinson.

Kirsh, I., and J.T. Guthrie. 1977. The concept and measurement of functional literacy. *Reading Research Quarterly* 13: 485-507.

Kozol, J. 1980. *Prisoners of silence.* New York: Continuum.

———. 1985. *Illiterate America.* New York: Anchor Press/Doubleday.

Laver, R. 1983 (September 8). Dismal rate of adult literacy assailed in Canadian study. *Globe and Mail*, 1-2.

Leonard, D., and M.A. Speakman. 1986. Women in the family: companions or caretakers? In *Women in Britain today*, edited by V. Beechey and E. Whitelegg, 8-76. Milton Keynes: Open University.

Levine, K. 1982. Functional literacy: Fond illusions and false economies. *Harvard Education Review* 52(3): 249-66.

———. 1986. *The social context of literacy.* London: Routledge and Kegan Paul.

Lewis, J. 1980. *The politics of motherhood, Child and maternal welfare in England 1900-1939.* London: Croom Helm.

Life without literacy. 1987 (September 12-20). *Chronicle-Herald*.

Literacy in Canada: A special six-part report. 1987 (September 12-17). *The Toronto Star*.

Maguire, P., R. Mills, D. Morley, R. O'Rourke, S. Shrapnel, K. Worpole, and S. Yeo. 1982. *The Republic of Letters: Working class writing and local publishing*. London: Comedia Publishing Group.

Martin, B. 1982. Feminism, criticism and Foucault. *New German Critique*, 27: 3-30.

[Media image workshop]. 1987 (October). Workshop at the International Literacy Symposium, Toronto.

Monette, M. 1979. Need assessment: A critique of philosophical assumptions. *Adult Education* 29(2): 83-95.

Morton, J. 1985. *Assessing vocational readiness in low income women: An exploration into the construction and use of ideology*. Unpublished master's thesis, University of Toronto, Toronto.

National Council on Welfare Report. 1977. *Jobs and poverty*. Ottawa: National Council on Welfare.

No literacy means no jobs. 1984 (April 19). *The Toronto Star*, A20.

Nova Scotia Advisory Council on the Status of Women. 1984. *Dialogue and decision for teenagers*. Halifax: Nova Scotia Advisory Council on the Status of Women.

Oakley, A. 1981. Normal motherhood: An exercise in self-control? In *Controlling women*, edited by B. Hutter and G. Williams. London: Croom Helm.

Olson, D. 1977. From utterance to text: The bias of language in speech and writing. *Harvard Education Review* 47: 257-81.

Parliamentary Task Force on Employment Opportunities in the Eighties. 1981. *Work for tomorrow* [The Allmand Report]. Ottawa: Queen's Printer.

Pierson, R. R. 1986. Women into the war effort. In *The politics of diversity: Feminism, Marxism and nationalism*, edited by R. Hamilton and M. Barrett, 101-35. Montreal: Book Center.

Rigg, P., and F. E. Kazemak. 1984. *23 Million illiterates? By whose definition?* Unpublished manuscript, Spokane, WA.

Rockhill, K. 1983. Motivation out of context. *Mobius* 3: 21-27.

———. 1987a. Gender, language and the politics of literacy. *British Journal of Sociology* 8(2): 153-67.

———. 1987b. Literacy as threat/desire: Longing to be SOMEBODY. In *Women and education: A Canadian perspective*, edited by J. Gaskell and A. McLaren, 315-31. Calgary: Detselig.

Rowbotham, S. 1985. What do women want? Women-centred values and the world as it is. *Feminist Review* 20: 49-69.

Scott, H. 1984. *Working your way to the bottom: The feminization of poverty*. London: Routledge and Kegan Paul.

Scribner, S., and M. Cole. 1978. Literacy without schooling: Testing for intellectual effects. *Harvard Education Review* 48: 448-61.

Seabrook, J. 1978. *What went wrong? Working people and the ideals of the labour movement*. London: Victor Gollancz.

Shamai, S., and P. R. D. Corrigan. 1987. Social facts, moral regulation and statistical jurisdiction: A critical evaluation of Canadian census figures on education. *The Canadian Journal of Higher Education* 17(2): 37-58.

Skodra, E. 1987. *The reinterpretation of Southern European immigrant women's everyday life experiences.* Unpublished doctoral dissertation, University of Toronto, Toronto.

Smith, D. E. 1986. Women and the inertia of the educational system. *Canadian Dimension* 20(3): 33-34.

Sola, M., and A. T. Bennett. 1985. The struggle for voice: Narrative, literacy in an East Harlem school. *Journal of Education* 167(1): 88-109.

Southam Newspaper Group. 1987. *Broken words: Why five million Canadians are illiterate* [The Southam literacy report]. Toronto: Southam Newspaper Group.

Spivak, G. C. 1987. *In other worlds: Essays in cultural politics.* New York: Methuen.

Steedman, C. 1986. *Landscape for a good woman: A story of two lives.* London: Virago.

Steedman, C., C. Urwin and V. Walkerdine, eds. 1985. *Language, gender and childhood.* London: Routledge and Kegan Paul.

Street, B. V. 1984. *Literacy in theory and practice.* Cambridge: Cambridge University Press.

There's an epidemic with 27 million victims. And no visible symptoms. 1985 (September). [Advertisement, Coalition for Literacy]. *Scientific American,* 113.

Thompson, J. L., ed. 1980. *Adult education for a change.* London: Hutchinson.

TVOntario. 1989. *Lifeline to literacy: People with disabilities speak out.* Toronto: Ontario Education Communications Authority.

Veltmeyer, H. 1979. The capitalist underdevelopment of Atlantic Canada. In *Underdevelopment and social movements*

in Atlantic Canada, edited by R. Brym and J. Sacouman, 17-35. Toronto: New Hogtown Press.

Walkerdine, V. 1985. Dreams from an ordinary childhood. In *Truth, dare or promise: Girls growing up in the 1950s,* edited by E. Heron. London: Virago.

Weedon, C. 1987. *Feminist practice and poststructuralist theory.* Oxford: Blackwell.

Williams, R. 1988 (March). Malign neglect. *New Maritimes,* 11-12.

Jennifer Horsman began working in literacy in 1973 as a volunteer tutor and has continued in the field since that time. She has coordinated a literacy program in Sierra Leone, West Africa, worked with community literacy programs in Toronto and co-chaired the Metro Toronto Movement for Literacy for two years. The research for this book, undertaken in rural Nova Scotia, was prompted by questions arising from her literacy work. Jennifer currently divides her time between rural Nova Scotia and Toronto, where she continues to be active in the literacy community.